SECRETS

of the OCEAN

REALM

MICHELE *and* HOWARD HALL

SECRETS
of the OCEAN
REALM

FOREWORD *by* PETER BENCHLEY

9,578.77

A CARROLL & GRAF / BEYOND WORDS PUBLICATION

Beyond Words Publishing, Inc.

20827 N.W. Cornell Road, Suite 500

Hillsboro, Oregon 97124-9808

503-531-8700

1-800-284-9673

Carroll & Graf Publishers, Inc.

19 West 21st Street, Suite 601

New York, New York 10010

212-889-8772

Editor: Marvin Moore

Design and typography: Princípia Graphica

Printed in Italy by Editoriale Bortolazzi-Stei

Distributed to the book trade by Publishers Group West

Library of Congress Cataloging-in-Publication Data

Hall, Michele.

 Secrets of the ocean realm / Michele and Howard Hall.

 p. cm.

 ISBN 0-7867-0453-5 (cloth)

 1. Marine organisms. 2. Marine organisms—Pictoral works.

3. Deep-sea ecology. 4. Underwater photography. I. Hall, Howard,

1949– . II. Title.

QH91.H25 1997

578.77—dc21 97-21824

 CIP

To JOHN *and* JANORA, PHYLLIS *and* MEL

Thanks for the opportunity

CONTENTS

o One of the sad ironies of the age is our dogged persistence in spending untold treasure in search of the merest hint of life on some distant world, while we all but ignore the wonders that await discovery, study, and understanding right here on our home planet. o More than 70 percent of Earth's surface is covered by water. Less than 5 percent of that has ever been seen, much less thoroughly explored, by human beings. o Almost certainly, there are in our oceans plants and animals that could offer medical miracles, biological breakthroughs, and existential explanations—if only we would devote more of our funds and energy inward instead of out into the enormous emptiness of space. o The oceans have often been described as Earth's last frontier, and despite the shameful indifference of most governments, there are among us a few pioneers who—for scant recognition and even scantier reward—devote their lives to pushing the limits of that frontier. o The best of that breed is Howard Hall. The images he has captured, still and moving, have revealed the creatures of the water world in breathtaking beauty, detail, and drama. o Wildlife photography is difficult under any circumstances: subjects are elusive and uncooperative, if not downright hostile. A good photographer must have talent, of course, and an artist's eye, but neither is as critical as patience, daring, and an infinite capacity for boredom. Frustration is a daily diet. o Underwater wildlife photography requires all of the above *plus* the willingness to work in the hazards of an alien environment, where carelessness can cost a life.

o I've had the pleasure of working with Howard— or, rather, of watching Howard work—for nearly a quarter of a century, ever since, as a very young man, he was a production assistant (aka gofer, serf, or esne) on the movie version of *The Deep.* I have seen his work grow and diversify and mature to a point where it is now, in my judgment, among the finest in the world. o His wife and partner, Michele, is a fine photographer in her own right, and the sight of her graceful form aboard the back of a huge manta ray was the inspiration for a book I called *The Girl of the Sea of Cortez.* o Their films have won pretty much every award offered in the field, which leads to the inescapable conclusion that though some others may occasionally do as well, nobody does it better. o There is, however, a final, sad irony to the Halls' work. Just as they are reaching the pinnacle of their profession—arguably the finest documentarians in the business—they are unwittingly and unwillingly becoming archivists, memorialists, for there is a genuine and educated fear that several of the animals the Halls have recorded on film may not long continue to exist in the wild. o Never before has man assaulted the oceans with such wanton effect. As is happening to animals and insects in the rain forests, marine species are being extinguished as soon as—and in some cases even before—they are discovered. o The existence of the familiar is threatened, too. For example, twenty years ago the average size of the broadbill swordfish caught in the Atlantic Ocean was 600 pounds; today the average swordfish caught weighs 60 pounds. We are killing the juveniles, the breeding stock, even before

they are sexually mature. ❀ And the populations
of some shark species—never accurately counted because
until recently nobody cared—have been so devastated
by overfishing that they may not recover. ❀ My lingering
nightmare is that my grandchildren will never
know a great white shark or a giant tuna or any

number of other wonderful animals, except as fleeting
memories caught by the Halls and their few peers.
❀ But enough of gloom. Enough of words, in fact.
Secrets of the Ocean Realm is a book of glorious images and
engaging stories. Enjoy it, as I have, and be grateful, as I
am, for the talents of Howard and Michele Hall. ❀

Peter Benchley

INTRODUCTION

● I'm often asked how I got into this business. It's a career no one would have imagined, much less predicted, for my future. ● I grew up a city girl, born to city folks. My idea of an outdoor adventure was a Sunday walk in a city park or sunbathing at a hotel swimming pool. As a child we didn't visit national parks, and only once— a short trip to a resort in the Bahamas—did I travel outside the continental United States. ● Being a registered nurse was the only job I ever wanted. When I was in nursing school, I'd have laughed at the suggestion that I would have a second career twenty years later as an underwater filmmaker. I probably would have found the idea terrifying. ● A few years after college graduation and a move to San Diego, California, I began dating a young doctor whose favorite pastime was scuba diving. That increased my motivation to take up the sport, a seemingly daring act at the time. ● I soon found myself immersed in the temperate Pacific Ocean and enthralled with the new world I discovered in the sea. I fell in love—first with the ocean and its inhabitants, and later with my instructor, Howard Hall. I'm sure my parents were horrified upon discovering that my romantic attentions had drifted away from a doctor and future plastic surgeon and toward a diving instructor! Eventually Howard became my wildlife guide. ● Howard's interest in the wilderness had begun as a young boy.

His upbringing contrasted dramatically with mine, and although we were both raised in the suburbs, the nuances of our environments were as different as night and day. While I was playing on concrete playgrounds, Howard was exploring neighborhood meadows and woods. He was happiest when collecting insects and reptiles. His mother never knew what surprises might be concealed in his pockets on laundry day. ● As a youngster, Howard resented almost every minute he was required to be indoors. School days, from elementary through college, were a time to be endured, not enjoyed. He eventually recognized that there was a value to the education hidden within classroom walls and textbook covers, but fulfilling the requirements was a genuine endurance test. ● While in college, teaching diving became not only a diversion from the classroom but a way for Howard to pay for his education at San Diego State University, where he earned a degree in zoology. By 1972, college graduation and a diploma set him free from lecture halls and biology labs. He was now faced with searching for a career that wouldn't require being cooped up indoors. ● Howard's search for a career in diving caused him to leave behind the sport of spearfishing and take up underwater photography. He began using his spearfisherman's skills to pursue fish, whales, and other sea creatures for photographic opportunities. His affinity

for wildlife paid off as he began bringing home some terrific and unusual photographs. By 1976, he'd developed a reputation for photographing sharks, which led to being hired as shark advisor on the motion picture *The Deep*. This assignment gave him enough capital to build an underwater movie camera, and in 1978 he gave up scuba instruction. Soon he was making a modest living marketing his still photos. As an assignment cameraman, "Have Camera Will Travel" became his slogan. ‧
I went on my first underwater filming expedition with Howard in August 1980. He was producing his first film about the hammerhead sharks that school in great number over a seamount in the Sea of Cortez (Gulf of California). Underwater cameraman Stan Waterman and author Peter Benchley were along as hosts for the show. During this expedition I had an experience that changed my life forever. ‧ Returning from a dive on the seamount, I saw one of the cameramen, Marty Snyderman, perched on the back of a Pacific manta ray. It was an enormous animal flying over the seamount with wings that spanned more than eighteen feet. I couldn't believe my eyes. Marty was trying to cut loose a fishing net that was wrapped around the manta's mouth. As the manta flew by, Marty signaled to me that he was almost out of air and needed to surface. Just then the manta turned in my direction and stalled beneath me.

There was no mistaking its intent for me to pick up where Marty had left off. I settled down on the ray's back and succeeded in removing the last tangle of fishing net embedded in its mandible. Whether this behemoth thought me Androcles or what, I'll never know. But it took me for the ride of my life. ‧ It's difficult to explain what I felt during those moments. Awe, trust, exhilaration, tranquillity—these words are barely adequate. With no effort on my part, the ray and I flew around the seamount. My sense of time was confused, as it seemed we were moving in slow motion. Or maybe I just wanted it that way; I didn't want the experience to end. At one point we glided past Howard, Stan, and Peter as they returned from a dive. Howard later told me that upon seeing me perched on the ray's back he'd halted dead in the water, marveling in disbelief as the ray swept me away and helplessly thinking he might never see me again!
 ‧ When I saw my exhaled bubbles splayed behind me instead of rising directly to the surface, I realized how fast we were moving. I experienced the need to equalize the pressure in my ears and knew we'd begun to descend. But I was on a magic carpet of my very own, and I was ready to be taken away. My senses returned when I checked my pressure and depth gauges. I knew I had to ascend and head for the boat. If the ray had taken me too far away, I could have an impossible swim back. The boat crew

might have difficulty finding me in the late afternoon light. Just as I began to worry, I realized we were at the boat's anchor line. The ray had taken me full circle and was depositing me where we'd started! o For several days following my removal of the net from the giant manta, Grand Dad—as he became known—returned to the seamount. Before the trip's end he'd taken us all for a "ride," and Howard had added a manta ray segment to the film's story line. Grand Dad had also inspired Peter to write a new story, which became his novel *The Girl of the Sea of Cortez*. o More than ten years passed before I made such adventures my new career. But clearly, from the moment I settled on Grand Dad's back, my life was altered. When I remember the relatively simple plans I'd had for my future when I was a girl growing up in Midwest cities, it's hard to believe where life has taken me. o

o Howard and I were married in 1981. Ten years passed before I left the security of my nineteen-year nursing career and, quite literally, dived into the unpredictable life of natural history film production. o Seven months later I went on my first expedition as a full-time natural history filmmaker. I was associate producer for "Shadows in a Desert Sea," an episode of the PBS series *Nature* about the marine wildlife in the Sea of Cortez. Howard was the producer and primary cinematographer. o I remember lying in my bunk late one night, reading Kenneth Grahame's *The Wind in the Willows*. I came across a passage that Stan Waterman often quotes from this children's classic: "Take the Adventure, heed the call, now ere the irrevocable moment passes!

'Tis but a banging of the door behind you, a blithesome step forward, and you are out of the old life and into the new!" The passage caught my attention and I identified with it, realizing that it aptly reflected how my life had been transformed after changing careers. o I love my new career. I love sharing the wonders of the sea with those who view our films. And it's fun—most of the time, at least, when the winds aren't raging and the seas aren't crashing. But I've learned that sometimes good memories must be paid for with discomfort. No matter where I am, I try to always be ready for the unexpected and to enjoy the Adventure! o

o After making several films together, Howard and I began thinking about making a marine life television series. That idea came to life during a bus ride while attending the Jackson Hole Wildlife Film Festival in 1993. An idle conversation with Ron Devillier, president of Devillier Donegan Enterprises, Inc., a television film distribution company based in Washington, D.C., led to his asking, "Howard, have you thought of what you want to do next?" With that, the idea for *Secrets of the Ocean Realm* was born. o Ron and his partner, Brian Donegan, opened the door for us to produce a high quality television series, requiring that we explore new territory and return to old filming locations to shoot fresh footage. For almost a year we nurtured the seed which was planted that night on the bus, and we became increasingly excited about the upcoming venture. The series would be a compilation of the best material from our film library plus forty hours of new footage

obtained specifically for the production. ✺ As the series' concept took shape, a companion photography book was suggested. Howard and I both have roots as still photographers, and even though our film work takes precedence during our expeditions, we make the most of every opportunity to take still photos. The book seemed a natural. ✺ Almost four years have passed since that conversation. Following is a collection of our favorite photographs and Howard's accounts of many of our adventures while filming over the years. No one should presume this book to be a resource or reference text. Rather, it's a visual and verbal chronicle of the adventure of underwater filmmaking. ✺

✺ One of the advantages to producing our own films is the control we have over who we hire for a film crew. When a group of people must spend twenty-four hours a day together for days—and sometimes weeks—at a time in the confined quarters of a dive boat, it's best if they like each other. If they don't, the results can be very unpleasant. ✺ Virtually the same small handpicked crew has been with us since 1988. We each have overlapping responsibilities, and additional members are added as needed for their special talents. Our core crew consists of Bob Cranston, Mark Conlin, and more recently, Mark Thurlow. ✺ Howard and Bob spend most of their in-water time together, searching for animals they hope to film. Once the camera is in position, Bob's assistance enhances Howard's ability to "get the shot." Bob also lends a hand as second cameraman when needed. In 1990, Howard and Bob began diving with mixed-gas

rebreathers. These experimental devices greatly increased their ability to stay underwater. ● Mark Conlin is invaluable as our assistant cameraman. When we're out in the field he takes full responsibility for keeping Howard's movie camera water-ready at any given moment. Aside from having the correct type of film loaded and lens mounted, the camera must be precisely placed in its underwater housing to avoid leaks. The last thing you want is salt water on your expensive camera and film! He, too, does some filming for us at times. And we also take advantage of Conlin's marine biology degree. While on scouting dives, he often spots animal activity that Howard later films. ● Mark Thurlow is the newest member of our team. A precocious inventor, he's the kind who's always trying to come up with another way of doing things because he knows "It's OK as it is—but just maybe I can make it better!" And as his dive buddies, we reap the benefits of his seemingly never-ending ideas and sleepless nights. His strong scuba and rebreather diving skills are also tremendous assets to our team. ● Other Californians have worked with us, including Marty Snyderman, Chip Matheson, and Norbert Wu, all of whom have gone on to pursue their own filmmaking careers. ●

● The stories which follow are not intended to detail everything that went into making our television series *Secrets of the Ocean Realm*. However, they reflect many tales of our diving and filming adventures over the past decade. I hope these stories will give you a sense of the wonder that lies below the ocean's surface. ●

Michele Hall

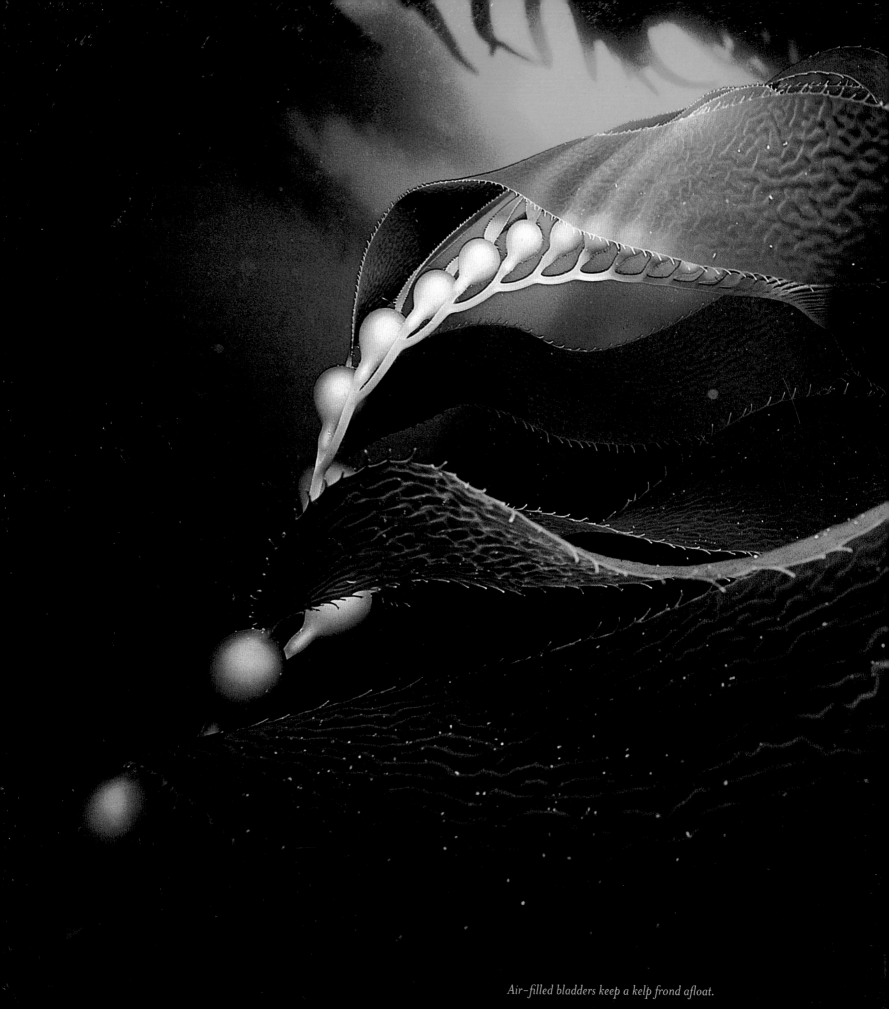

Air-filled bladders keep a kelp frond afloat.

CALIFORNIA CHANNEL ISLANDS

CATHEDRAL *in the* SEA

● Amber sunlight lanced down through gaps in the kelp forest canopy and dappled over the reef sixty feet below. My eyes adjusted to the dim light as I entered the forest, and as always, I was stunned by a sense of déjà vu. I can't really call the kelp forest my second home. As much as I would like to claim such familiarity, I remain an alien in this world. But having made my first scuba dive in a California kelp forest more than three decades ago, and thousands more in the years that have followed, this wilderness holds special significance for me. Now every time I move through the golden twilight of the kelp forest, I am deluged with memories. ● I have often struggled to find words that adequately describe what it is like to drift through this forest beneath the sea, and I have always failed. When the water is clear and hundred-foot-high trees of giant kelp sway gently to the rhythm of waves and current, and when the amber twilight penetrating through the dense canopy far above reveals the carpet of fluorescent anemones and red gorgonian corals clinging to the reef below, to say that it is overwhelmingly beautiful is accurate but not adequate.

● I paused for only a moment before moving on into the forest. And once again, I rejoiced in my good fortune at having a job that requires me to visit such places. Mark Conlin and Bob Cranston followed me into the forest carrying powerful movie lights and a heavy tripod. I pushed the 16mm movie camera ahead as I swam. Michele Hall was not far behind with her still camera and flash. ● Deep in the forest, a bright orange fish hovered above a four-foot-high rock. A dark yellow

patch, about eighteen inches in diameter, colored the side of the stone. This was our destination. Bob spread the legs of the tripod and set it next to the rock. I mounted the camera and Mark passed the movie lights, which I attached to the top of the camera housing. The bright orange fish looked on with mounting horror.

He was hesitant to leave. The fish was a male garibaldi, and the yellow patch was his nest filled with tiny golden eggs. He'd spent the last three weeks happily seducing female garibaldi who regularly enriched his nest with their precious cargo. Now his happy little penthouse in the sea had been invaded by gigantic,

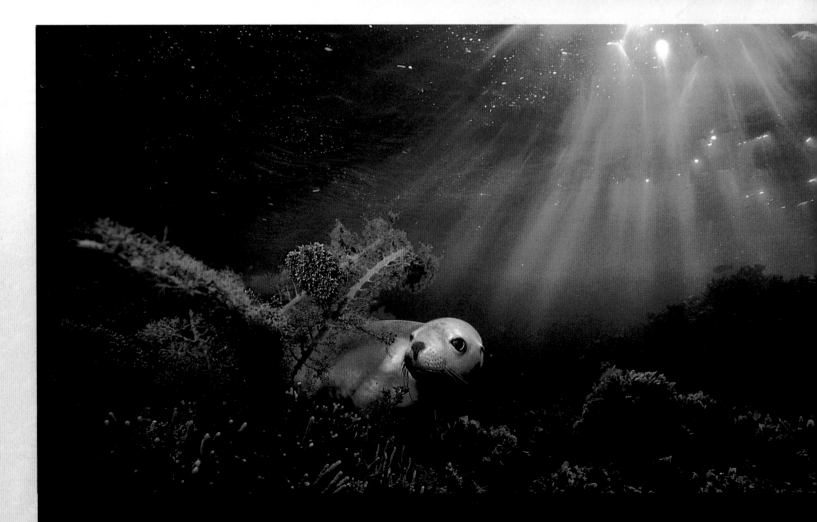

An Australian sea lion.

NEPTUNE ISLANDS, SOUTH AUSTRALIA

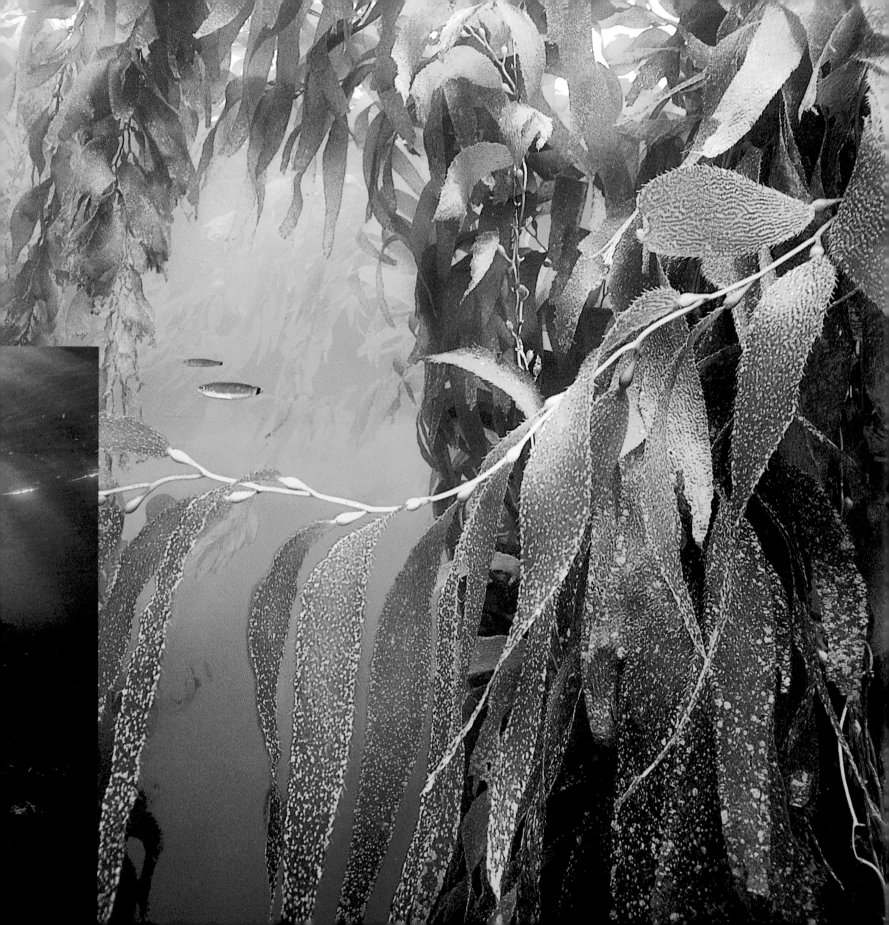

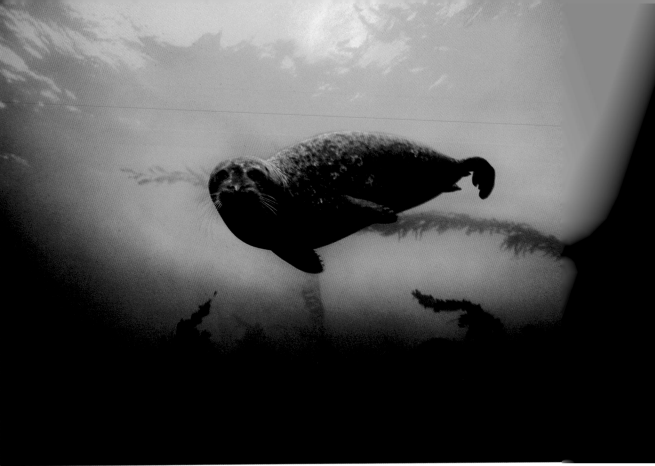

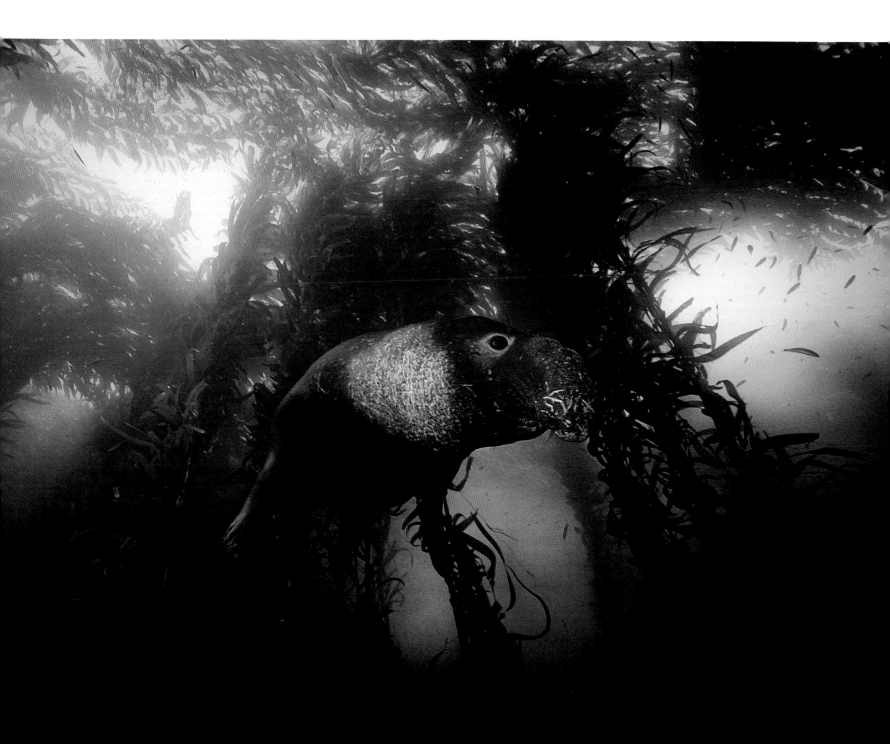

An adult male elephant seal in a kelp forest.

SAN MIGUEL ISLAND, CALIFORNIA

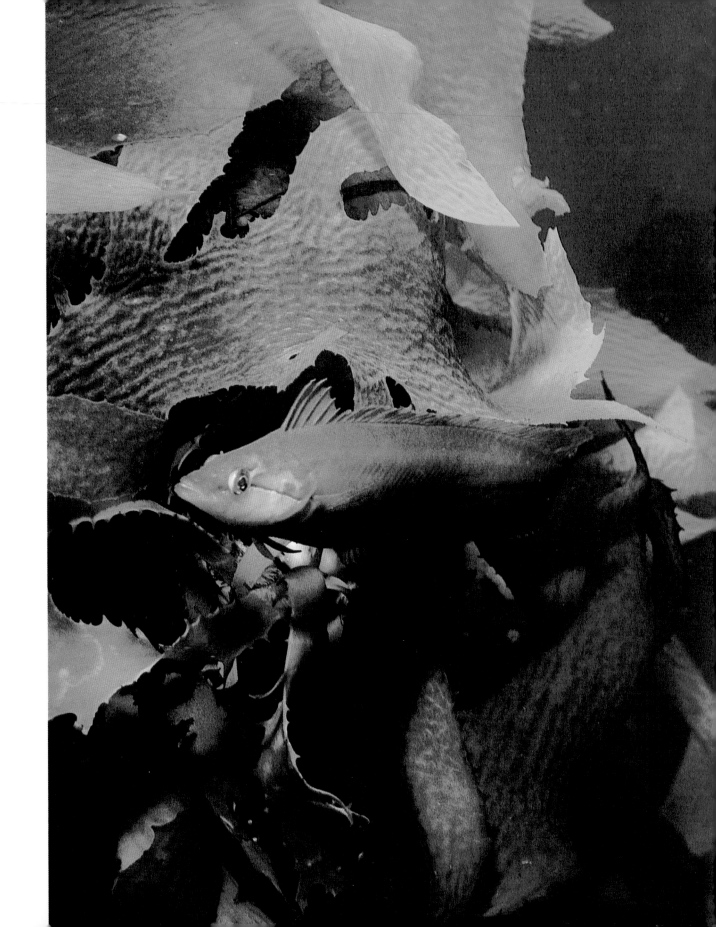

misshapen aliens spewing roaring columns of bubbles and flooding his nest with bright, unnatural light. For the garibaldi, life had taken a disturbing turn. ○

Of course, I meant the fish no harm. All I wanted was to film the natural history of garibaldi reproduction. I hoped that the crowd of divers, the bright movie lights, the occasional flash from Michele's strobe, and all this alien activity would leave the garibaldi unfazed and that he would carry on, blissfully attracting females to his nest. But I didn't really expect to be so lucky immediately. I anticipated a period of adjustment. ○

In fact, it took three days before the garibaldi's

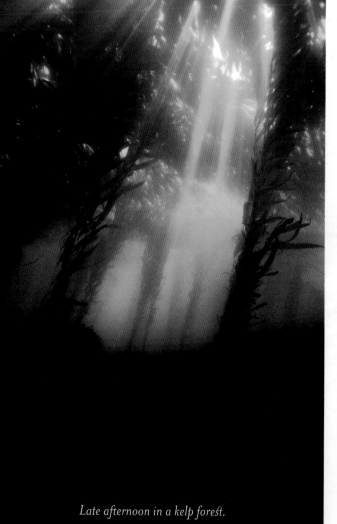

Late afternoon in a kelp forest.

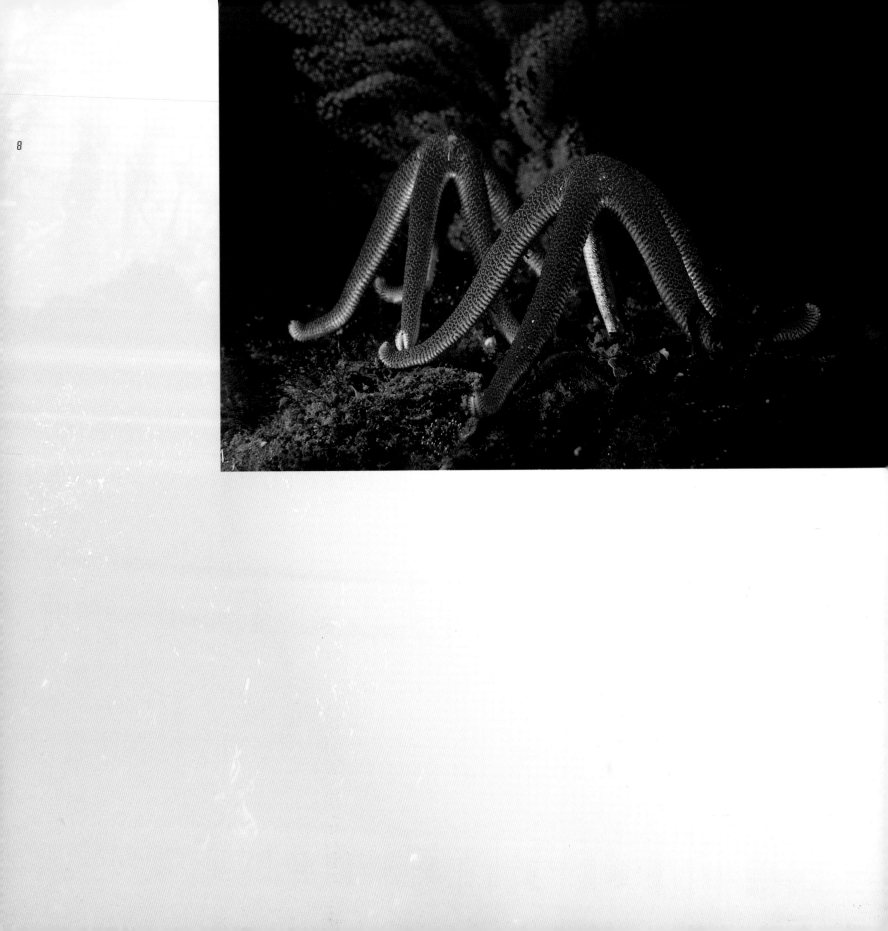

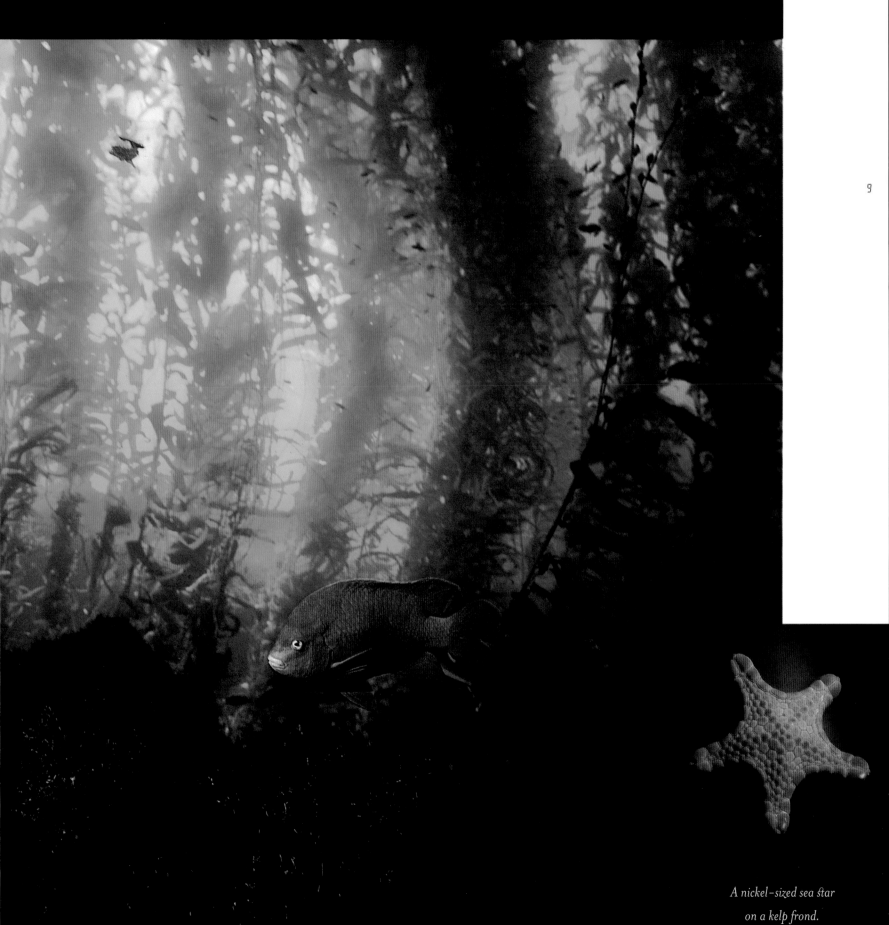

A garibaldi swims through a kelp forest.

CALIFORNIA CHANNEL ISLANDS

9

A nickel-sized sea star

on a kelp frond.

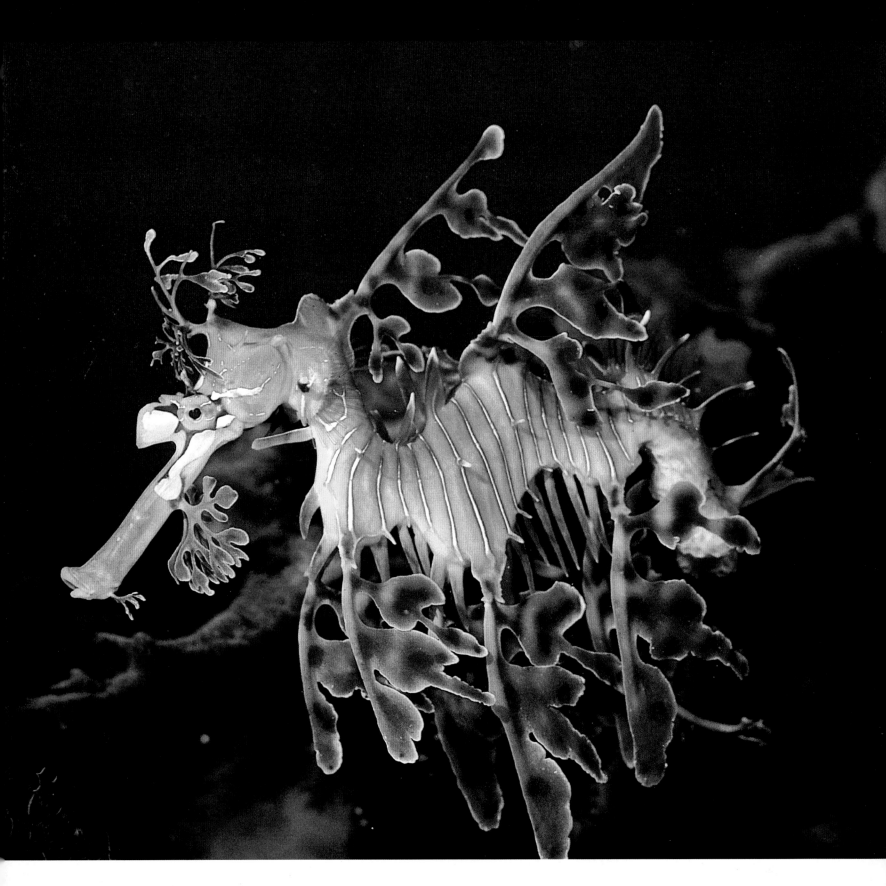

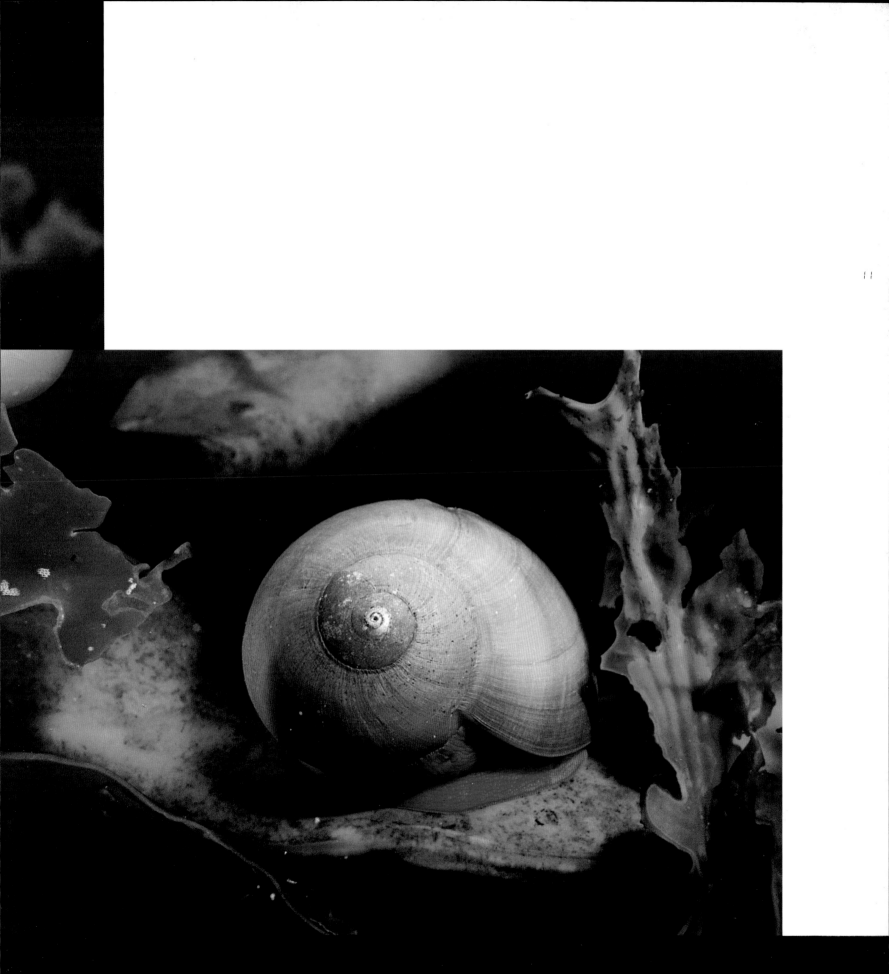

A Norris top snail lives high above the seafloor on a giant kelp frond.

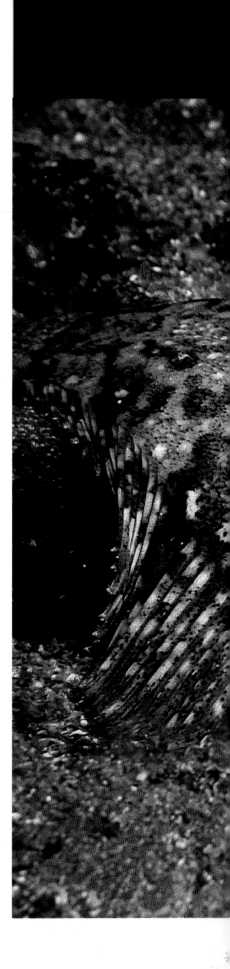

behavior returned to normal. At first he just hovered
over his nest in a state of shock. Certainly, his hopes would
rise each time we left the area and returned to the
boat for fresh air tanks. But we often left our camera and
lights mounted next to his nest. At sunset on the first
day, his unwelcome visitors left, and the garibaldi was
overjoyed that his ordeal was over. Perhaps tomorrow
he could return to his role as an aquatic Don Juan.

o But early the next morning we descended upon
his nest again and the garibaldi's calamity resumed. The
shock he exhibited the day before was replaced by
anger, and the fish spent much of the day attacking the
camera. He could see his reflection in the camera
lens and perhaps thought his ordeal was caused by a
competing male who had somehow enlisted the aid of
monsters in an effort to drive him from his territory. He
jousted bravely with his mirror image much of the
morning before realizing the futility of his efforts.
By noon, he was exhausted. Then, early in the
afternoon, the garibaldi changed strategy. He decided to
simply ignore us. o The rest of the day, we filmed
the garibaldi as he resumed caring for his nest. In
garibaldi, domestic responsibilities fall to the male.
He builds the nest, grooms it, and cares for the eggs until
they hatch a few weeks after being laid. Females
promiscuously flit from one nest to another laying their
eggs for males who have seductive personalities and
have prepared attractive nests. For the next day and a half,
we concentrated on filming the domestic chores of
our unwilling host. Finally, on the fourth day, we filmed
his courtship display. o A female garibaldi advertises

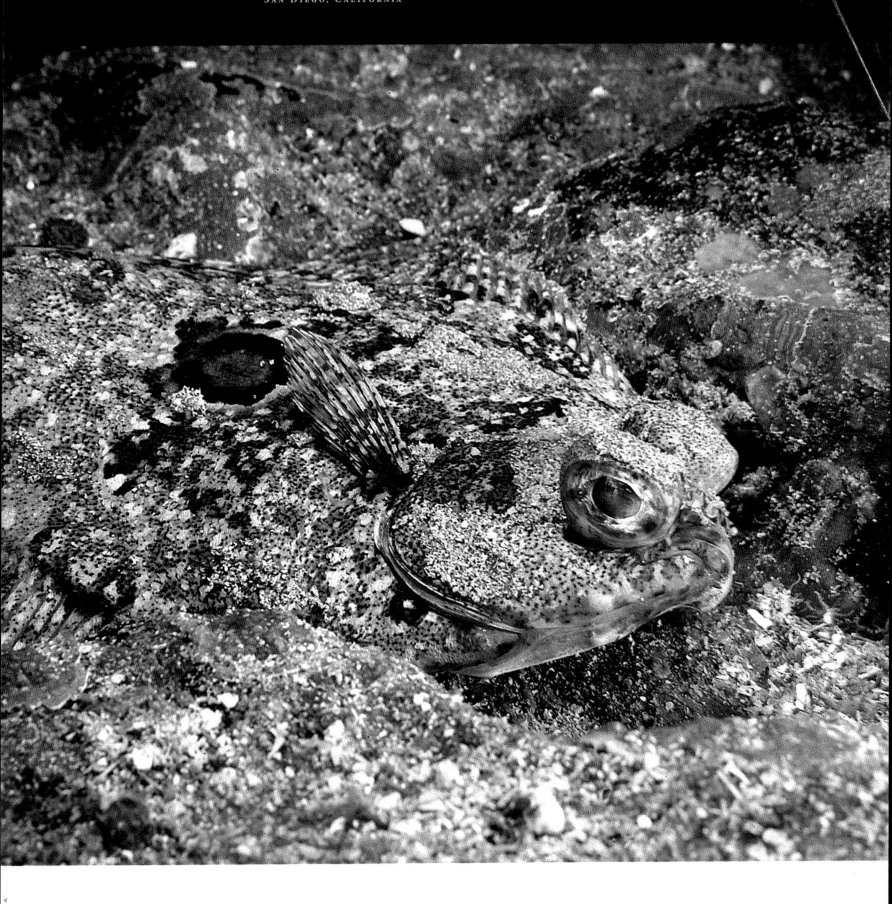

A turbot camouflaged on the seafloor.

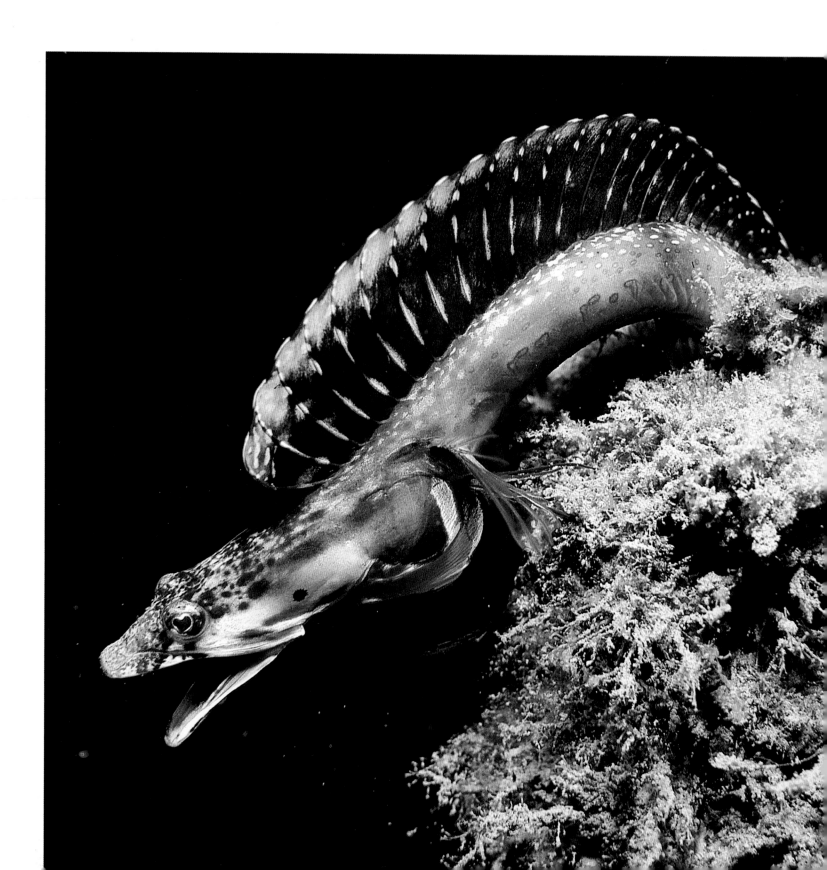

her availability by erecting her dorsal fin as she swims provocatively over the reef. Upon seeing this display, the male leaves the nest and performs a series of acrobatic loops. At the apex of each loop, he clucks twice. On the fourth day, our garibaldi saw a flirtatious female pass over his rock, and he rose to the occasion. He performed his dance flawlessly. At the end of three loops, he swam back to his nest followed closely by the female, who then entered the nest and began laying eggs. This was what I had waited four days for. o For five minutes, the female laid eggs in the male's nest. Then, with no eggs left to lay, she turned to eat some of those left by previous females. The male garibaldi would have none of this. Clucking wildly, he chased her away. o
I was completely satisfied with the sequence I had captured with my camera. With a nod to Mark and Bob, I dismounted the camera from the tripod. We gathered up all of our gear, turned, and swam back toward the boat. The garibaldi looked on in stunned silence. His ordeal was over just when he was getting used to having us around. o Three weeks later, we returned to the same kelp forest and once again fell upon the garibaldi's nest with our bulky and noisy equipment. I'm sure the poor fish couldn't believe his bad luck. I could almost hear him think, "Oh, my God, they're back!" He was immediately furious and began attacking his mirror image in the lens only to rediscover that his opponent returned each blow with equal ferocity. o I had no plans to inconvenience the garibaldi to the extent I had weeks earlier. All I wanted was a close-up shot of the eggs. I hoped that the eggs would have matured to the point

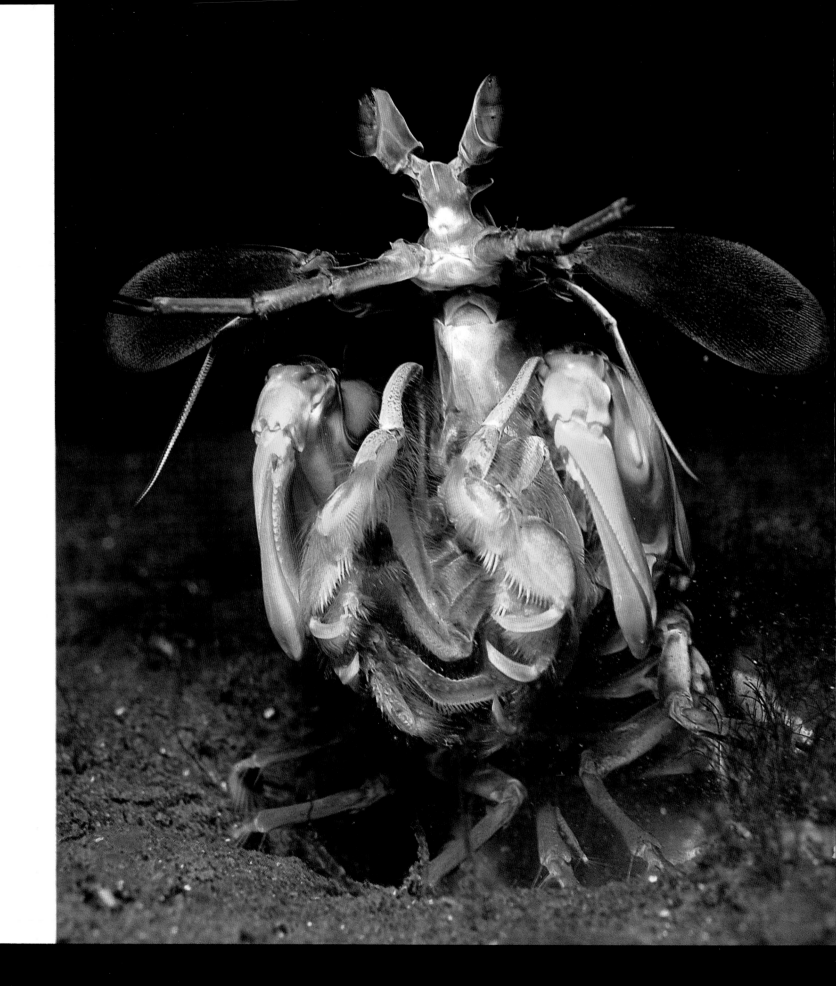

A mantis shrimp in a threat display.

SANTA CATALINA ISLAND, CALIFORNIA

where my close-up lens would reveal faces of baby fish inside the transparent egg casings. But my timing was late and I was disappointed. There were no eggs in the garibaldi's nest. They had all hatched. Nor were there females swimming about offering to lay more. Summer was over and the season had passed. The garibaldi was wasting his energy protecting an empty nest. His children had long since hatched and drifted away on the gentle currents that blow through the forest. After a few minutes, I picked up my camera and turned to swim back to the boat. The garibaldi hovered over his nest proudly. He was delighted that he had finally managed to force his mirror image into retreat. o

o The kelp forest is an excellent shelter for creatures quietly practicing their strategies of reproduction. Giant kelpfish build nests at the base of kelp trees and lay masses of sticky eggs in tangles of red algae. Swell sharks deposit a single six-inch-long egg among the branches of gorgonian corals. Tendrils attached to the egg secure it to the coral. Looking like an amber blade of kelp, the egg remains attached to the gorgonian for ten long months before hatching. But it was late one afternoon as I swam along the edge of the forest that I witnessed one of its most beautiful secrets. o
Assistant cameraman Norbert Wu had returned to the boat and told me he had seen a dozen or so bat rays swimming near the edge of the kelp forest. He thought the behavior might be related to courtship. Since bat ray mating behavior had never been filmed, I decided to make a scouting dive to see what was happening.

o At the edge of the kelp forest, the reef gave way to a gently sloping plain of sand and silt. As I glided slowly along the edge of the forest and high over the sandy plain, I began seeing dozens of bat rays sleeping in the sand far below, their four-foot wingspans partially covered with silt. The farther south I moved, the more sleeping rays I saw, until the bottom was covered with them. It looked like a good shot, so I decided to swim back to the boat for my movie camera. o By the time I returned to the boat, loaded my camera, and filled my scuba tank, the sun was low on the horizon and the high clouds had begun to color with orange light. It would be pretty dark at one hundred and twenty feet, perhaps too dark to get an exposure. I considered waiting until the next day to make the dive but quickly discarded the idea. The rule in natural history filmmaking is to get the shot when the opportunity presents itself. If you can do it better tomorrow, then fine. But if you wait until the next day, the animals often leave or the weather blows up or something happens to punish you for violating the rule, and you find opportunity has passed you by. o
There was another reason to make the dive. When the sun is about to set and the sea is filled with golden shafts of light spilling through the kelp, swimming along the edge of the forest can be incredibly beautiful. Even if I didn't get the shot, the dive would be fun.
o When I returned to the place where I had seen the sleeping rays, I was amazed to find them gone. I had been away for only an hour or so, and during that time hundreds of bat rays had awakened from their slumber and departed. I couldn't believe it. I decided to

search farther out over the sandy slope and turned away from the forest to swim toward deeper water. A few minutes later, I had descended to one hundred feet. I could just make out the ocean floor fifty feet below and still there were no rays. Then it became suddenly dark. ● A great shadow had passed over my head. I looked up into the sunset light lancing through the surface far above. Silhouetted against the golden light flew hundreds of bat rays. The swirling school looked much like a great flock of huge birds circling before beginning an evening migration. The bat rays had wakened from their day of rest and had begun a spectacular courtship ballet. The school slowly circled, and occasionally males and females broke away for brief periods of mating. I watched as a male approached a female from below, caressing her stomach with his back. Mating occurred on the wing as the rays flew in tandem, she above and he below. ● After mating, the pairs returned to the dance. The school would sometimes split into parts and then converge again, forming beautiful patterns of movement. Pointing my camera directly at the setting sun gloriously silhouetted the school of rays and produced more than adequate exposures even as the sun began to fall below the horizon. ● We dived early the next morning. Bat rays were still milling about in small groups, and I was able to catch a couple distant shots of courting pairs in the act of mating. Already the sandy floor at the edge of the forest was littered with sleeping rays. I dropped down to the sand and watched as the last dancers glided to the bottom and landed like student pilots, skidding and bouncing over the seafloor before coming to rest and lowering their heads to sleep. ●

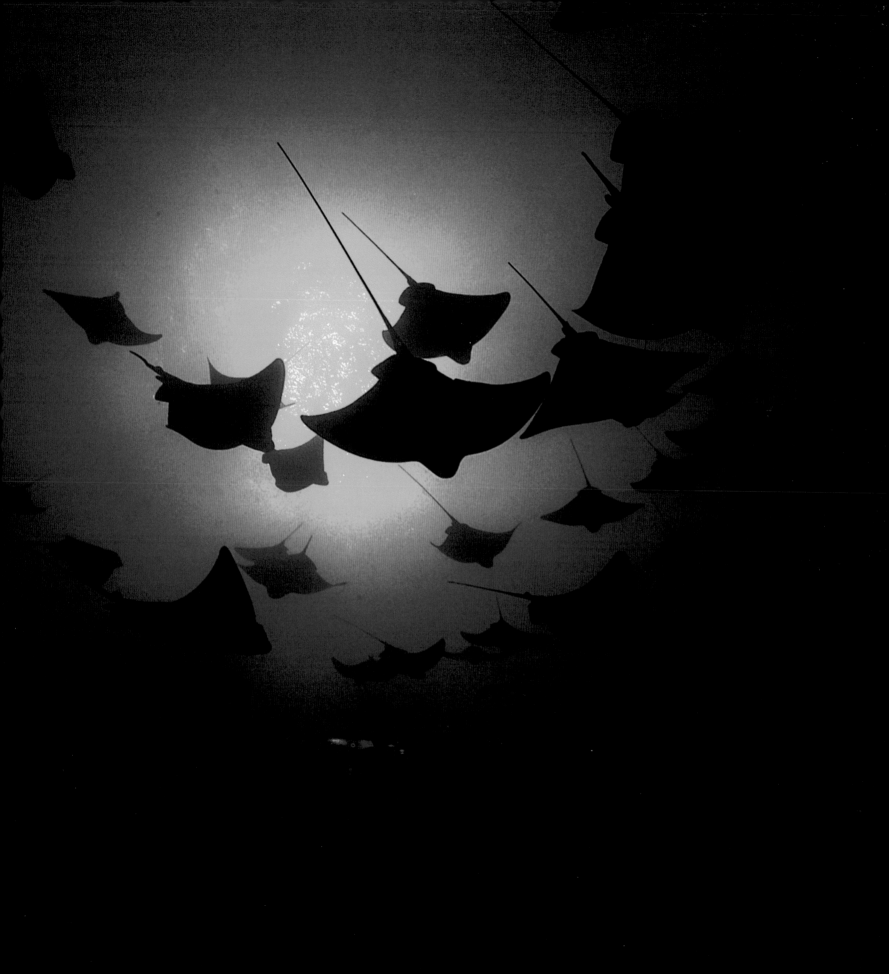

A school of bat rays.

CREATURES *of* DARKNESS

● Underwater, things that go bump in the night are silent. A three-thousand-pound great white shark could be just feet away and a diver would never hear a thing. Instead, things leap out of the darkness soundlessly, and grotesque shapes are suddenly illuminated by the pathetic beam of your underwater flashlight in total silence. ● Bob Cranston knows about things that go bump in the night. He was hanging on the anchor line twenty feet below the surface decompressing after a long night dive near Australia's Great Barrier Reef. The ocean floor was more than a hundred feet below. He held his movie camera in his left hand. His assistant carried Bob's bright movie lights. The lights penetrated the water only twenty feet or so and did little to force back the darkness. Still, keeping the lights on felt better than hanging in total darkness. ● Plankton gathered around the movie lights as Bob and his assistant waited for their decompression computers to permit surfacing. The plankton attracted small fish, which darted in and out of the darkness snapping up creatures smaller than themselves. Occasionally, the smaller fish were attacked by larger fish that dashed into the small pool of light and then dashed away a moment later. Bob knew there might be larger things circling as well, moving silently just beyond the light. You're very much alone with your thoughts while decompressing at night. You can't help but wonder what's out there watching. Things do go bump in the night. But Bob never heard it coming.
● Bob never saw it coming either. He was suddenly struck on the left side by something big. It was like being hit with a baseball bat. His movie camera was jarred

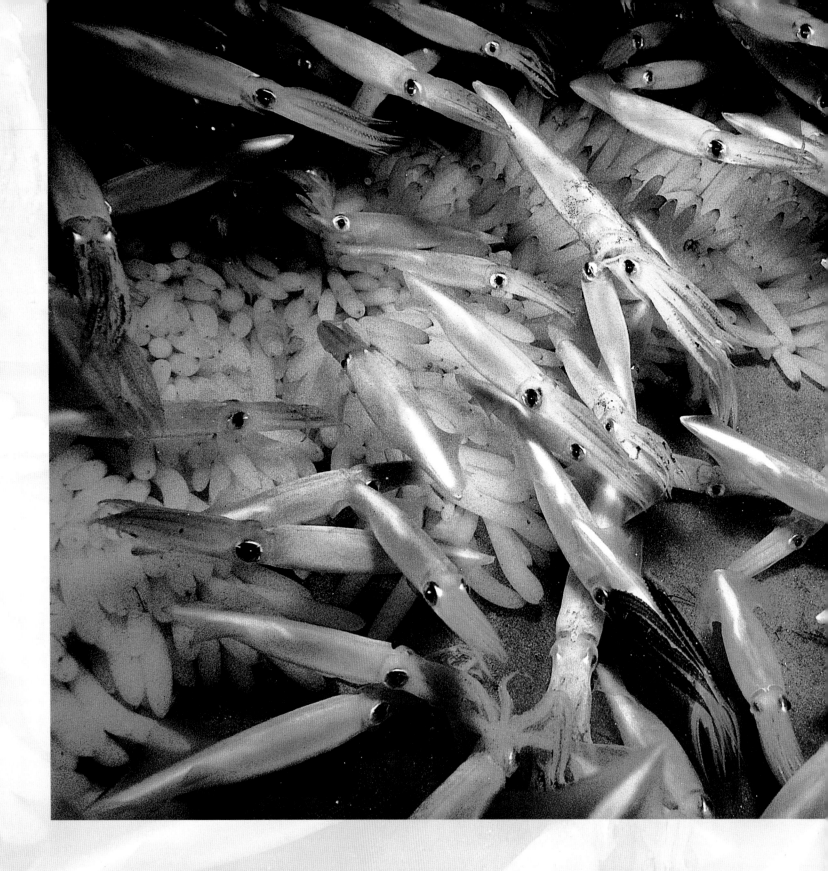

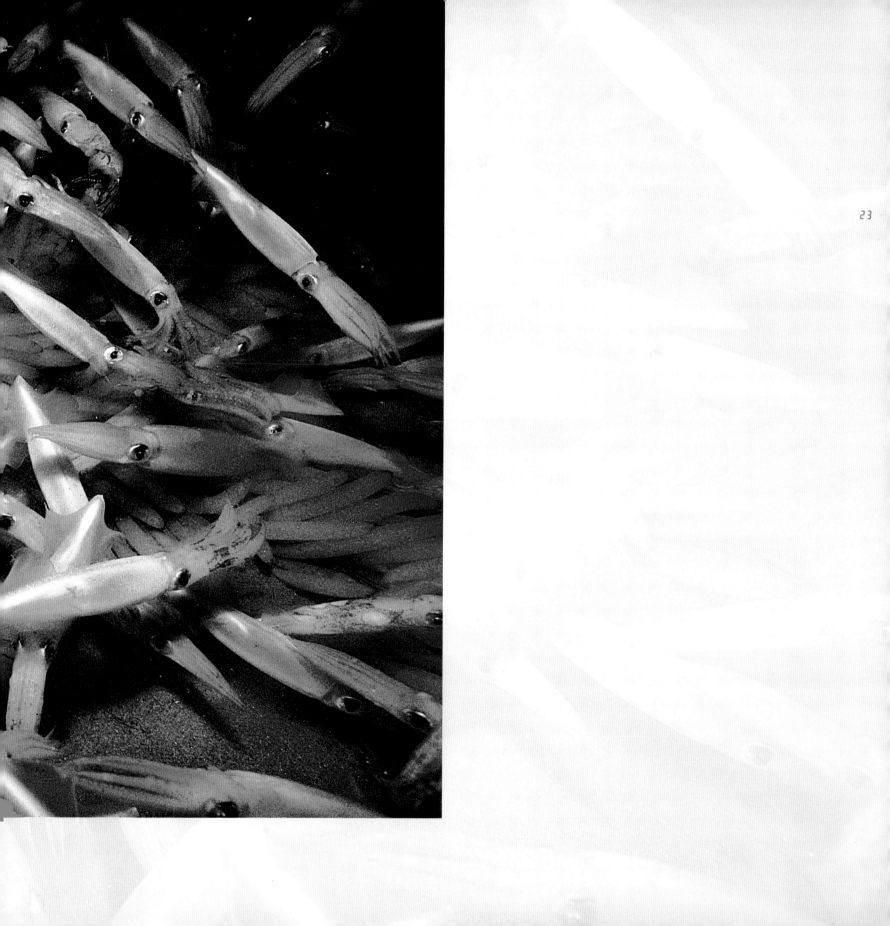

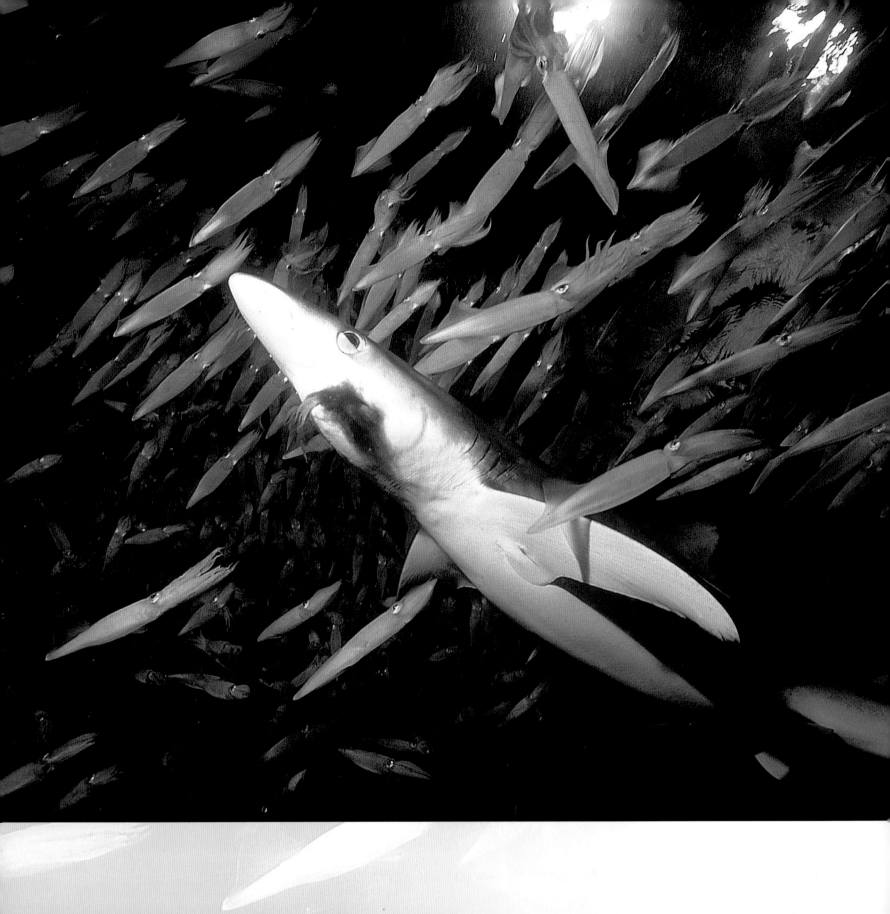

from his hand. Instinctively, he reached for it, but his left hand wouldn't grasp. He caught the camera with his other hand and reached back for the anchor line. That's when he saw the blood. ● Adrenaline is a great painkiller. Bob didn't know why his hand didn't work, but he knew the blood must be his. There was blood

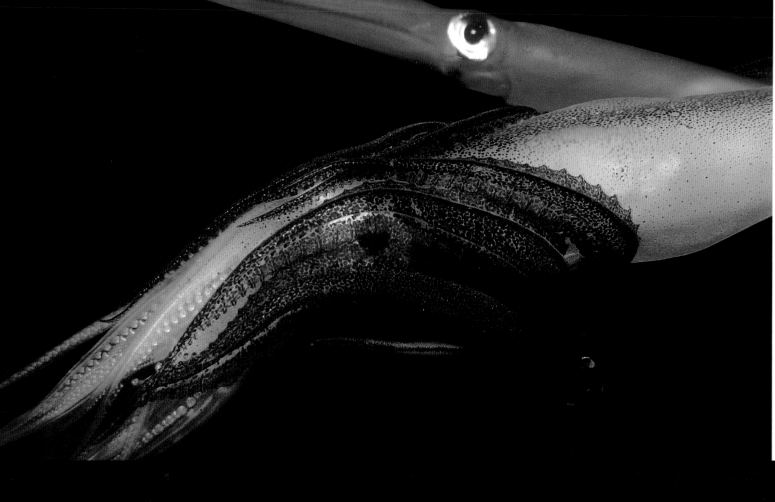

Opalescent squid mate.

A Caribbean reef squid on the reef.

LITTLE CAYMAN ISLAND

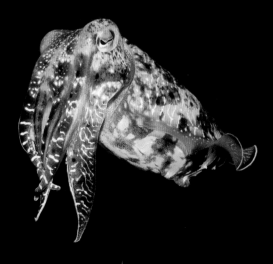

A cuttlefish changes color and texture,

reflecting its activity and mood.

PAPUA NEW GUINEA

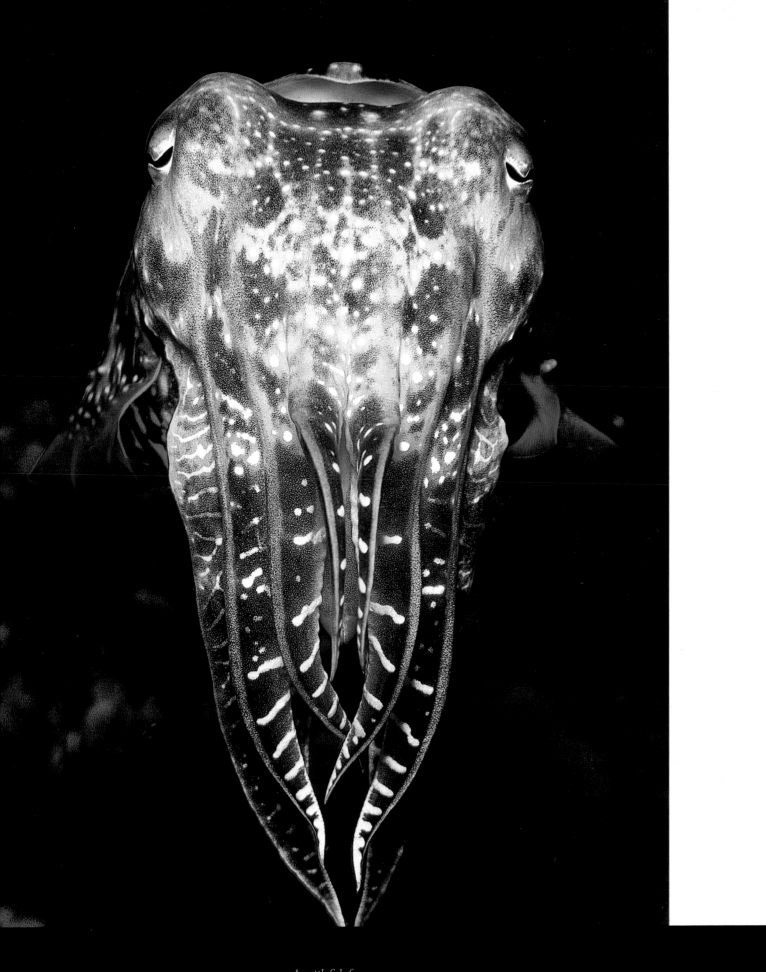

A cuttlefish face.

PAPUA NEW GUINEA

everywhere. "I've been attacked by a shark," he thought. But it had been no shark. ๑ Bob ended his decompression early and made it to the swim step of the boat. There was a tear in his wet suit near his left biceps. When his wet suit was removed, he found that his arm had been stabbed clean through. There was a large slash wound on the outside of his biceps and a smaller exit wound on the other side of his arm. ๑ Bob never saw what had attacked him. Almost certainly it was a large needlefish that had bolted blindly into the lights at terrific speed. We'll never know for sure. It was just something that went bump in the night. ๑

๑ A few months later Bob and I were filming squid for *Secrets* at Anacapa Island, off the coast of Santa Barbara, California. At night. I was looking forward to our first night dive together after Bob's accident. Bob was less enthusiastic. I planned to entertain myself during decompression by occasionally grabbing Bob by the leg when he wasn't looking. Or punching him gently in the arm when his back was turned. Of course, Bob anticipated this behavior and had steeled himself for the inevitable pranks. I felt a bit sorry for Bob and so only grabbed him when he wasn't looking three or four times that night. ๑ Opalescent squid spawn in the winter and spring, ascending from the deep ocean to mate and lay their eggs on sandy submarine slopes. They come in prodigious numbers. Millions of squid form schools that are often so dense that movie lights will penetrate only a foot or two and photography becomes impossible. When they leave, white egg casings form a carpet covering the ocean floor

several feet thick in all directions, as far as you can swim. And when the spawning is done, all the squid die, trusting the survival of their species to the eggs they have left behind. ๐ All night, male squid grab females with ten sucker-lined tentacles and deposit a packet of sperm beneath the female's mantle. The females generate an egg case that is nearly the length of their ten-inch-long bodies. They carry the egg case to the sandy floor, where they dig deep beneath the sand, depositing an anchor. The egg case is left suspended above the sand attached to the anchor by a silken thread. ๐ Capturing this natural history on film was relatively easy. The squid are everywhere, and instead of being frightened by bright movie lights, they're attracted by them. I lay on the sandy bottom a hundred feet or so below the surface and only had to pan the camera on the tripod to capture a different aspect of behavior. ๐ Once spawning has begun, the squid's fate is sealed and they lose all fear of death. They're not afraid of anything. They have a single priority: to reproduce now on this single night. For opalescent squid, there is no coming back tomorrow night for another try. The squid mate by the millions and then die by the millions. It's an awesome event in California's marine wilderness, an event that beckons numerous ocean predators from far away. Blue sharks, pilot whales, sea lions, bat rays, and many other predators accumulate over sandy slopes waiting for the sun to set and the squid to arrive. ๐ I'm not a great enthusiast for night diving. It's not so much the things that go bump in the night as a matter of energy. By the time darkness falls, I've inevitably spent hours underwater and I'm ready to sleep

standing up. Dragging on a chilled, wet dive suit and jumping off a warm, comfortable boat into cold, inky darkness usually seems like a really bad idea. But my attitude changes when the squid are spawning. There's so much going on that, despite dozens of dives to film the event, I always see something new. I get caught up in the behavior of the small animals that perform beneath my movie lights and entirely forget to worry about things that may be swimming just over my head. o Once, while swimming up the sandy slope after a scouting dive, I did feel the need to look behind me. I had only a small two-battery flashlight, but when I turned and guided the beam into the darkness, I saw the faces of three large blue sharks feeding on the squid my flashlight had attracted. I turned the light off and swam the rest of the way up the slope in absolute darkness, reaching out to feel the sandy slope for guidance. Ironically, I was anxious to return with my movie camera and capture the predation on film, but the sharks were gone when I returned. And in the years since that night I have yet to again see sharks feeding on opalescent squid.

o Other predators are often attracted to the squid that gather under the movie lights. Of these, bat rays are most common. These are large animals, sometimes approaching one hundred pounds. They can move quickly on broad birdlike wings. Bat rays, like many marine creatures, act strangely around underwater lights. You would think that something so unnatural as artificial light in the night sea would frighten animals away. But underwater, artificial light is so unnatural that many animals have no instinctive fear of it. In fact, the bright

movie lights often disguise the cameraman behind the light. Sometimes this allows me to easily approach animals that would otherwise see me and flee. o The negative side to being rendered invisible behind the glow of movie lights is that animals sometimes try to swim right through you. When filming big predators at night, you never know whether the invisibility produced by the movie lights is going to help you capture a great scene on film or help you get a broken rib. It can be a toss-up when approaching a bat ray at night. o It seems only fitting that we came upon a bat ray that night at Anacapa Island. I had tired of grabbing Bob by the leg when he wasn't looking during our descent and was beginning to look for the squid school as we approached the egg-covered ocean floor. Naturally, two other members of the film crew, Mark Conlin and Mark Thurlow, were prepared to keep Bob on his toes by giving him a grab now and again after I had lost interest. By the end of the dive, a shark could have gnawed off Bob's foot and he wouldn't have turned to look. Michele was also with us to take still photos, and we all settled on the bottom at the same time. A white blanket of squid eggs two feet thick carpeted the bottom as far as our lights could penetrate. During the previous ten nights, immense schools of squid had gathered here. But now they were gone. Only the carpet of eggs and thousands of dead squid remained. We had prepared all day to film the event and had missed it by twenty-four hours. o I took a couple of shots of the field of eggs and was turning to return to the boat when I saw the bat ray. With little else to accomplish, I turned the lights toward the

A baby leather bass hides among venomous urchin spines.

COCOS ISLAND, COSTA RICA

Venomous urchins cover the rocks at night.

ray and switched on the camera. The bat ray swam slowly across my field of view and made a gentle turn in my direction. Then something happened. The bat ray suddenly bolted, giving me no chance to react. The sixty-pound ray struck me perfectly in the solar plexus, knocking the wind from my lungs. I almost swallowed my mouthpiece. ○ It took me a minute or so to recover. I cleared the water from my mask and noticed that my friends all seemed to be similarly distressed. Conlin had bubbles pouring out of his mask, Thurlow seemed to have aspirated some seawater, and Cranston

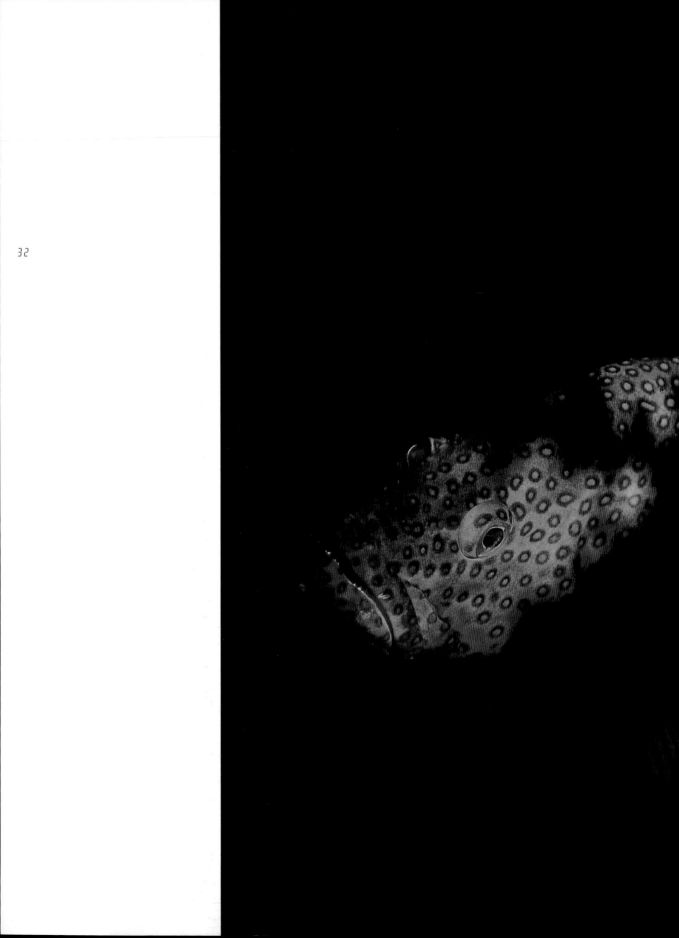

looked doubled over in pain. A moment later I realized that they were all laughing, no one harder or more appropriately than Bob. Michele had been photographing squid eggs with her still camera and had missed the incident. By the time she turned to look, she saw all of us inexplicably doubled over in laughter. ○

○ Squid come in all sizes. Most are even smaller than opalescent squid. But some are very much larger. One night we encountered the ultimate creatures of darkness. ○ Our boat was drifting in the Sea of Cortez (Gulf of California) on a hot summer night. Not even a breath of wind disturbed the placid surface.

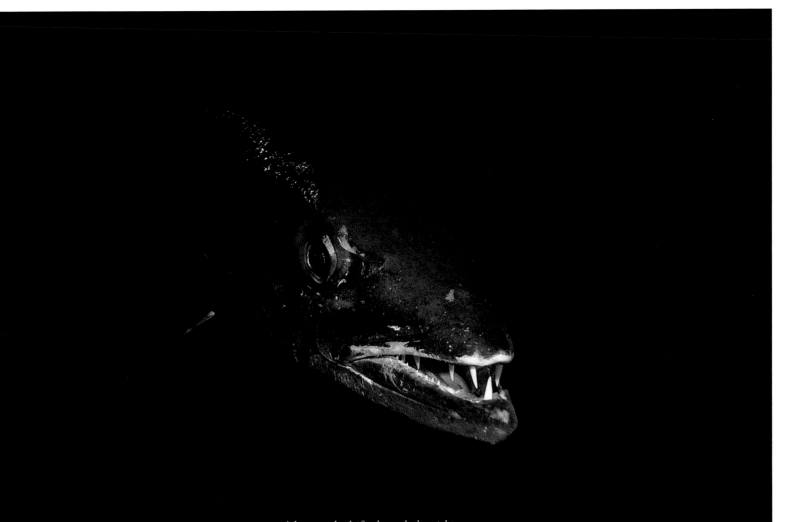

A barracuda drifts through the night sea.

THE BAHAMAS

Only an absence of stars separated the black sea from the night sky. A red glow illuminated Mike McGettigan's face as he checked the readings on the fathometer. The depth was five hundred feet, but at three hundred there were transient marks on the video display. "There's something down there," he said. "Something big." ● Mexican fishermen had told us there were big squid in these waters. We suspected that the fishermen had been seeing Humboldt squid, an animal that is common in the deep ocean but seldom comes to the surface. Humboldt squid can reach thirteen feet in length and weigh more than three hundred pounds. No one could tell us what it would be like to film these formidable creatures underwater. No one had done it before. ● The powerful lights on the stern of the *Ambar III* had attracted plankton, which were being fed upon by a school of small fish. Other predators were also gathering to feed on them. Looking over the side of the boat, I could see lights flashing in the dark depths below. I thought my eyes were playing tricks on me. Something was going on down there. It was as if flash bulbs were going off far below the boat. Then I noticed a large needlefish finning just below the surface about ten yards away. It was a big fish, more than three feet long and probably weighing about ten pounds. Suddenly there was a flash as ten powerful tentacles shot up, breaking the surface and ensnaring the fish. A moment later the surface was calm again. I looked over at Bob, who was staring in the same direction. "I guess that means we should go diving," he said. ● Our boat crew tied a line to a forty-pound tuna carcass and lowered it over the side to attract the squid as Bob and I suited up to dive. Our science consultant for the expedition, Alex Kerstitch, also donned his diving gear. Moments later we were standing on the stern of the *Ambar III* looking down into black water. We could still see flashes of light below. I had no idea what was causing that. It was weird and more than a little disconcerting. "You go first," Bob said. ● We went into the water together and descended about thirty feet. I could see what was causing the flashing now. There were large torpedo-shaped squid below. Some looked to be nearly six feet long. They were moving beneath the boat in short, rapid bursts of speed. As they moved they changed color from deep blood red to ivory white. These colors alternated rapidly, perhaps five times per second. The white color reflected the *Ambar III*'s stern lights like a reflective road sign. When the squid went dark red, they nearly disappeared. It was as if strobe lights were flashing on the animals. As they darted beneath the boat, they seemed to alternately appear and disappear four or five times each second. ● Our boat crew lowered our movie light system over the side by its cable and turned it on. I mounted it on the camera and turned to swim toward the tuna carcass. Squid were ascending to meet us as we moved toward the dead fish. Some were attacking the carcass. Bob and Alex followed. When I looked over my shoulder to check on Bob and Alex, I could see huge squid all around them. Several times I turned the camera in their direction to film the squid, but each time I did so, the squid retreated from the bright lights. "This may not be so easy," I thought.

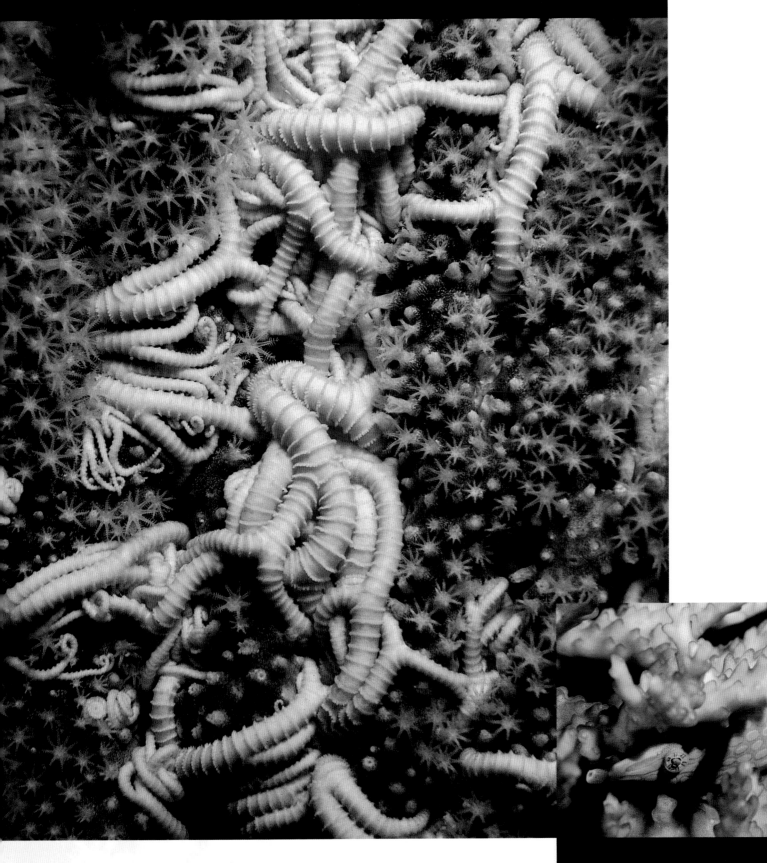

The serpentine arms of a basket star clutch the branches of a gorgonian coral.

GULF OF CALIFORNIA, MEXICO

A longnose filefish wedges

itself into the coral to pass the night.

GREAT BARRIER REEF, AUSTRALIA

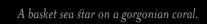

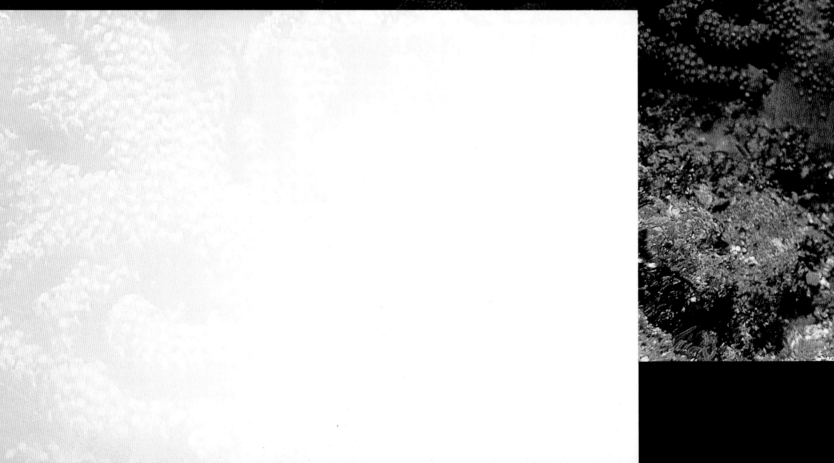

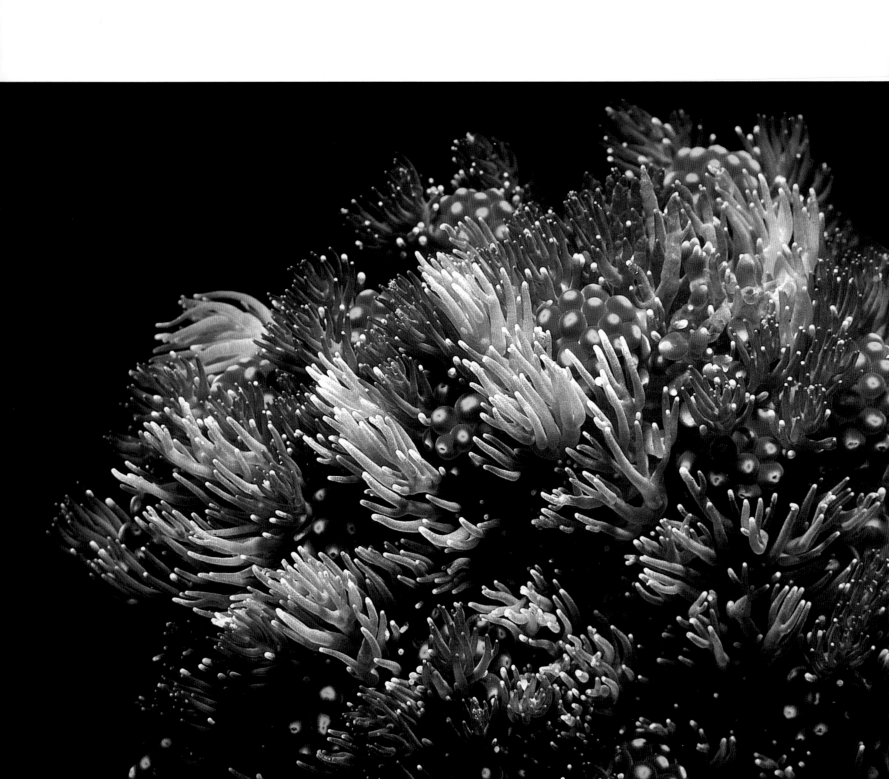

• There were two large squid feeding on the fish as I approached. When I got to within a few feet, one squid disengaged and swam away. But the other squid ignored the lights and continued feeding on the tuna. The squid was tearing the tuna apart, and a large cloud of fish blood and debris was drifting downstream, attracting schools of fish. Other squid were also becoming excited by the smell. They rocketed up and attacked free-swimming fish, then dragged their prey back to the depths below. Each time I turned toward Bob and Alex, there were more squid around them. I saw one grab Bob's scuba tank briefly. But the squid always backed away under my movie lights. • I got close to the squid feeding on the tuna. It was nearly six feet long and looked to weigh about a hundred pounds. It was too hungry to be put off by my movie lights. After shooting a minute or two of film, I reached out and touched the animal. I was surprised by its texture. It was not a soft, snail-like creature. Its flesh was hard and muscular. It flashed from white to angry red as I touched it. Then a tentacle lashed out, gripping my arm. I felt a stinging on the back of my hand and instinctively recoiled. I looked at the back of my hand and saw small drops of blood beading up. The squid's tentacles were covered with powerful sucker disks, each of which was armed with needle-sharp hooks. When the suckers grabbed on, the hooks dug in. • Bob stayed close to me holding the movie light cables. But Alex began to drift back into the darkness as he tried to photograph the squid with his still camera. The squid were not so afraid of his small flashlight as they were of my bright movie lights. As he drifted away, the squid became more bold. • Suddenly a large squid shot up and grabbed Alex on the shoulder. At first, he thought it was funny, expecting the squid to release him after a quick taste of neoprene rubber. But the squid held fast, and its tentacles began to wrap around his neck. Two other squid shot up and attacked. Alex felt a burning sensation as hook-lined suckers dug into the flesh around his neck. He was no longer amused. The squid were dragging him down toward the dark and, for a scuba diver, deadly depths below. • Alex began to fight back. He kicked hard with his fins and lashed out with his arms. His dive light was ripped from the lanyard on one wrist and his decompression computer was ripped from the other. One squid still had him by the neck, and he began to panic as he realized that any second the squid's huge parrotlike beak might bite into his neck. He fought harder still. • Suddenly the squid that had Alex by the neck broke free, tearing Alex's gold chain from his neck as it left. The other squid released him as well, and Alex made a mad dash for the stern of the *Ambar III*. • Bob and I had missed the whole thing. We returned to the boat to learn that Alex was already on board. He had climbed aboard, dropped his dive gear on the deck, and gone to bed without a word. Alex loved to dive at night. We were surprised he had quit so early. • We didn't learn what had happened until the next day when Alex related the story while surveying the damage to his dive gear. He had lost his dive light, a collecting bag, a collecting bottle, a decompression computer, a gold chain, a gold medallion, and his wits. •

Coral hermit crabs.

o I drifted along one evening at seventy feet, watching the reef forty feet below. The water was clear, and I could see a great distance down the coral formations that sloped gently away toward the Gulf Stream. The reef looked peaceful, even serene. This far above, I could see only the larger fish that hovered over the coral, and most of those seemed lethargic as they waited for night to come. o I was waiting for a shark to swim up from deep water through one of the canyons that interrupted the reef's gentle slope. A hundred feet away, I could see Bob hovering over a different coral canyon. Bob and I wore rebreathers, which produced no bubbles and allowed us to stay underwater as long as we wanted. Michele and Conlin had run out of air in their scuba tanks and had returned to the boat an hour or so earlier, leaving Bob and me to wait in silence. My rebreather occasionally made a clicking sound as the solenoid injected oxygen into the breathing mixture. That, and the sound of my own breath, alone interrupted the silence. o A natural history filmmaker's time is spent mostly just waiting and watching, even underwater. This time I was waiting for a Caribbean reef shark to swim up the coral canyon and enter a small cave at the top of the reef. Other divers had told us that sharks often enter the cave just before sunset. Inside the cave, a shark would settle on the bottom and go to sleep, a behavior once thought impossible for most requiem sharks. No one knew why the sharks did this, but I suspected it had something to do with cleaning behavior. o Cleaning behavior is perhaps the most elegant form of symbiosis. Large fish, even sharks,

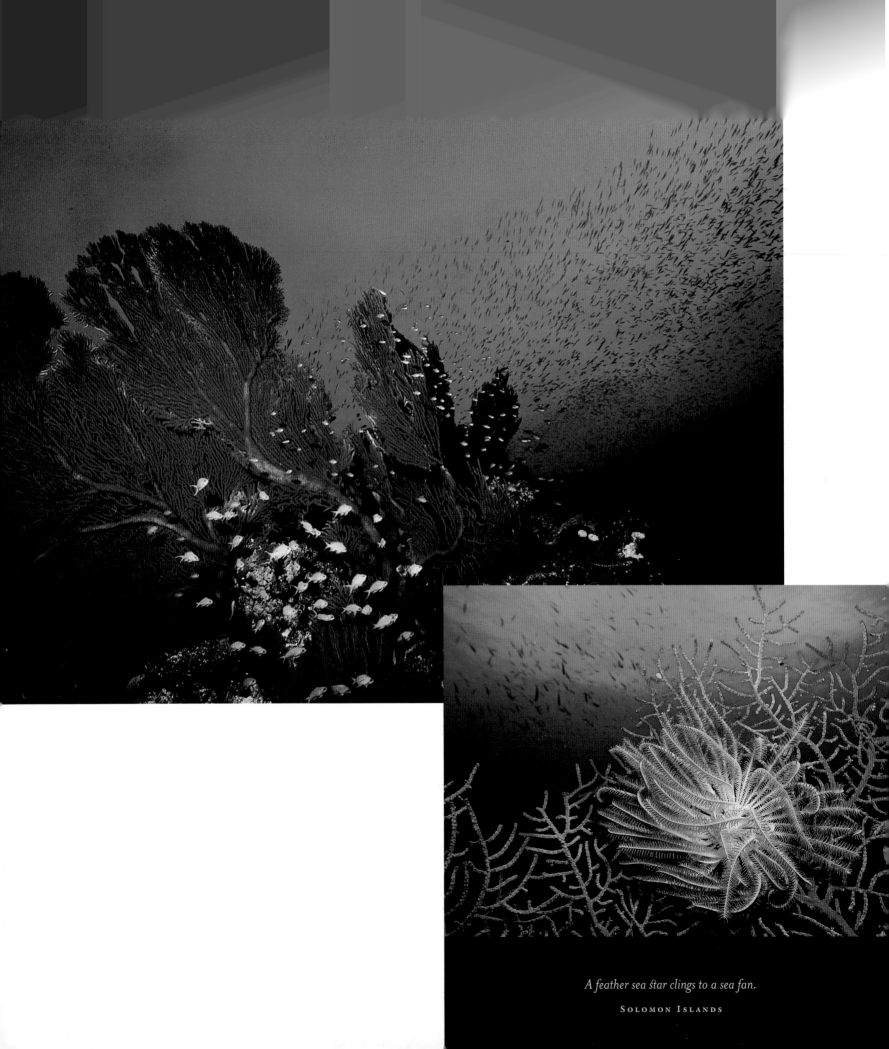

A feather sea star clings to a sea fan.

SOLOMON ISLANDS

come to rest at special places along the reef in response to subtle signals given by tiny shrimp and diminutive cleaner fish. The shrimp and cleaner fish leave the reef and move over the host's body, cleaning the skin of parasites and bits of damaged tissue. The host benefits by being groomed, while the cleaner benefits from whatever it may find to eat on the host's skin. o I was anxious to film a shark swimming up the canyon, entering the cave, and coming to rest on the cave floor. If cleaning behavior explained why the shark sought out the cave, that would be great. But I was prepared to capture a sequence on film no matter how the story evolved. o I descended to the edge of the coral canyon and picked up my movie camera where I'd left it near the mouth of the cave. Down among the coral formations, the reef no longer looked so tranquil.

A coral reef is the combination of thousands of species forming a single living entity. The reef is like a city. Every individual is concerned with its own survival. But at the same time, the reef couldn't exist without a confederation between species, an alliance of cooperation between citizens. Coral itself exists only

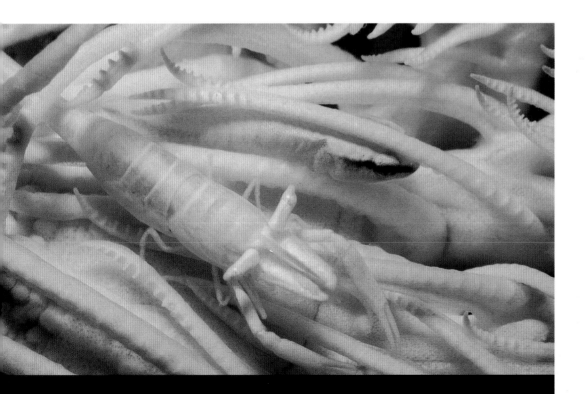

A shrimp and clingfish camouflage themselves within a feather sea star's tangle of legs.

SOLOMON ISLANDS

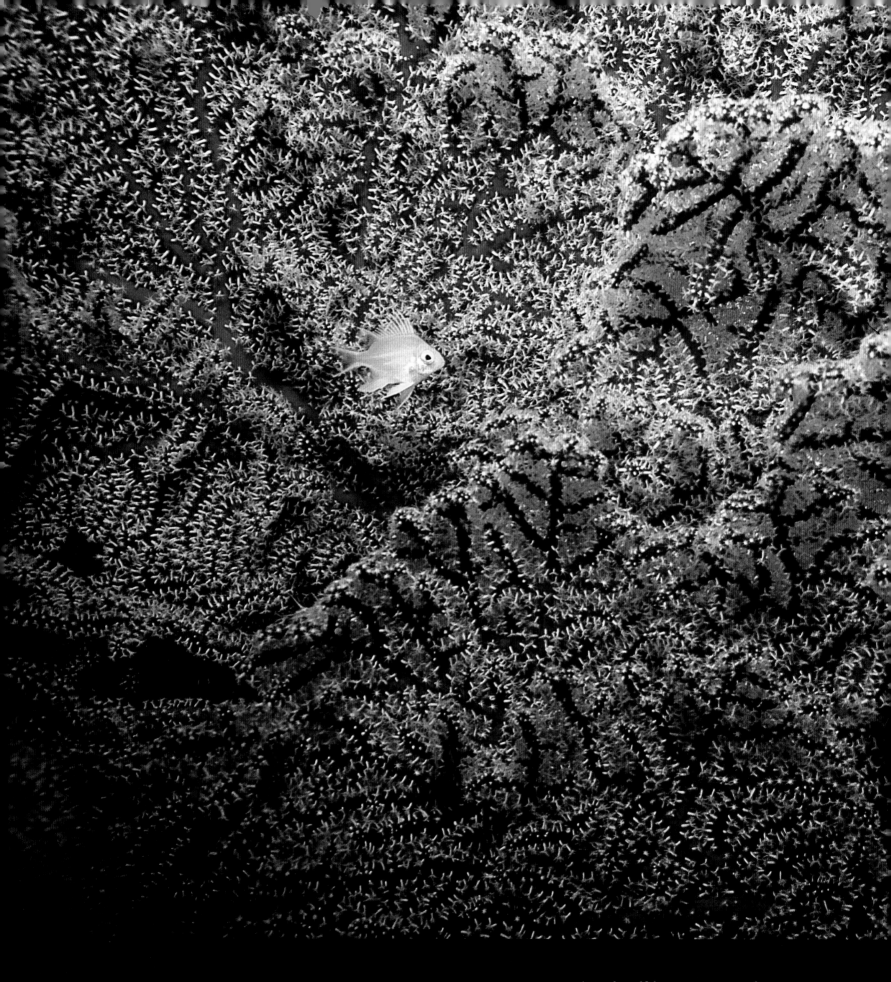

A tiny damselfish against a giant sea fan.

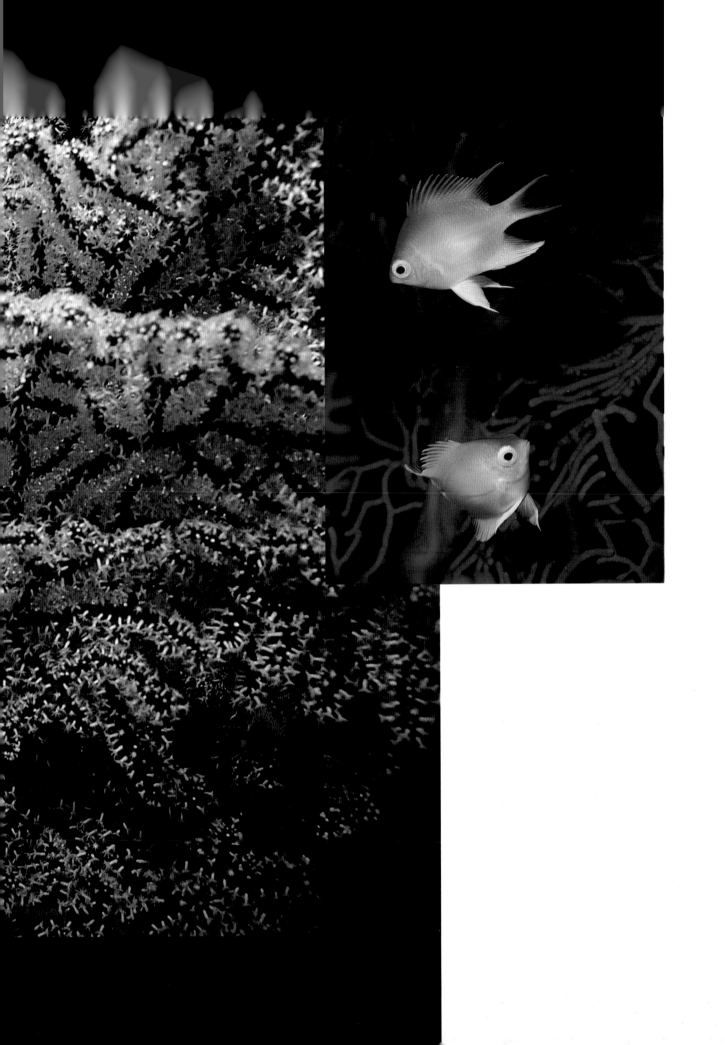

through the symbiotic relationship between the coral
animal and special algae that live within the coral's tissues.
The algae produces food for the coral, while the coral
provides habitat for the algae. Cleaning behavior is but one
more example of these alliances. o Even in the
failing light following sunset, I could see faces peering out
from the reef. Tiny blennies, smaller than your little
finger, watched from burrows within the stony coral,
occasionally darting out to grab even tinier planktonic
creatures that drifted by. Tiny cryptically colored crabs and
shrimp became visible only if they moved. And
countless species of reef fish darted in and out of coral
shelters. The longer I stared at a single place on the
reef, the more faces I saw. o A movement in the distance
caught my attention. Only an instant passed before
the shark my imagination had created vanished and I
recognized a loggerhead turtle slowly crossing the
coral canyon fifty feet away. Bob had his back turned as
the loggerhead passed, and for a moment the turtle
paused and looked longingly at the fiberglass shell covering
Bob's rebreather. Then it turned and moved on. The
turtle may have hunted these reefs for nearly a century.
What wonders you would know if you had the
memories of a loggerhead turtle! o I remembered
another loggerhead turtle that lived on a shipwreck
farther south along the Bahama Bank. He was a large
turtle, old and experienced. Each night he slept
beneath the gable of the wreck's overturned bow. Each
morning he would leave his den several hours after
sunrise and spend the day foraging over the reef. I wanted
to film the turtle as it hunted, and I hoped to make a

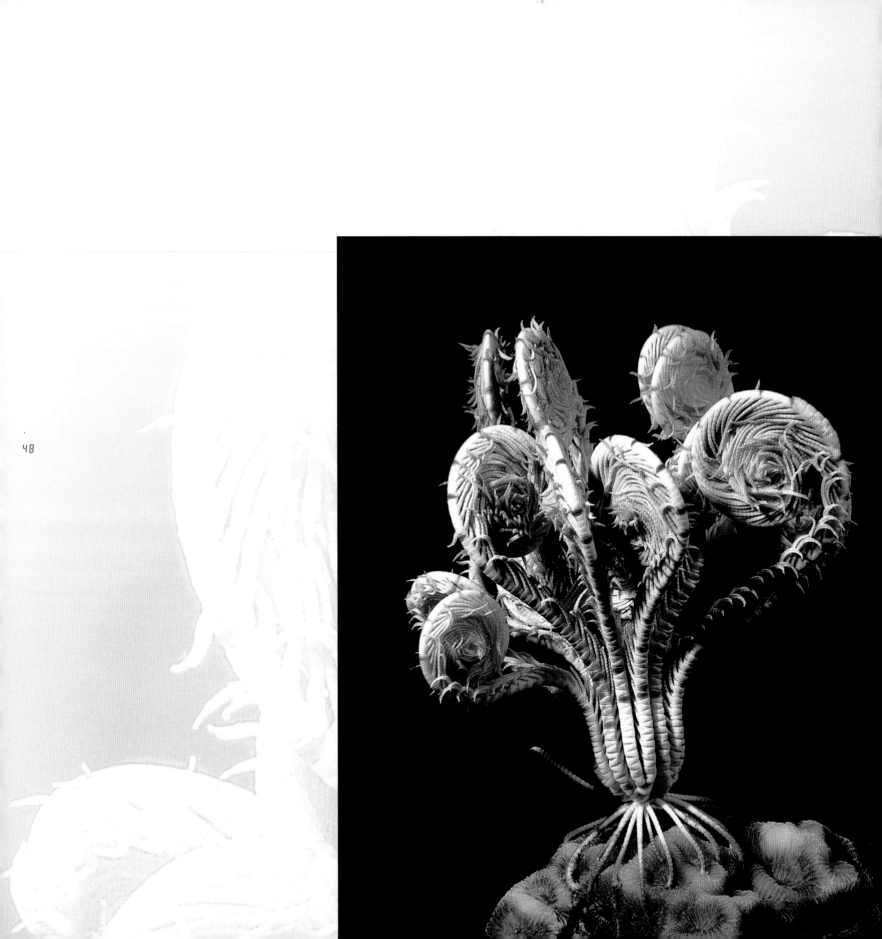

48

sequence of loggerhead feeding behavior. I spent four days diving on the shipwreck, hiding behind twisted steel wreckage as I watched the turtle leave his den. Then I would follow, moving carefully from hiding place to hiding place in an effort to remain inconspicuous. Occasionally the loggerhead would drop to the reef and pick up something to eat. I was always too far away to see what it was, and by the time I got close enough, the turtle had moved on. But each time I saw the turtle begin to feed, I tried to move a little closer. I hoped that eventually he would grow accustomed to my presence and that I would be allowed close enough to use my camera. o On the fourth day of following the loggerhead, things took a surprising turn. The turtle had dropped down to the bottom to investigate something, and I moved in a little too quickly. The loggerhead looked up and noticed me. But instead of bolting away, the turtle turned and began swimming in my direction. He swam right up to me, paused to look at my underwater camera, and then tried to eat the light meter mounted above the lens! Apparently my light meter looked enough like a conch shell to interest the turtle. I pulled the camera back just in time. He could easily have crushed the plastic meter with his powerful beak. As I backed away, the turtle followed, intent upon the prize mounted on top of my camera. I had spent four days trying not to frighten this animal away, and now I was running from him! o Eventually the loggerhead accepted the fact that I was unwilling to give up the meter. I was also finished with trying to be stealthy. I began swimming right alongside the turtle as it hunted over the reef.

Sometimes I would even discover something edible before the turtle saw it. I could compose my shot and then flash my light meter in the turtle's direction. He would turn toward my rolling camera, see the prey I had discovered, and then proceed to feed on it. o It was most amazing to watch the loggerhead crush conch shells. He could pick up a shell that I would find difficult to break with a hammer and easily crush it to bits with his beak. Then he would use his front flippers to hold the broken shell as he pulled the meat away. He could have made easy work of my light meter. o It hadn't been necessary to use our silent rebreathers to film the loggerhead. But hawksbill turtles are not so friendly. I was certain that our silent dive gear would lead to a breakthrough in filming hawksbills. Bob and I spent days swimming over the reefs in the Cayman Islands hoping to film hawksbill turtles feeding on sponges. To me, few things could be less appetizing than a sponge. But sponges are what hawksbills eat. I wanted to get it on film. o During our long dives in the Caymans, Bob and I often saw hawksbills feeding on sponges, but we could never get close enough to film the behavior. Upon seeing a feeding hawksbill in the distance, Bob and I would drop to the reef and inch our way forward, keeping coral formations between us and the turtle as much as possible. We would move slowly, occasionally peering around a sea fan or barrel sponge to see what the turtle was doing. But inevitably, before we could get close enough to use our cameras, the turtle would look up as if to say, "Who do you think you're fooling?" The hawksbill turtles may not have been able to hear us

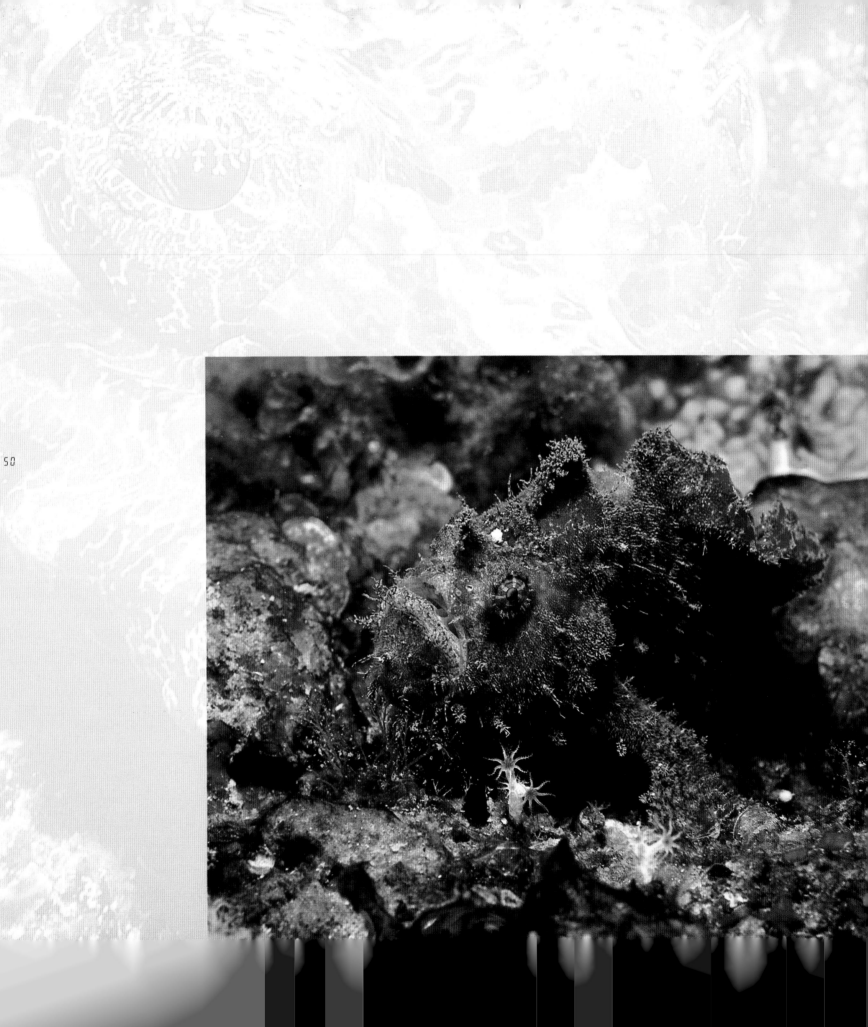

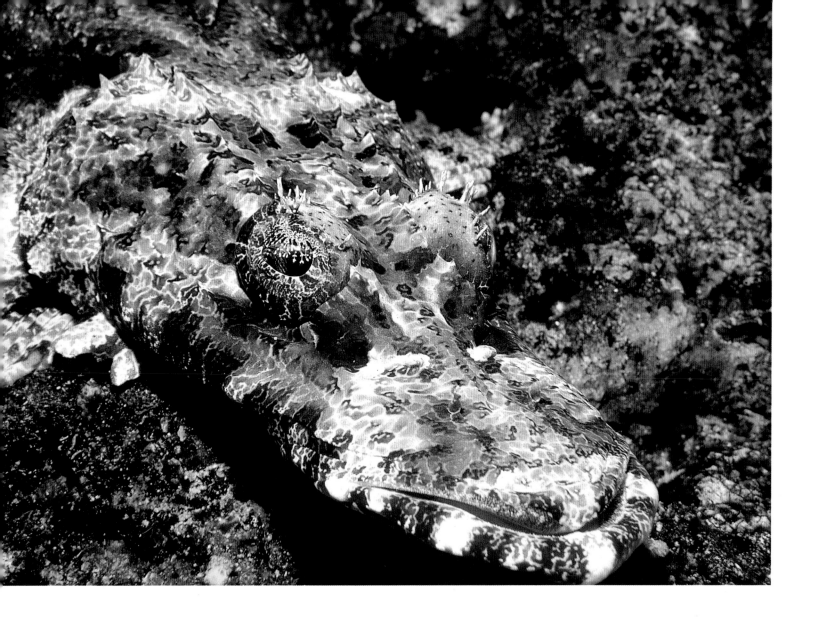

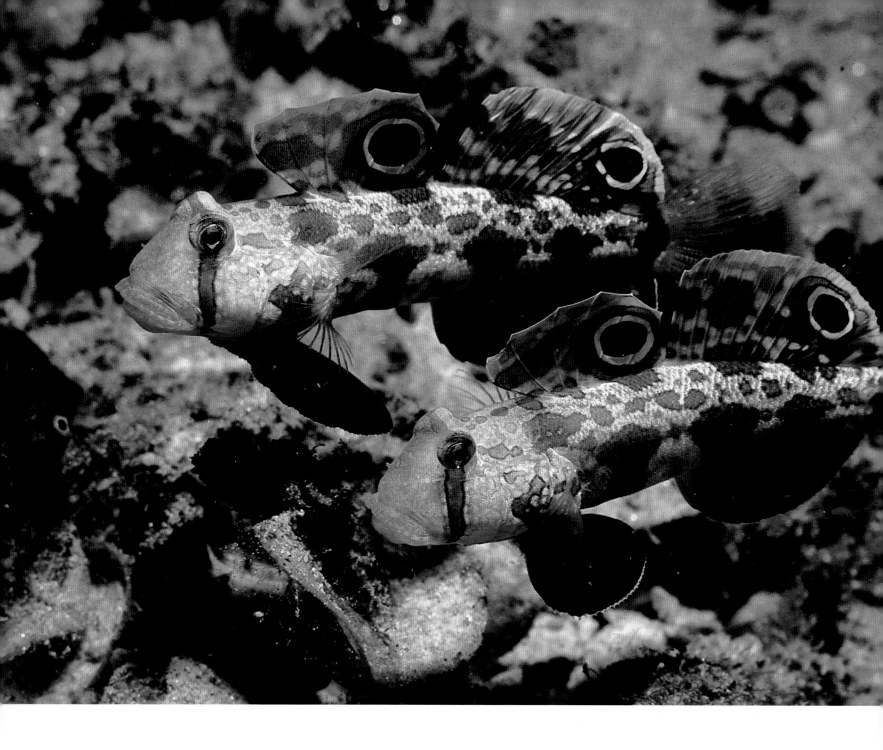

approach with our super-sophisticated, silent, space-age, bubble-free diving gear, but they could see just fine. ◑ Our silent rebreathers seemed to be most effective when filming sharks. It's not that sharks are dumber than turtles. Maybe they're just less complicated. It's easy for me to anthropomorphise the behavior of turtles and most other animals. The more you watch animals, the more you begin to see evidence of character, emotion, and individual personality. When I saw the hawksbill turtle look up from his sponge upon discovering my not-so-stealthy approach,

it was easy to get an impression of what he was thinking. I never get that with sharks. Their eyes seem to look right through you, revealing nothing. And when I wear a rebreather, sharks often seem not to see me at all. ◑ As Bob and I watched for sharks swimming up the coral canyons leading to the cave, we hoped our rebreathers would make a difference. But, unfortunately, we never had the chance to find out. Bob and I stood on the top of the coral embankment next to the entrance to the cave and looked out at distant formations of coral in the deeper water beyond. As the sun sets, the tropical water

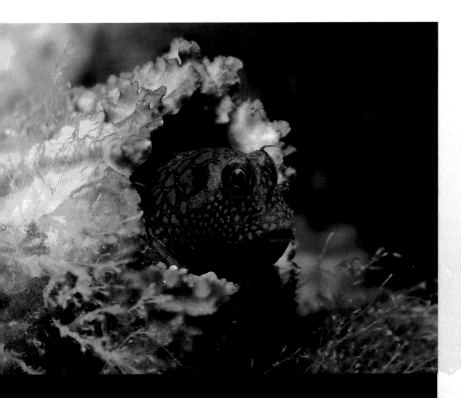

A tasselated blenny in an abandoned barnacle.

GULF OF MEXICO

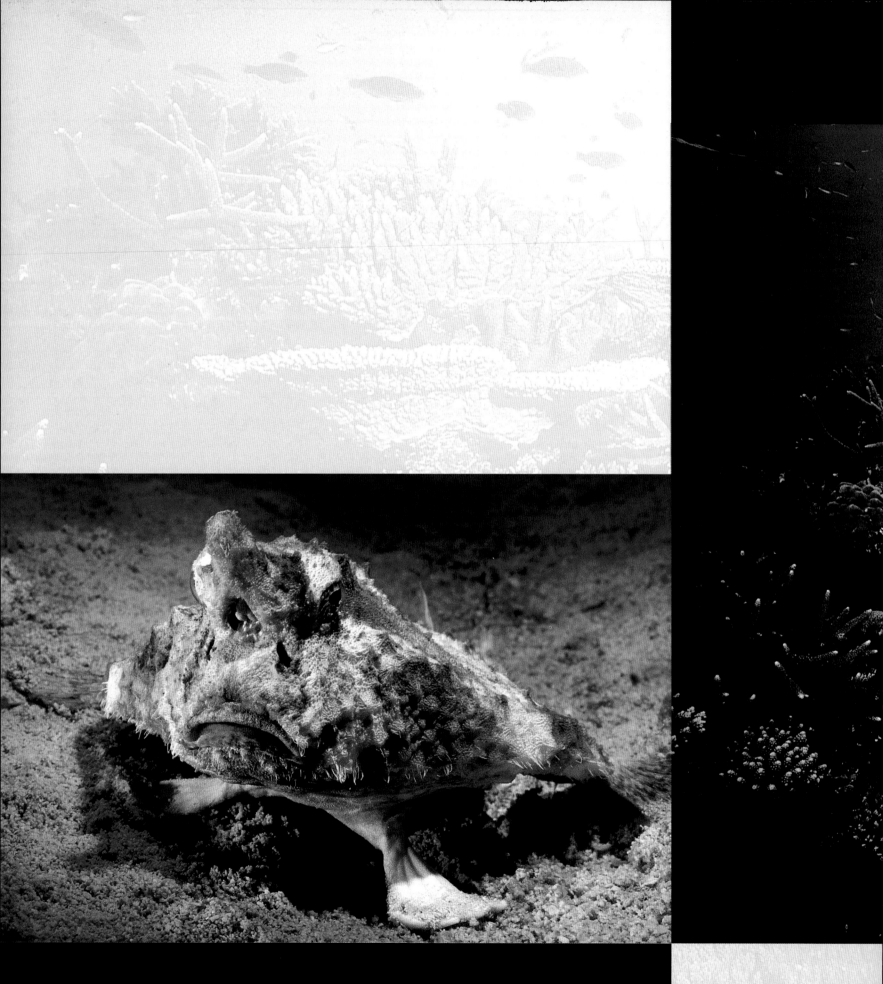

A shortnose batfish.

THE BAHAMAS

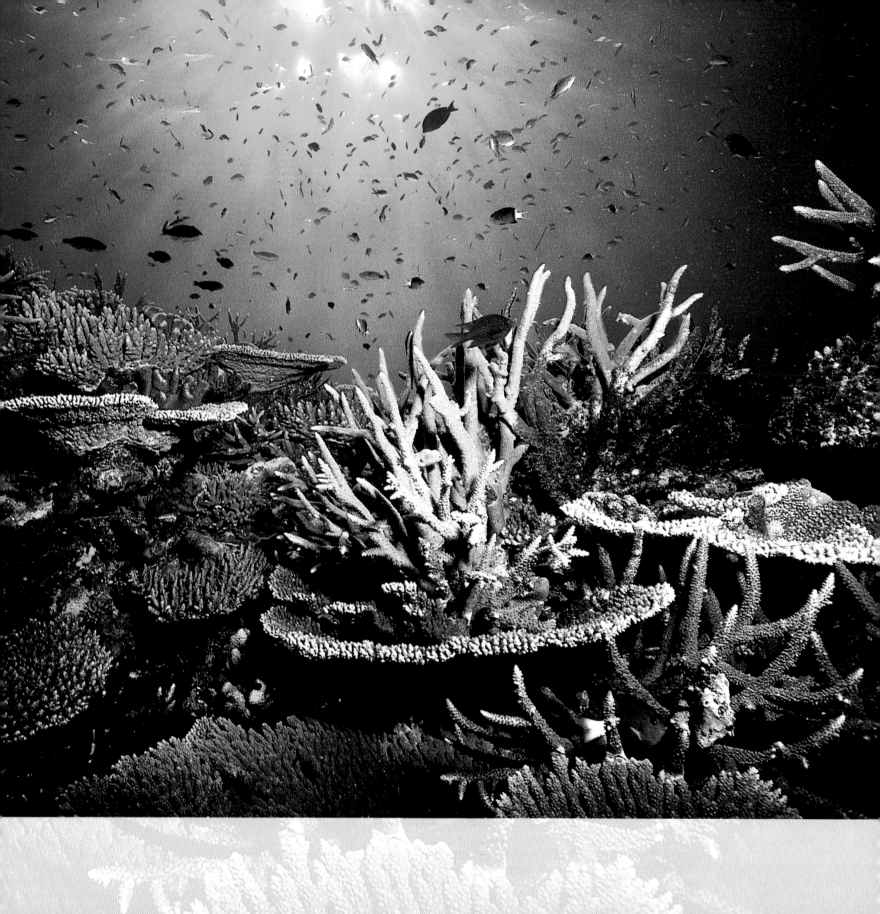

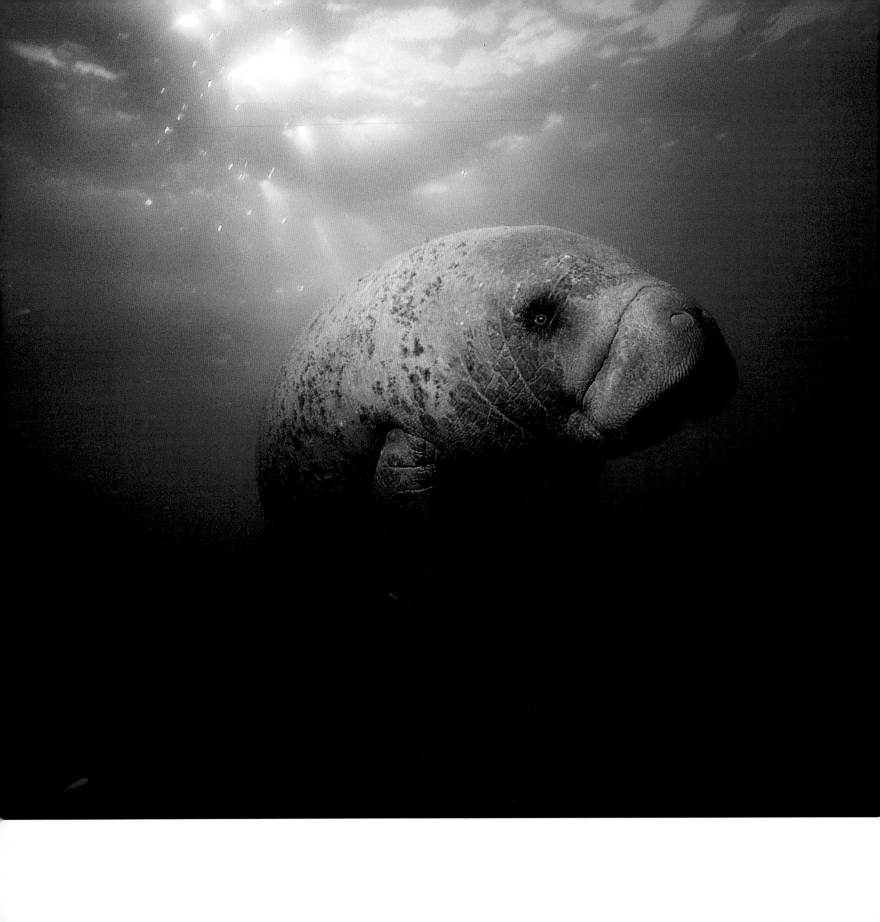

changes color from iridescent blue to somber gray. The behavior of the reef changes, too, as creatures of the day take shelter and nocturnal citizens begin to venture out. Sometimes there is a last-minute frenzy as predators dash through schools of prey, hoping to take them by surprise in the failing light. But that didn't happen on this night. In fact, nothing happened at all. The changing of the guard proceeded quietly and no shark came our way. ● It is perhaps odd that of so many hundreds of dives this one has remained so clearly burned into memory. I saw nothing unusual and I never once turned on my camera. But I did come away with something from that dive, something that makes the memory vivid, though I'm not sure I can say what it is. Perhaps it's only an increased sense of what life on the reef is all about, a final integration of knowledge gathered over many years. Perhaps it's even more complicated than that. Sometimes knowledge transcends the accumulation of input from five senses and becomes insight. Or perhaps I simply had the oxygen level turned up too high on my rebreather. ●

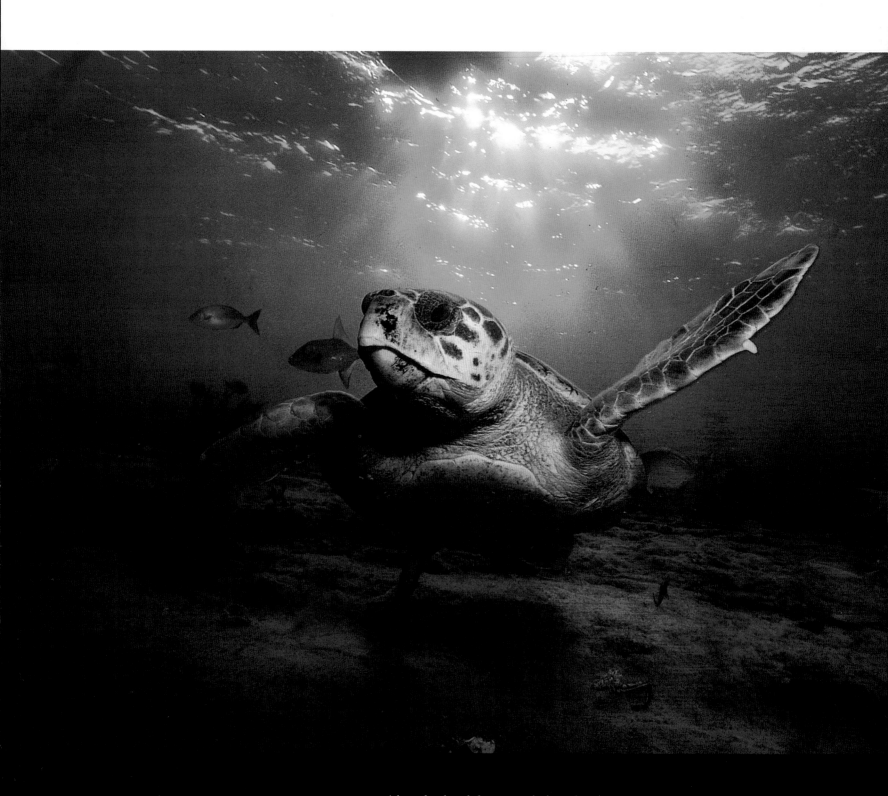

A loggerhead turtle hunting in the late afternoon.

THE BAHAMAS

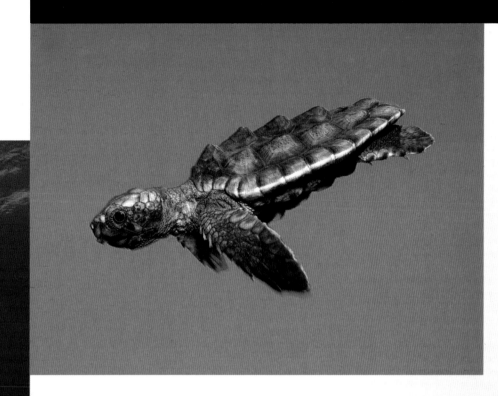

A baby loggerhead turtle swims toward open sea.

59

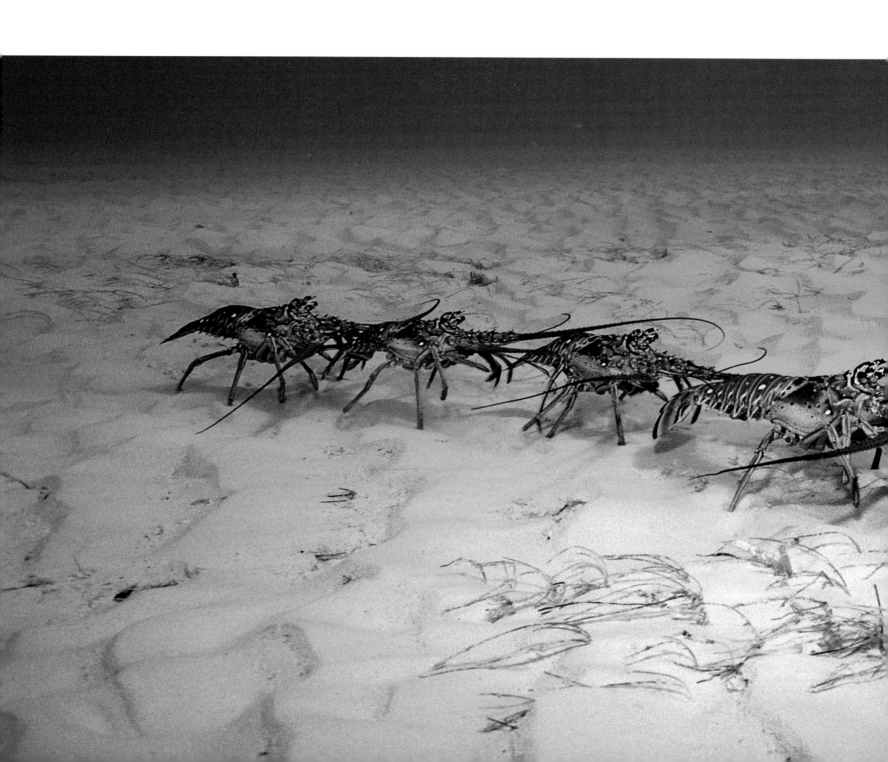

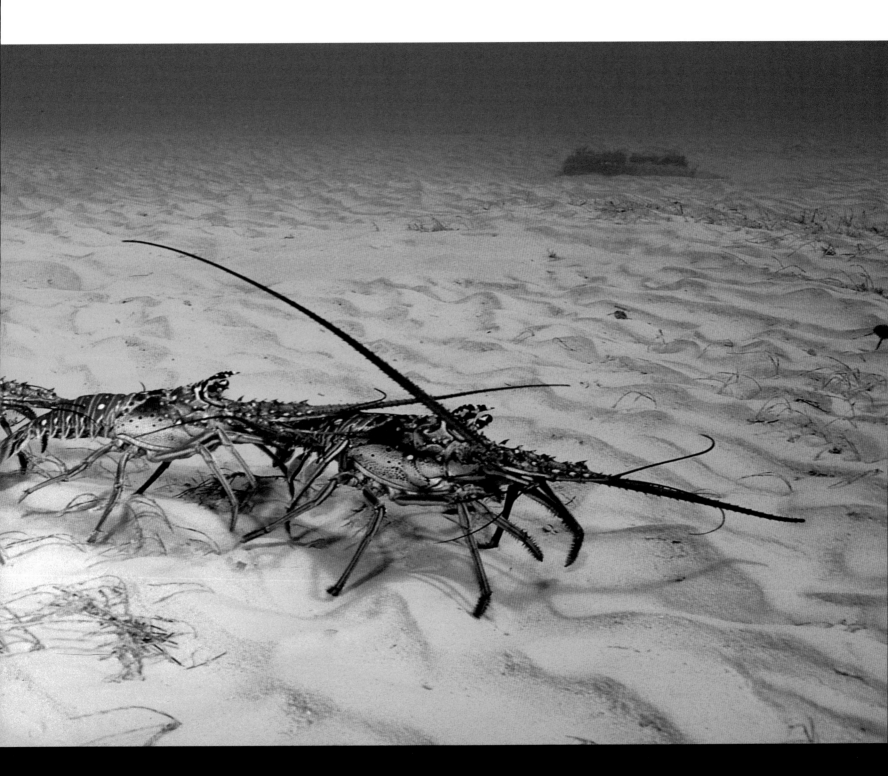

Lobsters migrate across shallow sand banks.

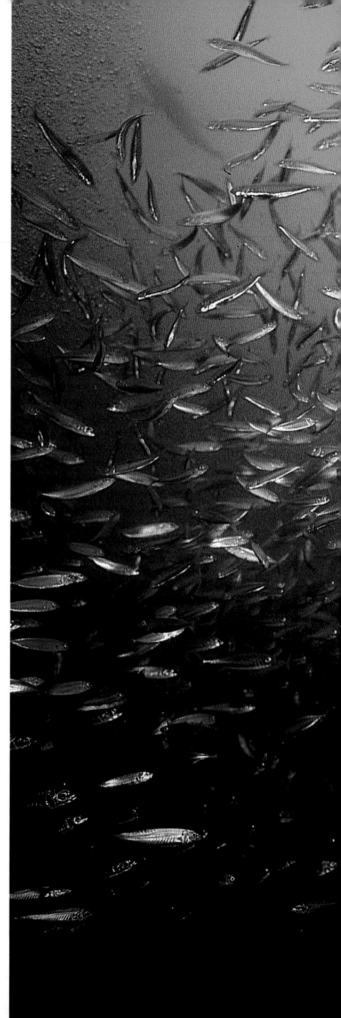

SHARKS

● Bob Cranston and I stood at the summit of the
Marisula Seamount sixty feet below the surface of the Sea
of Cortez (Gulf of California). This was the shallowest
spot within eight miles, and in each direction we looked the
ocean floor fell away to deep and dark water. After
checking my compass, Bob and I began moving north across
the seamount and over the edge into deeper water.
At one hundred and ten feet we encountered a rocky ridge,
which we followed a quarter mile farther north until
it ended, plunging off into deep water in all directions.
Here at the end of the ridge was a small sand-covered
terrace that I knew well. This was a special place. ●
A brown sea fan grew on a rock at the northeast end
of the terrace. Near the sea fan a tiny blenny looked out
from his home in an abandoned barnacle.
I acknowledged the blenny with a glance before scanning
the water above the terrace for sharks. What an
amazing view that little fish had from his tiny barnacle near
the base of the sea fan! Indeed, in my experience, this
was one of the most amazing places on Earth. ● Looking
up, I could see a bright place where the morning sun
struck the ocean's surface, but the surface itself was
indistinct. Large schools of fish were silhouetted
against the light. There were creole fish hovering in clusters
high above. A school of skipjack tuna raced across the
sky, sparkling like the tail of a comet as light danced away
from a thousand mirrored flanks. ● Below the
terrace was a world shrouded in twilight. Looking down,
I could see the dark shapes of rocky canyons in the
distance. Patches of coarse blue-white sand filled the
bottoms of these chasms and silhouetted the heavy

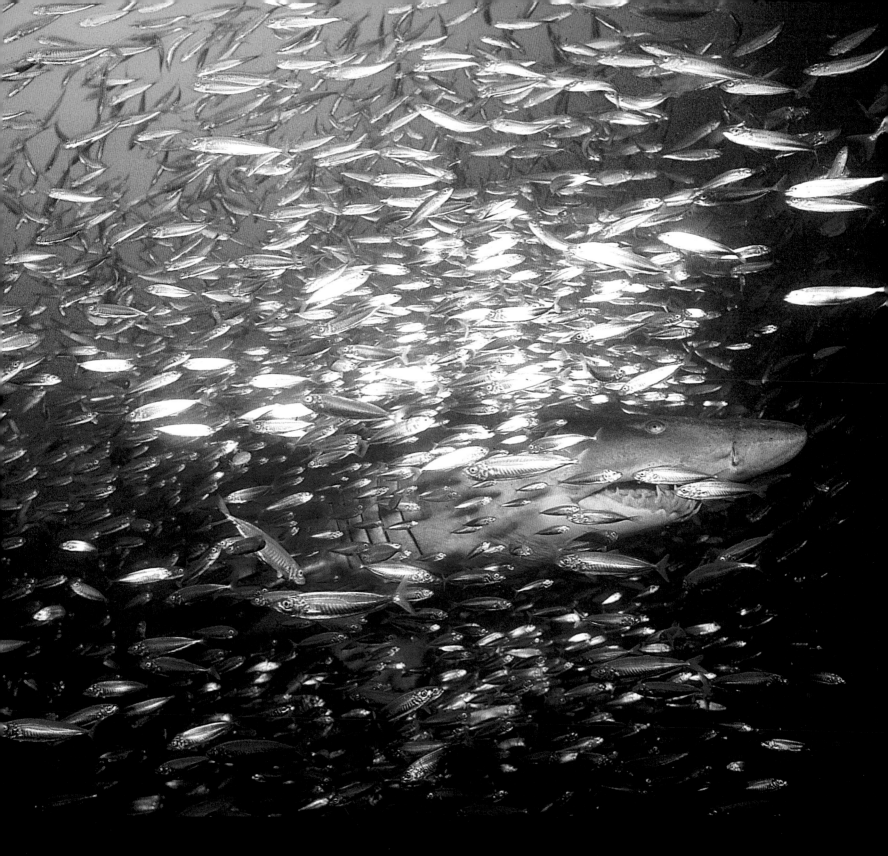

A sand tiger shark nearly concealed by a swarm of schooling fish.

NORTH CAROLINA

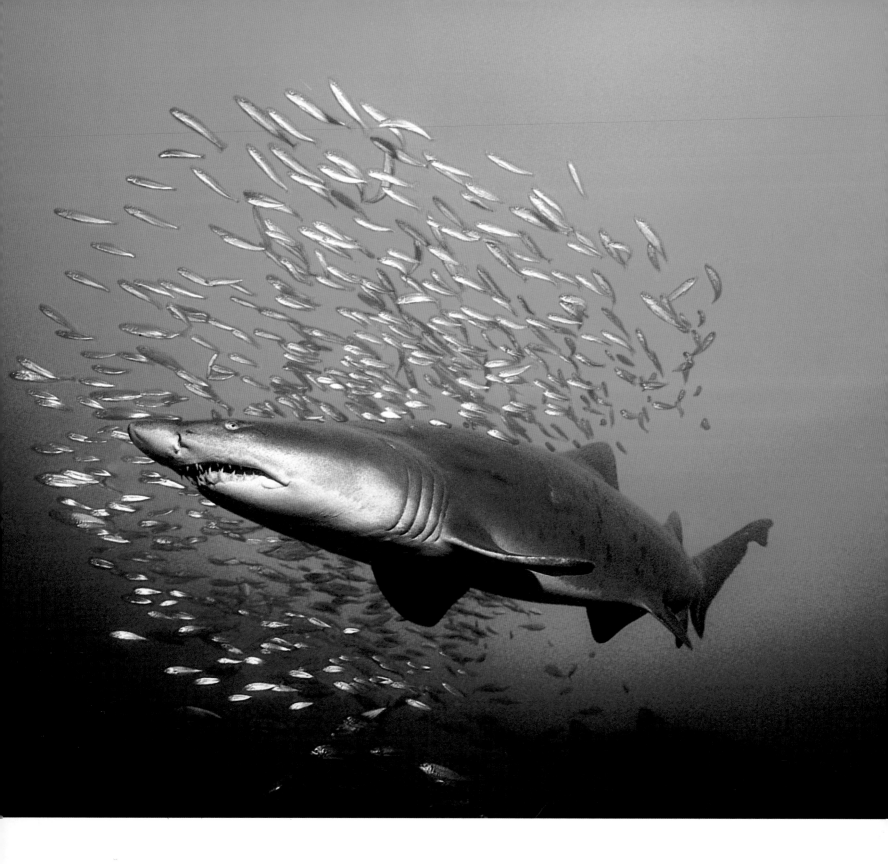

shapes of giant sea bass that occasionally moved between hidden caves. ● Bob and I had only a minute or two to check the instruments on our closed-circuit rebreathers and to take light-meter readings on the blackish-blue water beyond the ridge before the sharks appeared. When I looked up from my oxygen-pressure gauge, an immense dark shadow was moving my way. It was perhaps the most awesome sight to behold in this undersea wilderness. Gliding slowly in our direction was a school of over four hundred hammerhead sharks. ● Soon the school engulfed the small terrace at the end of the rocky ridge. Bob and I hid next to the rocks, inconspicuously raising our cameras to photograph the passing swarm. Hundreds of sharks were all around us. Ten- and twelve-foot sharks passed mere inches from the tops of our heads. Had I raised my hand, I could have caressed the bellies of countless passing sharks. But we stayed low, cowering for fear of being discovered. We feared discovery because if the sharks spotted us, we knew they would go away. ● *Sharks.* I dislike the word but not the animal. I dislike the word because it represents a myth rather than a group of wild animals. People I meet for the first time, upon learning my profession, often ask about my experiences with sharks. In these situations, I find the topic difficult to talk about. Their preconceptions about sharks are so different from my knowledge of the animals that there is seldom enough common ground for discussion. ● "Have you ever had problems with sharks?" they might ask. ● "Often," I would reply. "Hammerheads cause me fits. They're very hard to get close to with scuba gear because as soon as you exhale, they

go away." At this point I usually receive a blank stare and the conversation comes to an abrupt end. ● Of course, I know what it is they want to hear. They want to hear about life-threatening adventures where I risked life or limb while swimming in shark-infested waters. The truth is, in thirty years of diving I have been in several situations where attack by a shark was a real possibility. But these situations nearly always arose due to such monumental stupidity on my part that I don't like to talk about them much. ● It's not that I'm completely insensitive to the fact that sharks can be very large animals, that many species have a mouthful of razor-sharp teeth, or even that some species occasionally attack and kill people. It's just that these things are seldom on my mind when I see a shark. This is because the "sharks" I know behave differently than the "sharks" most people fear. To fear sharks, one must first be entirely ignorant of the statistics relating to shark attack. In the United States, perhaps a dozen people are hospitalized each year due to shark bites. Seldom does even one of these cases involve a diver. More than five hundred people are hospitalized each year due to injuries sustained while handling Christmas ornaments. Statistically, an ocean infested with sharks should be much less frightening than a home infested with a Christmas tree. ● Still, most people simply can't understand that while standing on that terrace, surrounded by hundreds of hammerhead sharks, I had only minor concerns for my safety. I was slightly concerned that my rebreather might stop functioning properly, that Bob and I might have difficulty navigating back to the seamount and our boat,

and that the current might come up and sweep us off the seamount. But all of these concerns were minor, and none of them had anything to do with the sharks. The absence of real threat may, for some people, diminish the thrill of looking up at a school of four hundred hammerheads, but not for me. Despite the lack of risk, the experience was absolutely awesome. o Photographing spectacular scenes of giant hammerhead schools would have been enough to make our dives on the Marisula Seamount worthwhile. But Bob and I hoped for more. We hoped to discover the reason hammerhead sharks gather in such amazing aggregations. Using silent, bubble-free rebreathers, Bob and I might be able to spend extended periods on the bottom actually inside the hammerhead schools without the sharks being aware of us. o A typical reason that animals congregate is for mating. Bob and I thought that this might explain the hammerhead's schooling behavior. If true, we suspected that mating was occurring on the bottom. Scientists and photographers had spent hundreds of hours observing the hammerhead schools from above while snorkeling on the surface. But since the sharks were spooked by scuba bubbles, few people had spent more than a few seconds inside or below the schools. Our rebreathers would change that. Bob and I would stay close to the bottom, beneath the schools, looking for courtship between sharks near the reef. The plan worked, but what we discovered took me completely by surprise. o Bob had moved to the top of the ridge, where he had a good vantage of the deep reef below. I had moved deeper, descending to one hundred and

forty feet, where I could watch hammerheads that were milling around over a large patch of sand. The sharks were everywhere. Small groups traveled up ravines and past the ridge. Others suddenly appeared from behind jagged features of the reef. And above, the sky was filled with hundreds of hammerhead silhouettes. Occasionally I would check on Bob by looking back over my shoulder to where he was perched on the top of the ridge. The last time I looked back, I saw something amazing. o High over Bob's head and surrounded by dozens of other sharks, two hammerheads were mating. The two sharks were locked together. The male had grasped the female's pectoral fin in his mouth and wrapped his body tightly around hers. Entwined together, the sharks could no longer swim, and since sharks have no swim bladders and must either swim or sink, the sharks were sinking. In fact, to say they were sinking is an understatement. Even underwater, sharks are very heavy. A diver wearing fins would have difficulty lifting a twelve-foot hammerhead off the bottom and swimming it to the surface. Once the pair of hammerheads had stopped swimming, their intertwined bodies arched over and began falling headfirst, and falling fast. o Instantly I switched on my movie camera and began swimming in Bob's direction as fast as I could. I was too far away to get a good shot. I had to get closer. Bob saw my sudden change of behavior. He saw the camera pointing at a spot somewhere above his head and he saw that the camera's running light was illuminated. Bob knew something spectacular was happening very near him. But he had no idea what or where it was. He looked around

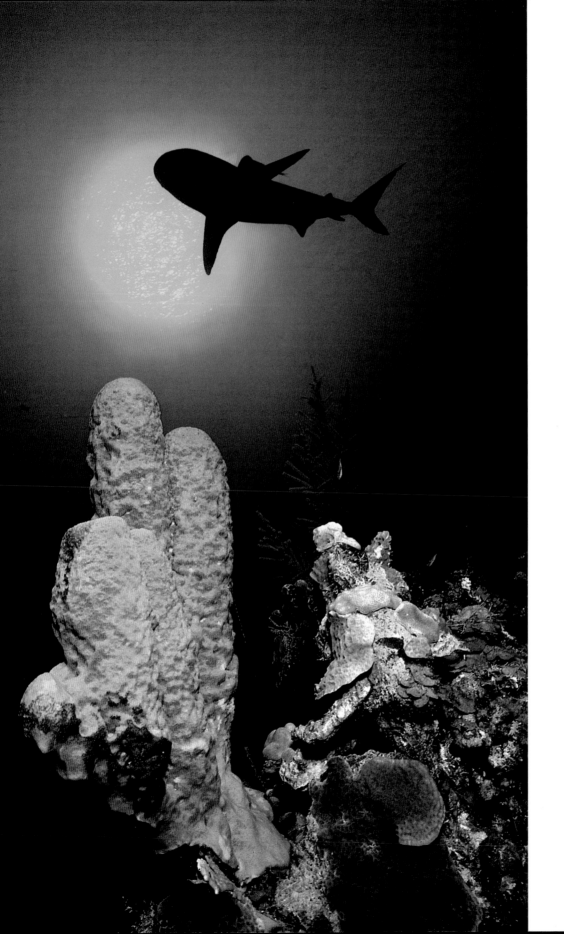

A great white shark looks for prey on the surface.

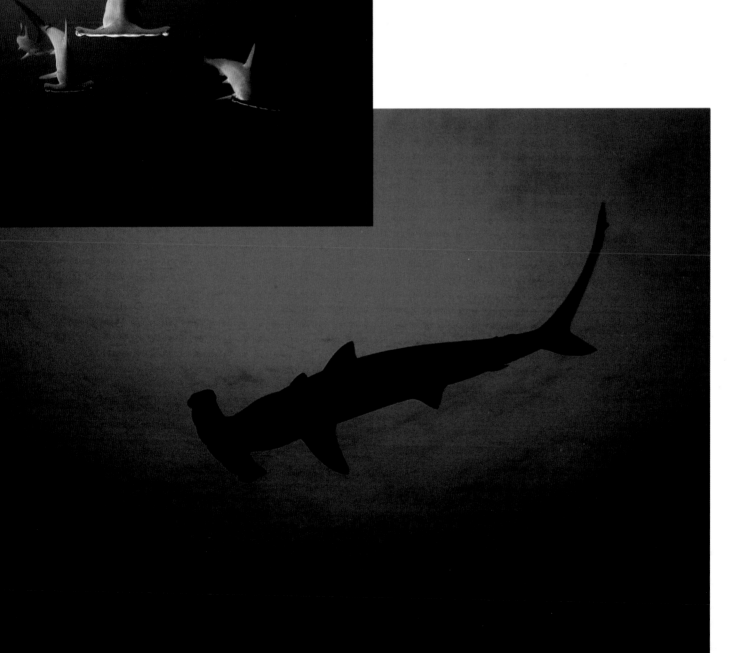

Three scalloped hammerheads cruise over a seamount.

69

frantically as I sprinted in his direction. o Bob couldn't see the mating sharks because they were falling right over his head. I thought there was a chance the two sharks might actually hit him as they came down. That would have hurt. Two ten- or twelve-foot sharks, falling as they were, would certainly have injured Bob. There was nothing I could do about it except, of course, get it on film. When Bob finally looked up, the sharks were already behind him. They hit the reef about six feet away. Neither Bob nor I will ever forget the crashing sound the sharks made when they hit the reef. Then I did something really stupid. I turned the camera off. o I turned the camera off for two reasons. First, there was a huge exposure difference between looking up, where I first saw the sharks, and looking down on the reef. Second, I had assumed that the sharks mate on the bottom. So I thought they would continue to mate where they fell, allowing me to adjust exposure and get closer. Instead, the sharks immediately split up when they hit the reef. When I saw what was happening, I instantly turned the camera back on, but the damage was done. My shot was interrupted. Although the scene was still usable, I was disappointed. o Bob was also disappointed. He had stood on the top of the ridge with a loaded still camera while the opportunity of a lifetime passed only a few feet behind him. o It occurred to me afterwards that, my statements above notwithstanding, diving within schools of hammerhead sharks is not without risk. Although the chance of being attacked by a hammerhead under these conditions is perhaps only exceeded by the chance of being struck by a meteorite, there is a significant danger. While diving within schools of hammerheads, you might be crushed to death by mating sharks falling out of the sky! o Of course, diving with sharks can be made as dangerous as required by adrenalin addicts or the hopelessly stupid. Both are qualifications I have been able to claim at one time or another. I've even been bitten by a shark. Shark bite scars make for impressive party conversation for people like Rodney Fox or Mike DeGruy. Both carry prize-winning evidence that there are exceptions to every rule. My scar is less spectacular. o It occurred in the waters off Costa Rica. Bob and I were filming whitetip reef sharks at night as they fed on creole fish under our movie lights. One of the creole fish decided to hide from the sharks under my movie camera. A shark pursued the fish and struck, biting down on the left handle of the camera. Unfortunately, I was holding the handle at the time. o I returned to the boat cradling my injured hand. Michele met me on the swim step and, upon seeing blood dripping from my glove, ran for first aid. A minute later she returned with a Band-Aid, which turned out to be the appropriate measure since the injury amounted to a half-inch-long cut on my pinky finger. The resulting scar is so pathetic that I seldom mention it. o The most certain way to increase the risk of shark attack from near zero to significant is through the use of bait. In most waters you could dive for a lifetime and never see a shark large enough to be dangerous. Tens of thousands of divers explore California's coastal waters each year and only a handful ever see a big shark. But with

a little bait applied in the right spot, monsters appear. It's really quite amazing that you can anchor a boat just offshore in central California, put some bait in the water, and within shouting distance of a hoard of surfers, quite predictably attract great white sharks. Of course, the surfers tend to take exception to people doing so. And this has caused some conflict between surfers and shark divers in recent years. But where do the surfers think the attracted sharks come from? Obviously, the sharks don't materialize because the smell of food is in the water. They show up because they live there and happen to be swimming by. Still, if I were surfing in the area, the sight of fifteen-foot great white sharks splashing around a boat just offshore might put me off my ride too. ● The most predictable place to attract great white sharks has always been South Australia, specifically a place aptly called "Dangerous Reef." But expeditions to South Australia are long and expensive. So many years ago, I decided to attempt filming my first great white sharks closer to home. Baiting California waters would be economically practical but would certainly make us intensely unpopular with surfers and sea-urchin divers. So we decided to try filming great whites at Guadalupe Island, eighty miles off the Pacific coast of Baja California. ● Guadalupe Island is a three-hundred-mile boat trip south from our base in San Diego, California. It's a strange and spooky place. The island rises from the sea abruptly to a towering elevation of nearly five thousand feet. Enormous cliffs rise from the surf, their summits often disappearing into dark clouds. Jules Verne would have loved this island.

It's the sort of place one might expect to find strange creatures lurking. But it's doubtful the writer could have imagined a monster more impressive than the predator that patrols the waters of Guadalupe. ● Guadalupe has a reputation for being the haunt of great whites. Two divers have been attacked by white sharks there. One died. These are amazing statistics considering the rarity of shark attacks in general and the isolation of Guadalupe. Despite these facts, we were not confident in our ability to attract a great white at Guadalupe. So when we reached the island, instead of putting bait in the water immediately, we decided to spend four days diving and filming other marine life before dispensing any bait. Of course, we could have put bait in the water and then gone diving while crew members on the boat watched for arriving sharks. But that would have been an act of the hopelessly stupid. At the time, no one had swum with great white sharks outside the protection of a shark cage. I had never seen a great white before and I didn't want to experience my first encounter with a seventeen-foot, three-thousand-pound monster by looking over my shoulder as I swam around the reef in a cloud of fish blood and guts. ● The water surrounding Guadalupe is gray and dark. Dark brown palm kelp grows thickly on the reef. Black volcanic sand covers the bottom surrounding the jagged reef and reflects no light. Looking down, it was as if we were descending into a well filled with black ink. Even without bait in the water, I confess to some lack of tranquillity while swimming in those dark waters. And on the fourth day, as five of us floated on the surface with empty air tanks waiting for

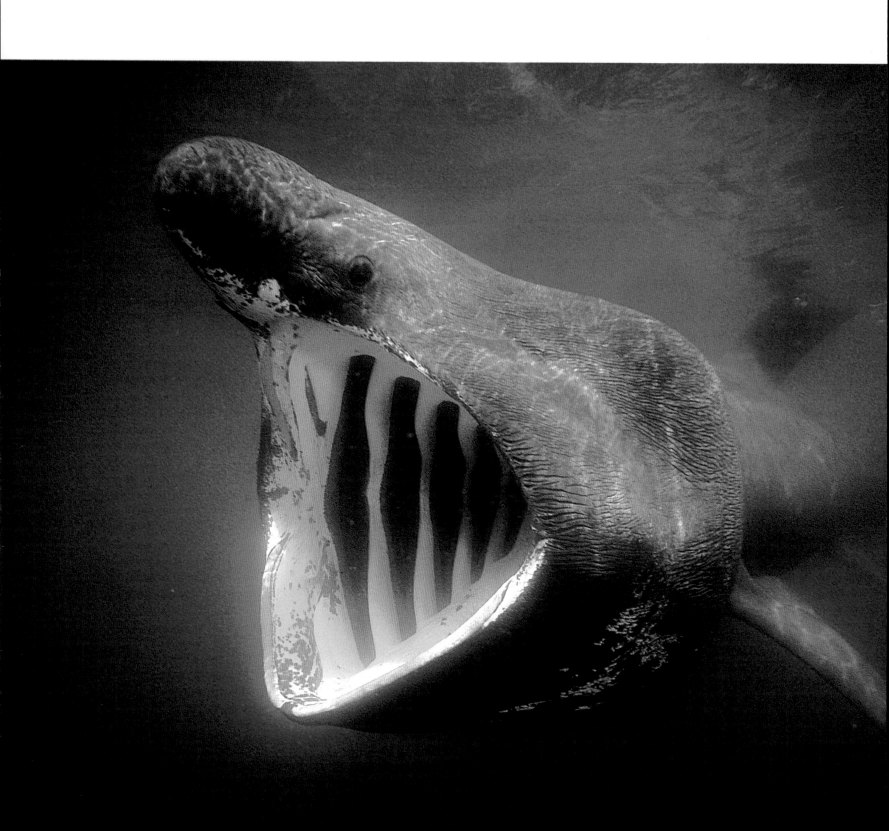

A basking shark filters plankton by engulfing great volumes of seawater.

the boat to pick us up, I remember feeling noticeably
uncomfortable looking down into that black water as my
imagination created images of monsters swimming
below. The next day we began baiting in that same spot.
Forty-five minutes later we attracted a gigantic white
shark. The shark was so large that our entire crew seemed
stunned by the sight of it. A suggestion that we deploy
our shark cage was met with a dramatic absence of alacrity
as we all stared down on a beast that looked to be at
least twenty feet long. The shark left before we succeeded in
launching the cage and making a dive. ● For three
days we continued to bait the dark waters of Guadalupe
Island, but the shark never came back. Pairs of divers
took turns dispensing bait and watching from the
submerged shark cage. On the afternoon of the third
day I was in the cage with Tom Allen when a small mako
shark showed up. Suddenly influenced by a transient
infection of hopeless stupidity, I suggested to Tom that we
leave the cage to film the small shark. The disease
being contagious, Tom agreed. I picked up my movie
camera and left the cage with Tom. I immediately
surfaced to yell our intentions to the others waiting on the
boat. Marty Snyderman and Jeremiah Sullivan quickly
caught the infection and decided to suit up and follow.
 ● Jeremiah entered the shark cage to resume baiting
while Marty, Tom, and I drifted downcurrent with the
mako. We had just drifted beyond sight of the cage
when we heard a series of crashing sounds. The noise was
obviously a signal created by someone pounding on
the shark cage. We immediately left the mako shark and
started swimming back to the cage. ● It was easy for

us to find our way back to the cage even if we couldn't

see it. Jeremiah was dispensing a cloud of bait, which was

drifting downcurrent. We had only to follow

the cloud back. When we came within sight of the cage, we

experienced a major shock. Jeremiah was pounding

on the cage with a forty-pound frozen tuna, creating an

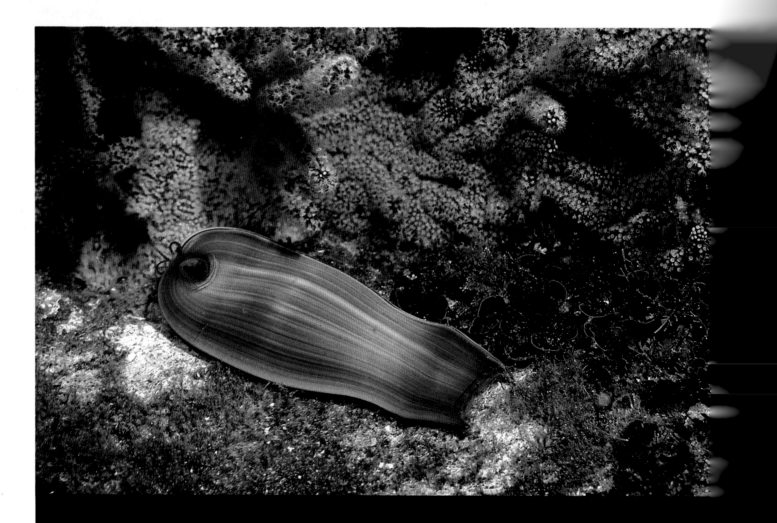

A swell shark egg.

SAN DIEGO, CALIFORNIA

enormous cloud of bait. And circling the shark cage
was a fourteen-foot great white shark. ● At that time,
none of us had ever seen a great white shark.
Certainly, none of us had ever expected to see our first
under these conditions: fifty feet from the shark cage,
downcurrent, surrounded by a cloud of bait. Although the
shark was much smaller than the monster we had seen
earlier in the week, it was still large enough to eat three or
four of us without much trouble. Marty confesses to
saying a prayer at that moment in which he promised to quit
diving and never do anything this stupid again if only
he might survive the afternoon without being eaten alive.
This was a lie Marty rather routinely told his Maker in
situations such as this. ● Marty was closest to the boat
and made a dash for the swim step. His strategy was
sound. The shark would likely eat Tom and I before it would
get to Marty. Tom and I found the shark cage more
attractive, however. When the shark was on the other side of
the cage, Tom and I dashed for the door. ● This
time, as is often the case with sharks, even an infectious
outbreak of hopeless stupidity resulted in no boastful
scars, loss of limb, or death. The shark completely ignored
the three of us as it swam around the cage. It had been
attracted by the smell of tuna and probably had a pretty
good idea what a tuna looked like. And none of us, it
seems, looked very much like a piece of fish. ●

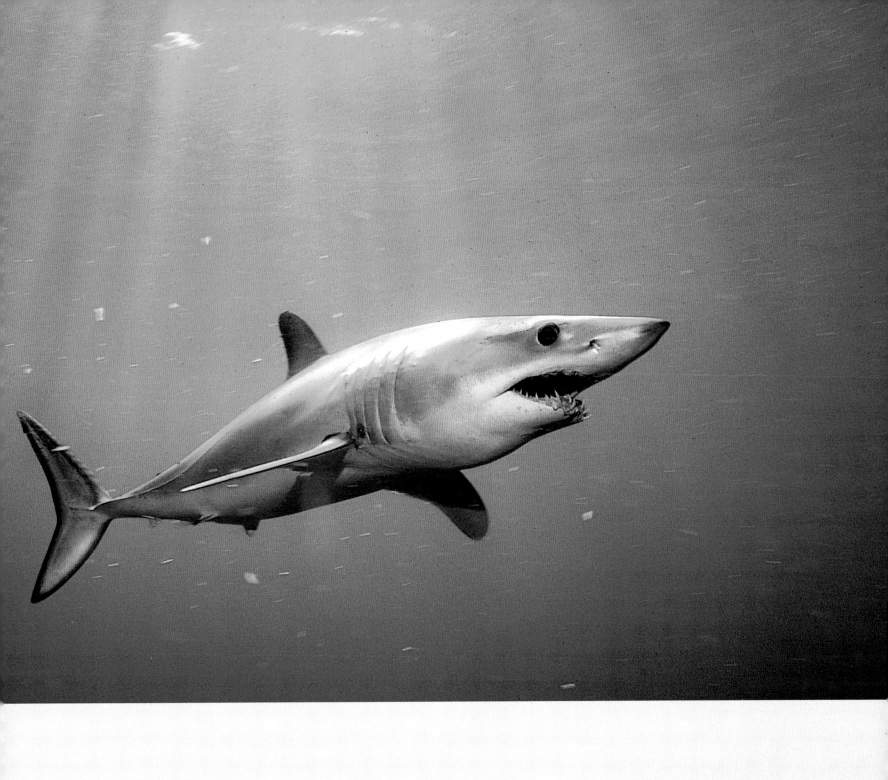

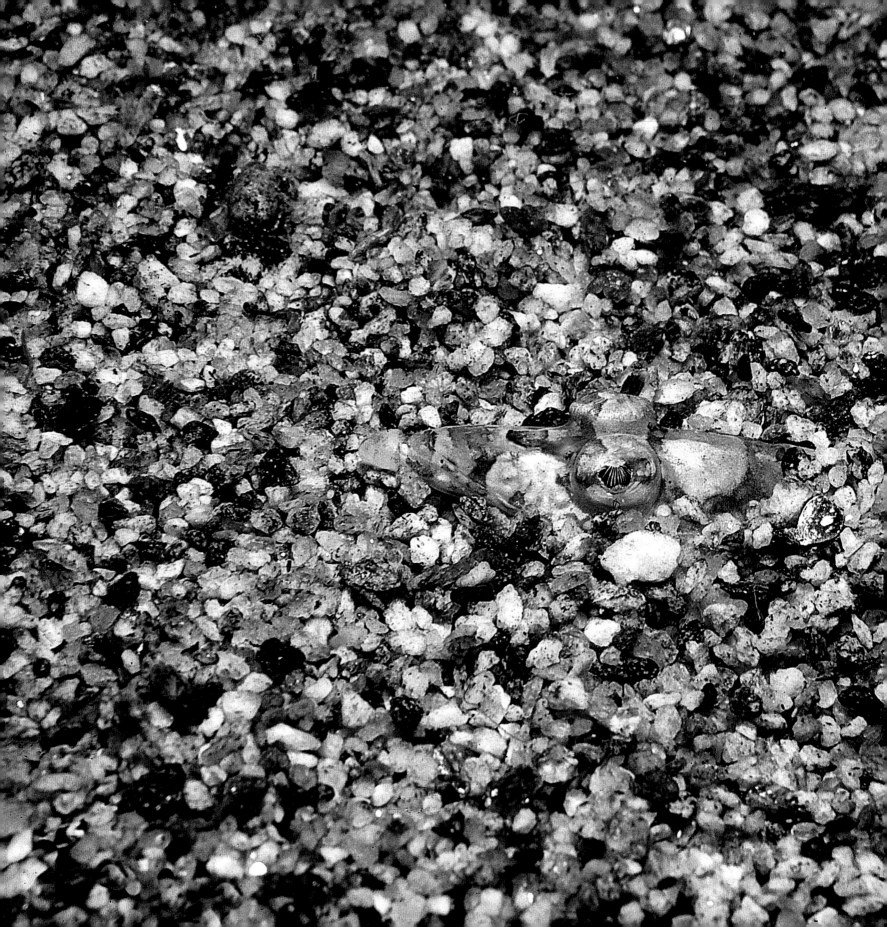

◔ I had been swimming hard for nearly a half hour and had gained no ground. The frenzy boiling in the distance remained just at the edge of visibility. If I fell behind just twenty or thirty feet more I would lose sight of the swirling mass and could give up, go back to the boat, have a cold beer, and rethink this whole idea. But as long as I could see the huge ball of sardines, I had a chance. ◔ The ball of sardines was growing smaller every minute. Fifteen or twenty enormous striped marlin were taking turns rushing through the ball at incredible speed while slashing at the sardines with their sharp swords. I followed through a trail of silver sardine scales. The water below was hundreds of feet deep and reflected very little light. Looking down into the dark blue water filled with countless fish scales that reflected sunlight like the facets of a diamond was like looking up at the Milky Way on a dark desert night. But I had little energy to spare contemplating the beauty of a galaxy of fish scales. I was quickly running out of gas. ◔ This was one of many dives I'd made during the last two days trying to get close enough to feeding marlin to capture the action on film. My legs were tired, and large blisters had formed on the tops of my toes. Now I could feel the blisters breaking as my fins rubbed away the skin. Marlin were casually passing me, sometimes only fifteen or twenty feet away, as they moved to join the feeding frenzy ahead. The marlin's sides were dull silver as they swam by. But when they began to feed, their colors changed dramatically. As soon as a marlin accelerated into the ball of sardines, its color deepened from dull silver to dark black with brilliant blue

vertical bars and a bright blue stripe that ran horizontally the length of the fish. It was a spectacular scene, if only I could get close enough to use my camera. o It soon became apparent that the sardines were not moving away in order to avoid me. They couldn't have cared less about me following a hundred feet behind. They had plenty to occupy their attention as marlin drove them insane with fear, rushing through the school slashing the fish to pieces. Instead, the sardines were being herded away. The marlin had complete control over the school, and they kept it a comfortable distance from me. They managed their prey like trained dogs herding a flock of sheep. o Occasionally the sardine school would try bolting straight down toward the bottom at high speed. When that happened, a dozen or so marlin casually dropped down like falling arrows. For a few moments the sardines would vanish into the dark water below. Then the school would come racing back to the surface as the team of marlin circled below. It was obvious that the marlin's behavior was highly cooperative. Some may say that such complex behavior is seen only in higher animals like wolves and lions. But I could never be convinced of that. These marlin controlled their food source. Many of the fish herding the sardines were not feeding. They circled the school and controlled it even after satisfying their appetites. o Adventure is made of good memories you pay for with discomfort. I was, indeed, having an adventure. But I was accomplishing nothing. I had a ten-minute load of film in my movie camera and had yet to expose a single frame. The raw flesh on my toes screamed at me as my fins massaged the

wounds with a mixture of sweat and salt water. Normally a scuba tank would last several hours for a diver at rest just below the surface. But after thirty minutes of hard swimming I had less than a quarter supply of air left even though I had never descended below ten feet. Many divers would have avoided the use of a bulky scuba tank and just used a snorkel in this situation. But when you're nearly exhausted it can be difficult to swim down ten or twenty feet and then hold your breath long enough to get a thirty-second scene on motion picture film. Of course, you could shoot while lying on the surface and breathing through a snorkel. But unless the ocean is absolutely dead calm, it's simply not possible to hold the camera still enough while being jostled about by the movement of water on the surface. o The school of sardines had been decimated. It was now only a fraction of the size it had been when I first entered the water. I realized that the marlin were going to eat all the fish without allowing me to get close enough to get the shot. I was tired and sore and getting nowhere fast. I gave up. o Lying there on the surface, breathing heavily through my scuba regulator, I expected to watch the school of sardines pull away and disappear with their legion of tormentors. But that's not what happened. For a few minutes, the marlin held the sardine school in position a hundred feet away where it had been during my entire swim. Hell, I thought, I could have stayed this close just lying here rather than swimming my butt off all afternoon. But then everything changed. o Suddenly the school of sardines and attending marlin were swimming straight at me! I was so stunned, I almost forgot

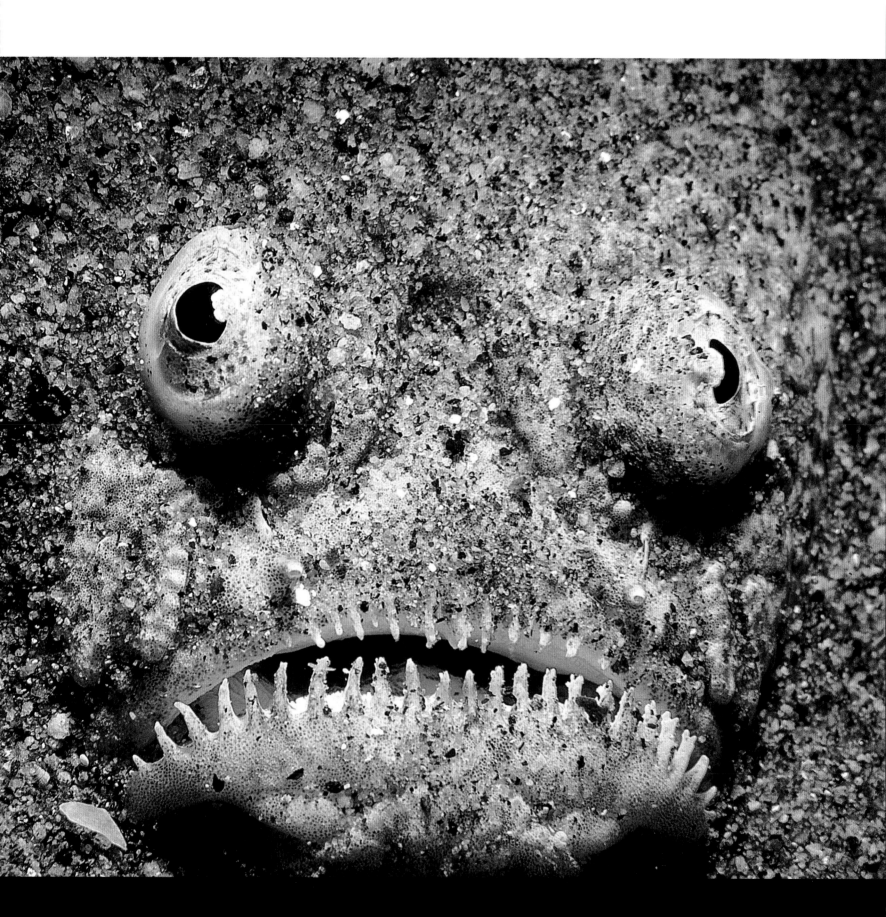

The face of a star gazer hiding in the sand.

the movie camera I had been dragging along for the last half hour. o The lapse lasted only two seconds. I dropped down ten feet, so that I could get a steady shot, and began rolling film. In moments the sardine school was right in front of me as marlin dashed through, cutting the fish apart. I watched as half of a large sardine drifted down from the school still quivering and spewing a trail of blood. o Then it got dangerous. The remaining sardines swam into the column of bubbles rising from my exhalations. Perhaps they sensed that the bubbles would help conceal them from the predators or that, at least, the relatively inert creature beneath the

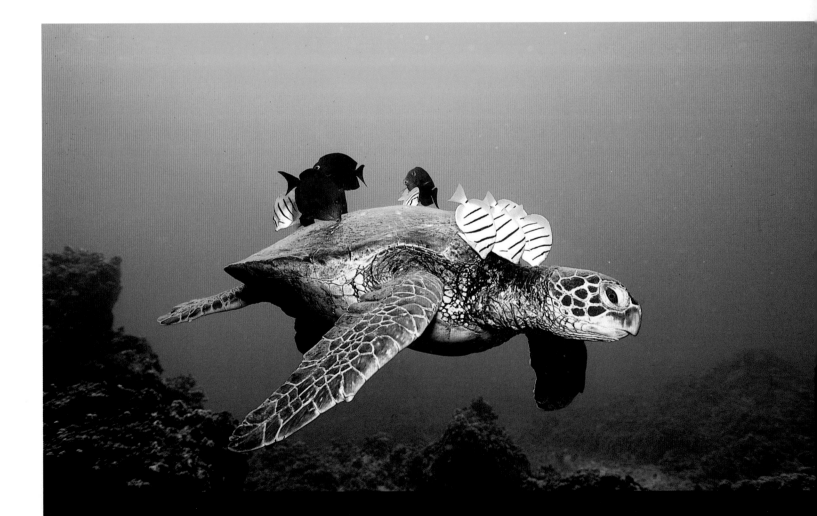

Reef fish clean algae off the shell and neck of a green turtle.

KONA, HAWAII

82

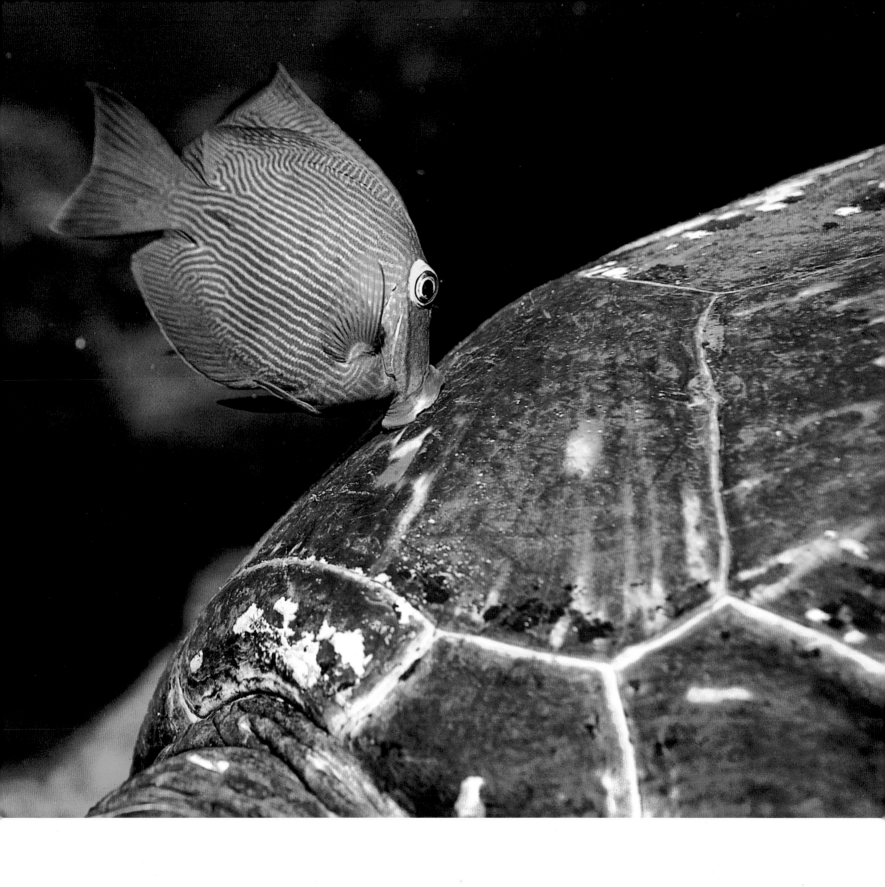

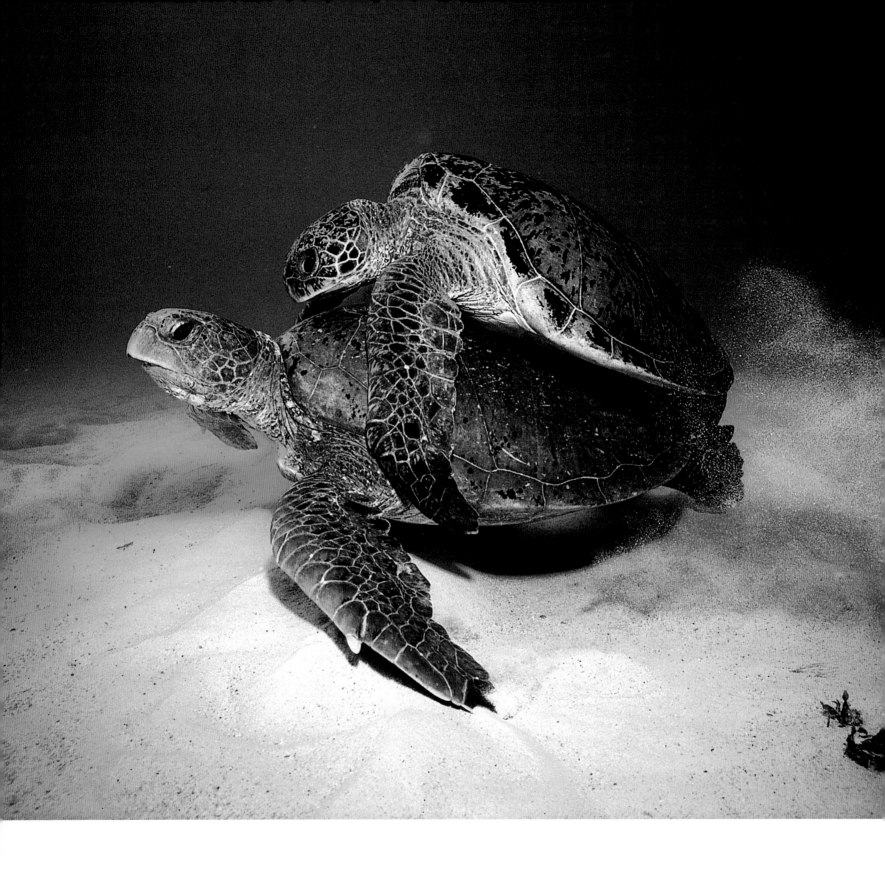

bubbles would shield them from marlin attacking from below. In any case, I suddenly found myself in the middle of the sardine school as marlin knifed through the ball of fish, slashing wildly with their spears. ○ The sardine school was so dense that I couldn't see the marlin coming. The school would suddenly part and a marlin would appear only two or three feet away, coming straight at me at warp speed. By the time nerve impulses reached my muscles to react, the marlin had changed course, missing me by inches. I pulled my legs up tight to my chest, hoping to make myself as small a target as possible. Repeatedly, marlin dashed through the school, miraculously missing me time and again by the narrowest margins. ○ On the boat, Michele looked on in mounting concern. John Kirkpatrick, captain of the *Megaladon*, had maneuvered the vessel close enough that everyone on board could see what was happening. Marlin were flying out of the water as they pursued their prey right over my head. The *Megaladon*'s owner, Dr. Pat Daily, is a cardiovascular surgeon. He noticed the concern on Michele's face. ○ "Don't worry, Michele," he said. "We have chest tubes, anesthesia, and all kinds of surgical gear right here on board." ○ Underwater, a minor irony flashed through my mind. I hoped to film this sequence for an episode about predation for our television series. The episode would be entitled "Survival in the Sea." Suddenly the title sounded more like a human interest story than a natural history piece. It was not difficult to imagine the sudden impact of a four-foot marlin spear and the frenetic thrashing of the ten-foot fish as it struggled to dislodge

its bill from my chest. The idea was disquieting. ○ But at the same time, I was thrilled with the images I was capturing on film. I held the camera before me like a shield, hiding as much of my body behind it as possible, and let it roll. I realized, of course, that if a marlin struck the camera, the sword would glance off and probably end up stuck in my face. The possible improvement in appearance hardly outweighed the potential discomfort. ○ After a few minutes I decided that either the marlin were incredibly dexterous with their awesome weapons or I had been incredibly lucky. I took a deep breath of air and swam straight down as fast as I could. Then before exhaling again, I swam away from the frenzy. When I turned to look back, I was surprised to see how few of the sardines were left. Most of the marlin had decelerated and changed color from black with striking blue bars to silver. The sardines were moving swiftly away and the marlin were following casually. After a moment they were gone. ○ Most people think of marine ecology as a long line of fish, each trying to eat the smaller fish ahead while being chased by a larger fish behind. And that's not an entirely inaccurate way to describe ocean food webs. But it's amazing to me how seldom I actually see it in action. Filming marlin attacking sardines was a special and unusual experience. Dozens of dives can go by without my ever seeing one animal preying on another. Certainly it must happen all the time. But predation doesn't occur so often that you can make a dive and expect to see it. Instead, the ocean gives you the impression that it is astonishingly peaceful. It's much more common to see

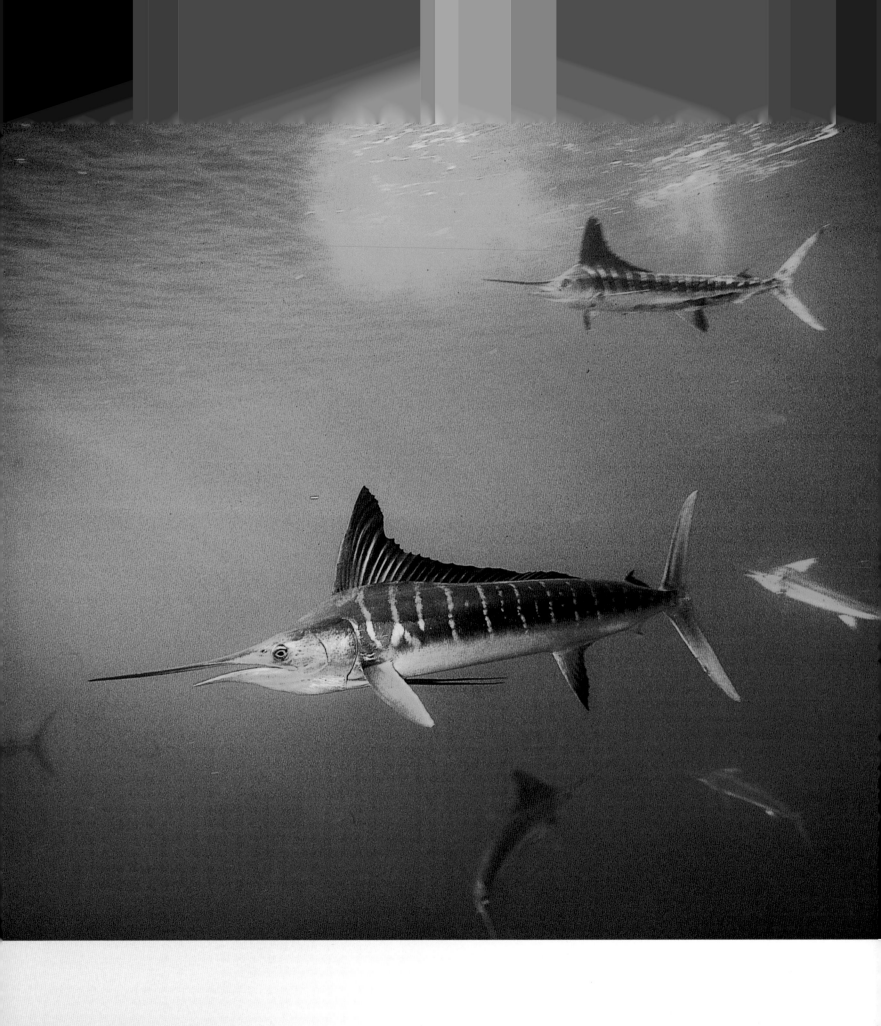

cooperation between animals than battles of life and death. ● In Hawaii, underwater photographer Jim Watt took Michele and me to Turtle Pinnacle. There really wasn't much of a pinnacle. I noticed only a large coral-covered rock rising ten feet above the reef. But green sea turtles know this place well. As we descended, I could count six turtles lying next to the rock sound asleep. When we reached the bottom, Jim pointed to a seventh turtle that was approaching in the distance. When it came to within twenty feet or so of the pinnacle, a cloud of reef fish rushed out and gathered around the reptile. During his travels, the turtle had accumulated a dense growth of green algae that now covered his shell. These specific reef fish eat green algae. Over the years, this population of fish had come to learn that passing turtles can provide a bountiful harvest. The turtles, not wishing to become overgrown, had come to learn that in this place the fish will readily clean their shells. It's a classic symbiotic relationship, and you can see examples of this kind of behavior every time you dive beneath the sea. ● You would think predation could be more easily observed. Not so. The inevitable acts of violence in the sea seem either impossibly infrequent or simply private. So capturing predation on film is especially exciting for an underwater natural history filmmaker. ● One of these rare moments came while we were filming on the Bahama Bank. Marine mammal photographer Dan Sammis had told us about crater-feeding behavior in bottlenose dolphins. The idea seemed very unlikely. Would dolphins actually expend energy digging

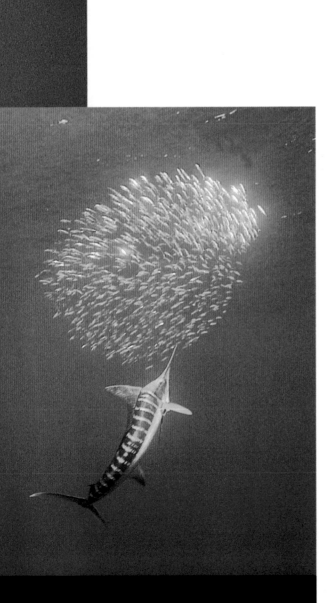

A striped marlin pursues a school of sardines.

BAJA CALIFORNIA, MEXICO

in the sand for a three- to four-inch-long razorfish?
Dan assured me that the behavior was predictable if not
common. It might take weeks to stumble across the
dolphins engaged in crater feeding. Then, even if we did
get lucky, Dan thought it unlikely I could get closer
than fifteen or twenty feet to feeding dolphins.
Underwater, twenty feet is too far away to capture
crisp, clear images of detailed behavior on film. At fifteen
feet, the images would be marginal. Still, I decided
it was worth a try. ● On days when the wind is still
and the surface of the ocean is as placid as a
mountain lake, cruising over the Bahama Bank can be an
especially delightful experience. The water is often
so clear that you feel as if you're riding on a cushion of air.
You can sit on the bow of the boat, legs dangling over
the rail, and watch the sugar-white sand pass beneath you,
twenty feet below, as clearly as if you were snorkeling
on the surface. Michele was doing just that in the late
afternoon of our second day searching for bottlenose
dolphins on the Bahama Bank. ● Dan and I were
standing on the roof of the flying bridge searching
the horizon when Michele yelled that she was seeing holes
in the bottom. I looked over the side, and indeed,
it appeared as if someone had been busy using a
posthole digger below the boat. "That's what we're
looking for," said Dan. Ten seconds later, dolphins
miraculously surfaced just a few yards away. Dan
watched the animals for a few minutes, studying their
behavior. Then he said, "Yes. That's it. They're doing
it." ● Although the water was dead calm and only twenty
feet deep, I decided to go in with a scuba tank.

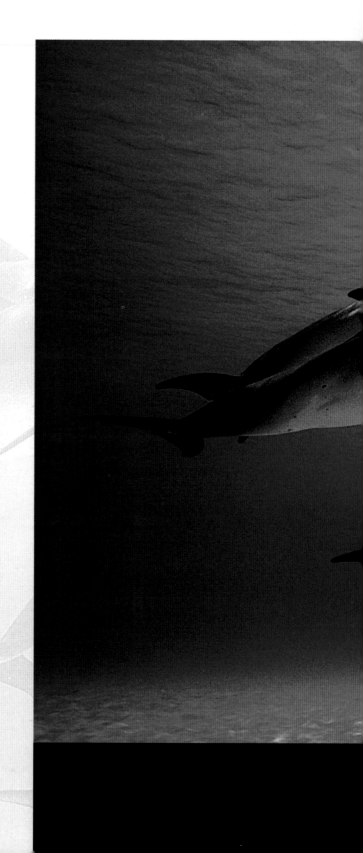

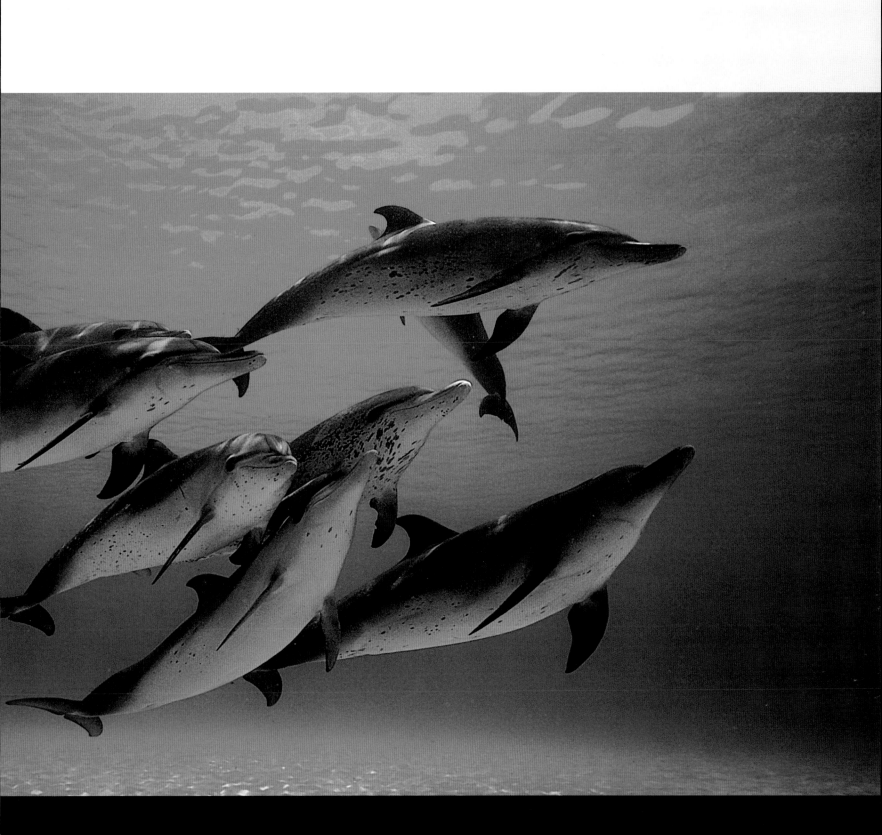

Atlantic spotted dolphins.

If I got lucky, I could do much better camera work if I didn't have to come up for air. Bob Cranston took his movie camera in while using a snorkel to shoot from overhead. If I got the close-ups, we would need wide establishing shots looking down on the dolphins to edit the sequence properly. Michele followed with her still camera. ❥ Almost immediately I came across a large male dolphin as he swam slowly over the sand, his nose almost touching the bottom as he used echolocation to detect fish hiding beneath the surface. Suddenly the dolphin stopped, his body becoming vertical as he scanned a small patch of sand. Then he began digging. ❥ I was already fifteen feet away, which was as close as I had expected to get. After letting the camera roll for fifteen seconds or so, I began slowly moving closer. I stopped only three feet away as the dolphin continued to dig, opening and closing his mouth to pump water and sand from the ever-deepening hole. I was so excited, I almost swallowed my mouthpiece! Soon his entire head was beneath the surface. He had dug at least eighteen inches into the bottom. Only his pectoral fins prevented him from going deeper. But that was deep enough. After completely burying his head in the sand, he rose clutching a small razorfish in his teeth. I could not have asked for a better performance. ❥ Amazingly, I got a better performance the next morning. Michele had discovered a mother and calf crater feeding. As I filmed the pair at work, it became obvious that the mother was instructing the baby in the technique. Remarkably, the mother allowed me to film this behavior at close range. I could not have been more pleased or surprised. ❥

A Pacific white-sided dolphin.
San Diego, California

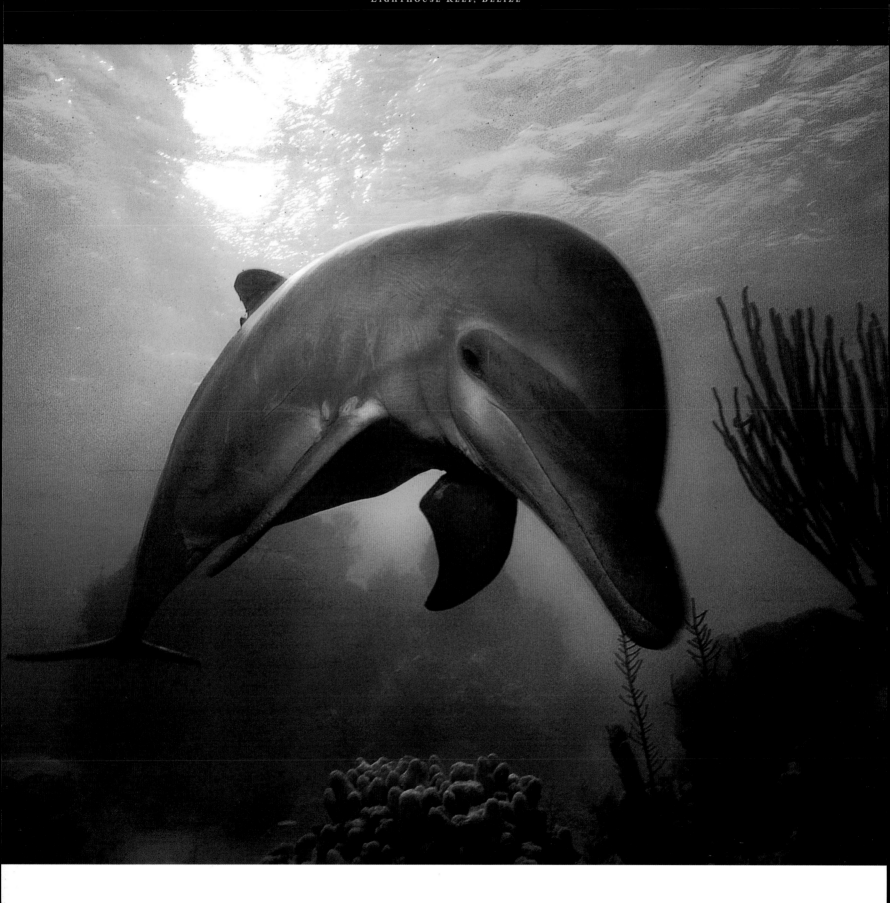

A bottlenose dolphin.

The GREAT WHALES

o The morning sun painted the mountains of Baja
California in soft shades of amber and vermilion. It was a
bit early for good light underwater, but the tide was
pouring into the mouth of Magdalena Bay and the time to
dive was now. If we were lucky, clear water from the
open Pacific would flood the mouth of the bay, producing
conditions suitable for filming whales. o Michele
wished Bob and me luck as we prepared to slip over the side
of the inflatable with our movie cameras. I took a last
look toward the mouth of the bay and the large breakers
crashing on sandbars that crossed the entrance to the
lagoon. The surf line was nearly a mile deep, and from
where I sat, it wasn't possible to see calm water on
the other side of the breakers. A four-knot current was
carrying us rapidly toward the waves, and our boat
operator, Tim Means, was becoming anxious to drop us
off so that he could move the tiny boat away from the
surf. o "Beware the 'arc of death,'" Bob said before
putting his regulator in his mouth and rolling
backward into the water. He needn't have reminded
me. No one is more familiar with the "arc of death"
than I. o The water was only fifteen feet deep where Bob
and I jumped in, and the seafloor was racing by as
we descended. Huge ripples, three feet high, formed a
washboard pattern in the coarse sand. Bob and
I experimented with digging our fins into the base of a
ripple to see if we could hold our position against the
current. It worked for a few seconds, then the ripple would
give way and we found ourselves tumbling over the
sand once again. Within a few minutes, the depth had
decreased to ten feet and I knew we were about to enter

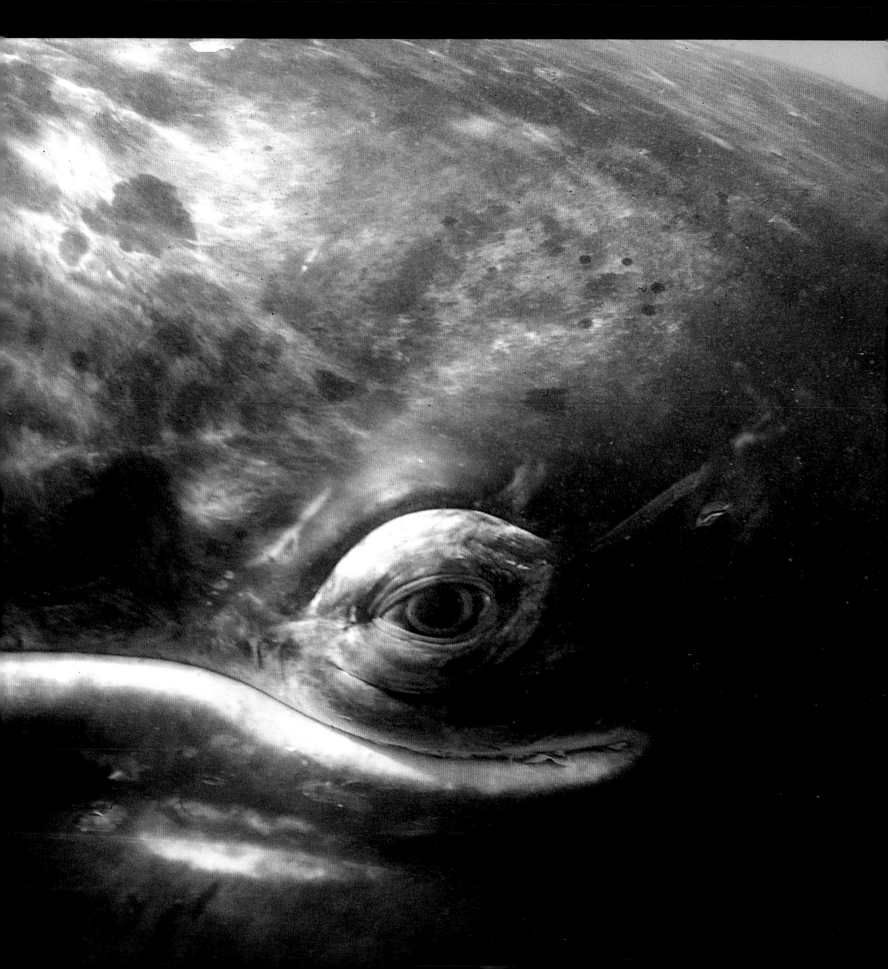

Eye-to-eye with a gray whale.
SAN IGNACIO LAGOON, BAJA CALIFORNIA, MEXICO ·

the breakers. o Beneath the breaking surf in the
current-swept entrance to Magdalena Bay seemed an
unlikely place to film leviathans. But Magdalena Bay
is winter refuge to hundreds of gray whales, and the animals
must cross this sandbar to enter. Inside the bay,
mature whales spend their days in rather violent courtship,
and females give birth and raise their calves. Most of
the time, however, the whales apparently have little to do,
and many seem to enjoy passing the time rolling
about in the surf that breaks over the sandbar. In fact, gray
whales are often observed actually body-surfing down
the face of the breaking waves. o The calm waters inside
the bay might seem a better environment for filming
the whales. But water visibility within the bay is terrible.
On a good day visibility might reach twelve feet. But
most of the time you can't quite make out the tips of your
own fins. Occasionally, however, the strong tide
brings clear ocean water into the mouth of the lagoon.
Water visibility over the sandbar can reach sixty feet or
more. These conditions make underwater filming possible.
The problem is that good visibility occurs in only ten
feet of water, over the sandbar, in a raging current, and
beneath the breaking surf. It's not the easiest place
to dive. Add to that, the breaking waves crashing down
above Bob and me might be carrying surfing whales.
o Once Bob and I dropped off the inflatable, we were
committed; we were destined to drift through the mile
of breakers carried by the powerful tide. There was simply
no way to avoid what was coming. The idea of being
pancaked into the sand by a gray whale as it surfed down the
face of a ten-foot breaker caused me some concern. But

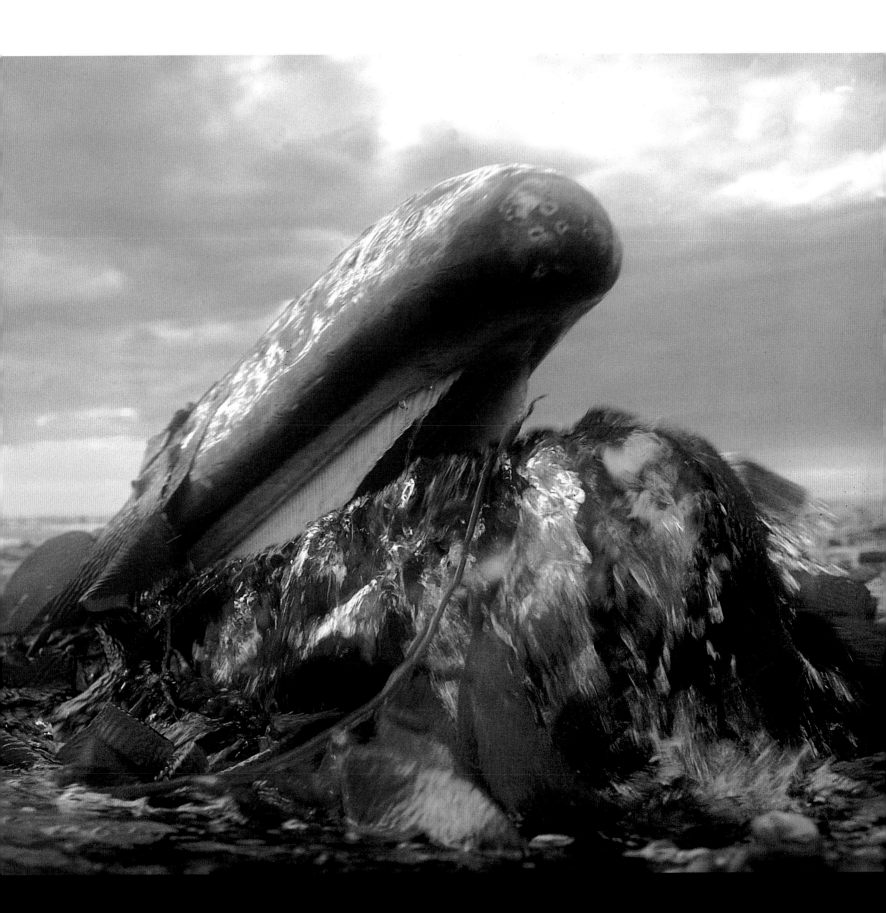

A California gray whale surfaces in a kelp bed.

SAN DIEGO, CALIFORNIA

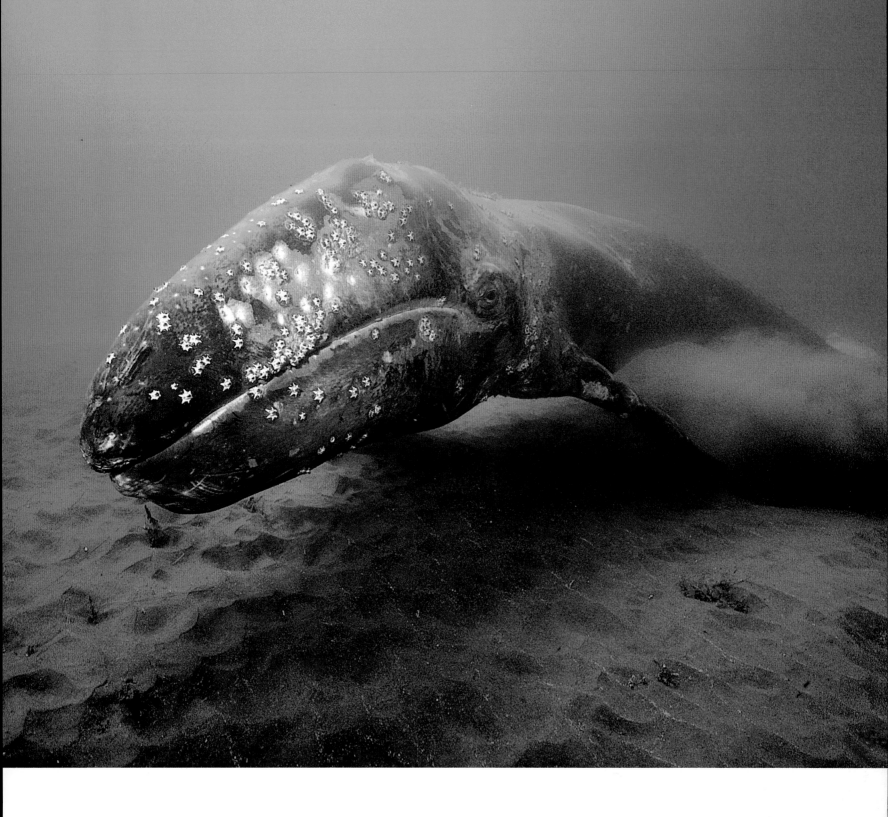

A California gray whale.

A California gray whale feeding on the muddy bottom.

ANACAPA ISLAND, CALIFORNIA

what worried me most was the "arc of death." o Most people enjoy a rather simplistic view of life in the sea. Among the common assumptions, whales are good and sharks are bad. Ironically, I find encounters with whales more worrying than encounters with sharks. It's been said that sharks are unpredictable. But compared with whales, sharks are as predictable as cold weather in Antarctica. Whales have brains as large, if not larger, than our own. They are capable of a wide range of complex behaviors. It is therefore very difficult to guess what might make one of them mad. Still, a little common sense can go a long way toward keeping you healthy when you swim in whale-infested waters. o

o Fifteen years ago, while filming gray whales in San Ignacio Lagoon on the Pacific coast of Baja California, I ignored my common sense and discovered the "arc of death." o Underwater photographer Marty Snyderman and I had been engaged to film gray whales in San Ignacio Lagoon for a German production company. I had explained to the producer that water visibility in the lagoon was so poor that all he could hope for was very close shots of gray whale faces, and then only if a gray whale became curious and purposely approached our boat. This sort of "friendly" behavior has been common in San Ignacio for years. But during our first five days in the lagoon with our German employers, friendly behavior was decidedly uncommon. For five days our producers sat in their inflatable boat and watched their expensive team of underwater photographers sit on their backsides doing absolutely nothing. They became

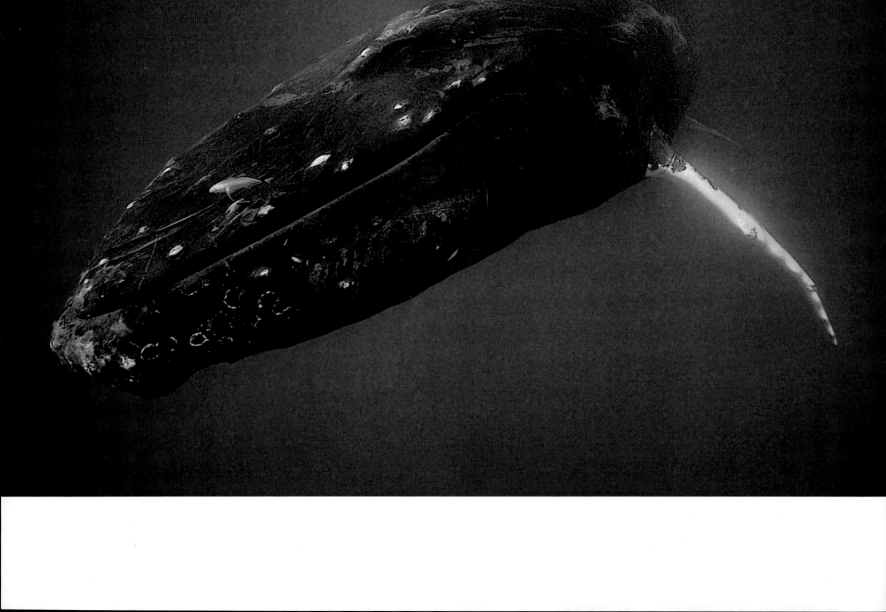

understandably impatient, suggesting that Marty and I try to film various whales that passed within a few dozen yards of the boat. It became increasingly difficult to convince them that filming fast-moving animals in six-foot visibility was simply not possible. o On the fifth day, Marty and I became so uncomfortable with the subtle but increasing comments about our lack of productivity that we decided to make a show of trying something different. Bolstered by our producers' overwhelming enthusiasm, we began swimming out into the paths of passing whales. Both Marty and I knew that capturing a usable image of moving whales in these conditions was extremely unlikely, but at least we were doing something that looked like work. Our charade took a dangerous turn when three courting whales began approaching our boat. o Gray whale courtship is rather violent. The details are not well understood, but the act requires two males and one female. During courtship there is often angry competition between the males and an apparent lack of consent from the female. The result is a great deal of fast swimming, breaching, and violent splashing. Such was the scene as Marty and I swam slowly out into the path of the approaching whales. From water level, I watched as whales leapt from the water, crashing down on rivals and sending geysers of seawater high into the air. My common sense was in full alarm and a voice in the back of my mind shouted a litany of insults at me. I knew that what I was doing was completely stupid. But I held fast, expecting that the whales would certainly turn away and pass harmlessly by. I was wrong. o Instead of turning

away, the whales suddenly accelerated directly at me. Now there was no way to avoid them. I decided to do what I had been employed to do and try and get a shot. I took a deep breath through my snorkel and dived. o Thirty feet beneath the surface, it was like swimming in dark pea-green soup. There was barely enough light to get a camera exposure reading. I felt intensely uncomfortable knowing that there were fast-moving whales all around me that I couldn't see. It was like cowering beneath a cardboard box at night in the middle of a busy freeway. Suddenly there were shadows moving overhead. The light fluctuated rapidly as massive shapes rushed over and around me. I was in a very bad place and I knew it. o The face of a whale almost instantaneously materialized out of the gloom. It couldn't have been more than four feet away. I saw its eye widen with surprise and then it was gone. Instinctively I knew what was coming. I pulled my legs up tight against my chest, hoping to make myself as small a target as possible. Then I saw a bright arc in the water extending from beyond visibility to my left side. The arc was caused by the vortex of the whale's tail as it sliced through the water, edge-on, and crashed into my left arm. I remember the briefest image of the great flukes next to my side, the sound of an explosion, and then darkness. o I woke up not knowing where I was. It was dark and I couldn't see. My left side was numb and I suddenly realized that I was underwater and still holding my breath. I reached down with my right hand and unbuckled my weight belt, but I didn't let it drop free. I thought, If I'm not really hurt, I'll need the

weight belt to finish my assignment. I decided to see if I could swim. ● Surprisingly, I reached the surface without much trouble. Marty was almost immediately at my side. ● "Are you OK?" he asked. ● "Yeah," I replied almost cheerfully, so glad to be alive and on the surface sucking in great lungfulls of fresh air.

● "No you're not," Marty replied. The impact had crushed the muscle covering the bone on the outside of my upper left arm. I had a small fracture just below the shoulder and two broken ribs. It may have been Marty who first described the vortex of the gray whale's gigantic judo chop as the "arc of death." ●

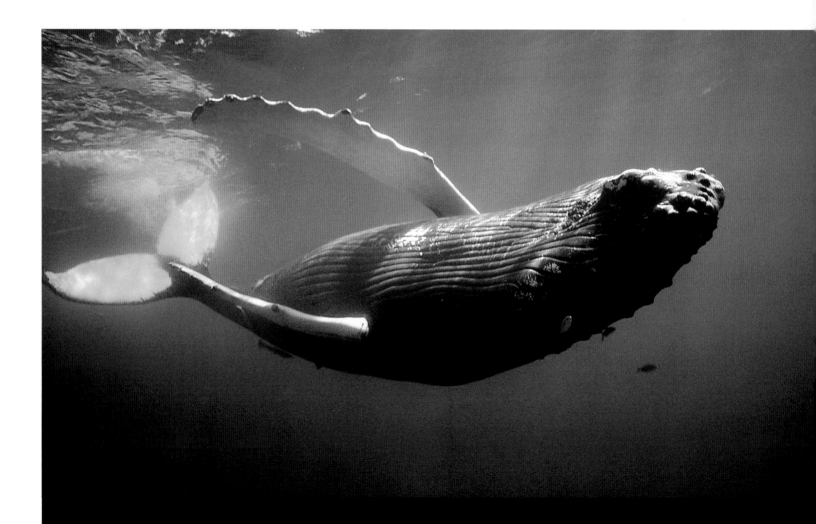

An Atlantic humpback whale rolls on the surface.
SILVER BANKS, THE BAHAMAS

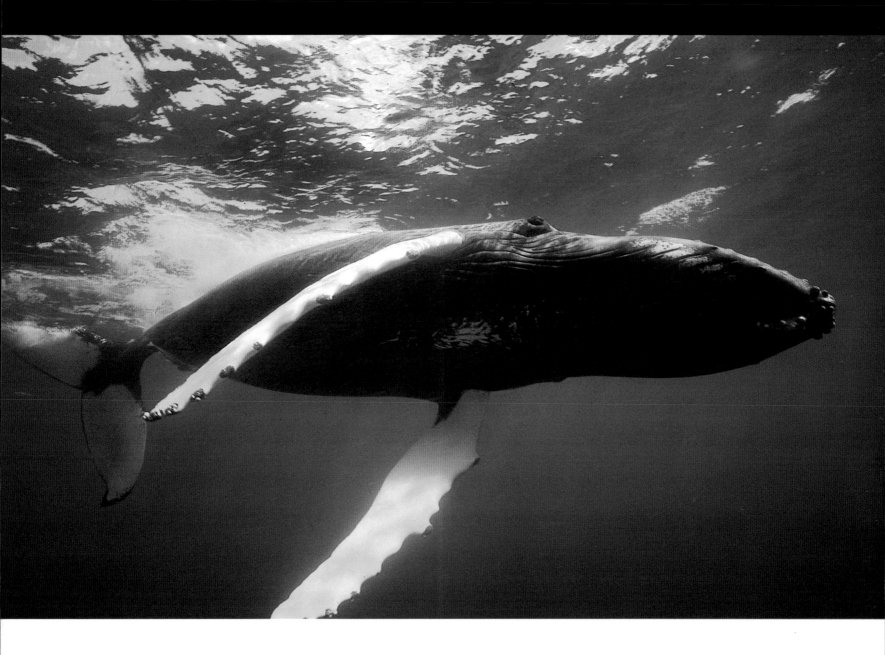

An Atlantic humpback whale.

The rapidly moving water was only ten feet deep as Bob and I entered the breakers. We stayed low against the bottom in an effort to avoid the increasing turbulence as waves began to crash overhead. Breaking waves rumbled above, producing great clouds of foam that blossomed down toward us like dark thunderclouds. Then I saw a large grayish-white object fifty feet ahead. A gray whale. ● I was rushing straight at the whale at a blistering pace. I began digging my fins into the sand to slow my drift as I tried to scuttle sideways around the animal. My camera was on and rolling film. A moment later I was nearly on top of the whale as it slowly turned and swam away. I looked over toward Bob to give him a signal saying that I'd captured a great shot. But Bob was hidden behind three whales that came roaring down from the crest of a wave. One of the three was gliding upside down. "Good lord," I thought. "I hope he has his camera running." ● For a few brief minutes we were surrounded by gray whales as we careened over the sandbar like submerged logs through a river rapid. I found myself rushing toward the tail of a whale that was lying in the sand. This time I couldn't scuttle sideways fast enough, and suddenly I was within the dangerous radius that defines the "arc of death." The great tail rose above my head and came crashing down, slicing through the water at a forty-five-degree angle and trailing a bright scythelike vortex in its wake. But the blow seemed more playful than angry and missed me by a good twenty feet, a perfect range for capturing the scene with my camera. ● A pea-green wall loomed ahead, marking the end of the shallow sandbar and the beginning of the murky waters of the bay's interior. I swam to the surface near Bob, and we began the usual whooping and hollering that always accompanies this kind of experience. Michele and Tim were not far away, and soon Bob and I were on board and racing back to the entrance of the bay for another ride through the rapids. ● Michele, Bob, and I spent ten days in Magdalena Bay filming gray whales for the *Secrets of the Ocean Realm* television series. We captured some wonderful images. But ironically it wasn't until July of the following summer, when gray whales are supposed to be feeding in the rich waters of the Bering Sea, that we filmed our most spectacular gray whale sequence.

● Bob and I were diving with our rebreathers near Anacapa Island a few miles offshore of Santa Barbara, California. We'd spent most of the morning searching south of our dive boat for a small but interesting fish called a sarcastic fringehead. Our first hour underwater had been fruitless, however, and we had just decided to spend another hour searching north of the boat. I remember thinking that the day was shaping up to be an expensive waste of effort when I heard Mark Conlin's voice through the Buddy Phone speaker mounted on my shoulder. "I don't know where you guys are or if you're interested or not, but there's a small gray whale in the kelp near Castle Rock, and it's been there for a half hour or so. I think you could film it." Some of my best encounters with whales have been with yearling grays that I've found playing or resting in kelp beds. I had no idea what this whale was doing here this time of year, but it sounded like an opportunity. I put my Buddy Phone mouthpiece up to my face and transmitted: "Load the

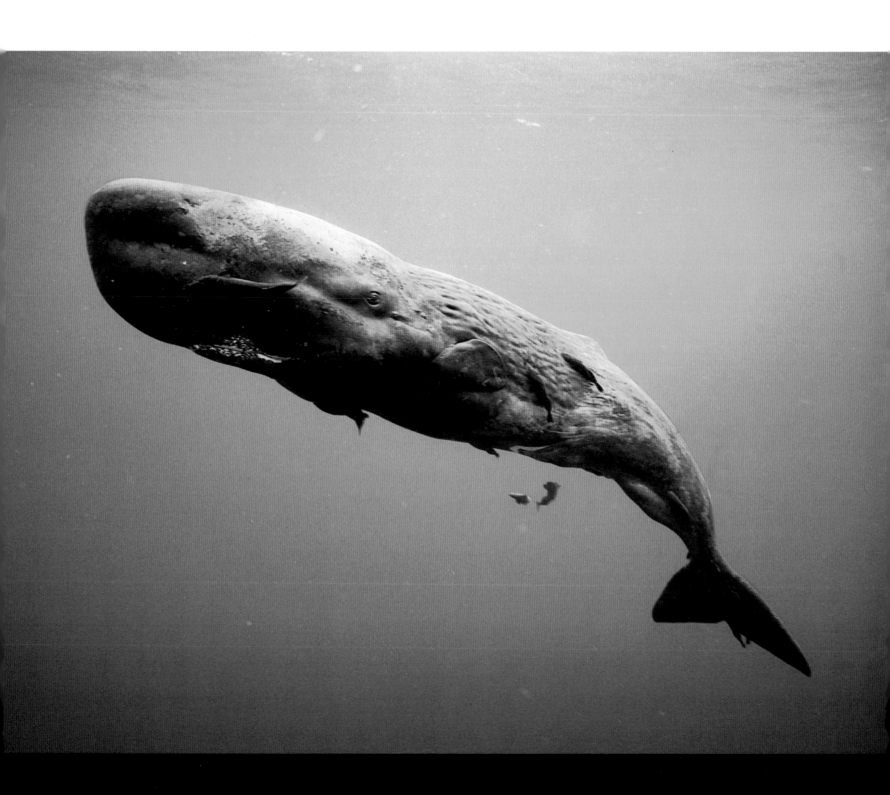

A sperm whale.

DOMINICA

camera with 7248 film, mount the 5.9mm lens and an 85 filter. We're on our way back." o Fifteen minutes later we were climbing up the swim step of the *Conception*. Michele and Mark were waiting on the stern with my camera. But before going back down, I wanted to change my diving equipment. Many divers think that silent, bubble-free rebreathers are ideal for filming whales. But it's been my experience that the best encounters with whales happen when the animals become curious and come to the divers. There's no sense in being stealthy if you're relying on the animal seeking you out underwater. Better to be loud and entertaining. o Bob and I dropped off our rebreathers and donned standard scuba tanks. Mark and Michele were already suited up and hoping to have an opportunity to dive. We all loaded into the *Conception*'s tiny inflatable and headed off toward the kelp. By the time we got there, the whale had submerged. "He was right here a minute ago," said Roger Wood, the *Conception*'s captain. "You want me to keep looking?" o "No," I said. "He'll either find us or we're wasting our time. This is close enough." o Bob, Mark, Michele, and I dropped sixty feet down to the sandy floor outside the kelp. We'd been standing on the bottom for only five minutes before I began to feel really foolish, realizing how unlikely it was that the whale would come over and give us a look. A minute later,

I was thinking about returning to the surface when the water ahead darkened and a whale materialized. I was very surprised. But what happened next completely amazed me. The whale swam a lazy circle around us, and then it rolled onto its side and began sucking in the sandy bottom. The gray whale was feeding! This is just the kind of animal behavior that I dream of capturing on film. o For several hours the young gray whale moved over the bottom, filtering sand through its baleen right in front of our cameras. I managed to return to the *Conception* twice, reload my camera, and find the gray whale waiting when I got back in the water. The first time I swam back to reload, the whale followed me back to the boat. When I was ready to dive again, I didn't need a ride in the inflatable. The whale was right below the swim step. o Just what the gray whale was feeding on remains a mystery. Normally, gray whales spend the summer in the Bering Sea feeding on amphipods and other crustaceans that live buried in the silt. But here at Anacapa, the sand held few crustaceans. Dr. Jack Engle suggested that gray whales may feed on tube worms, and indeed, there were plenty of those in the sand. But he agreed that tube worms would be a poor substitute for amphipods. o Michele and I were the last ones in the water at the end of several hours of swimming with the young gray whale. We were both tired. Although

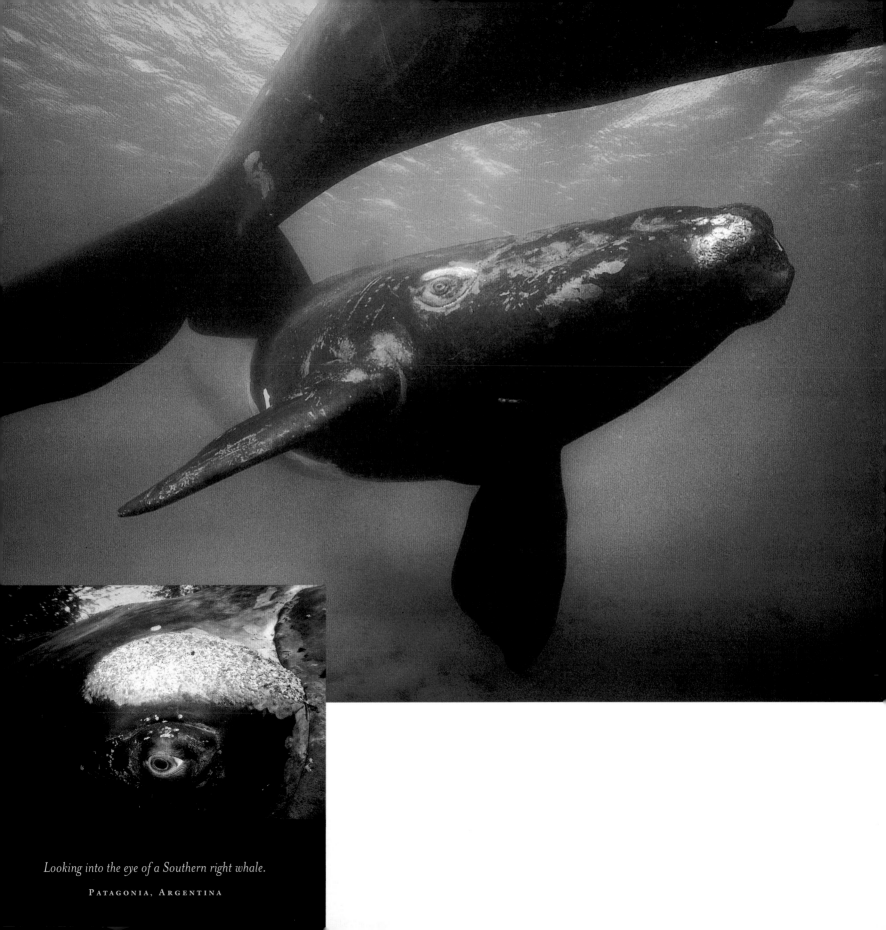

Looking into the eye of a Southern right whale.

PATAGONIA, ARGENTINA

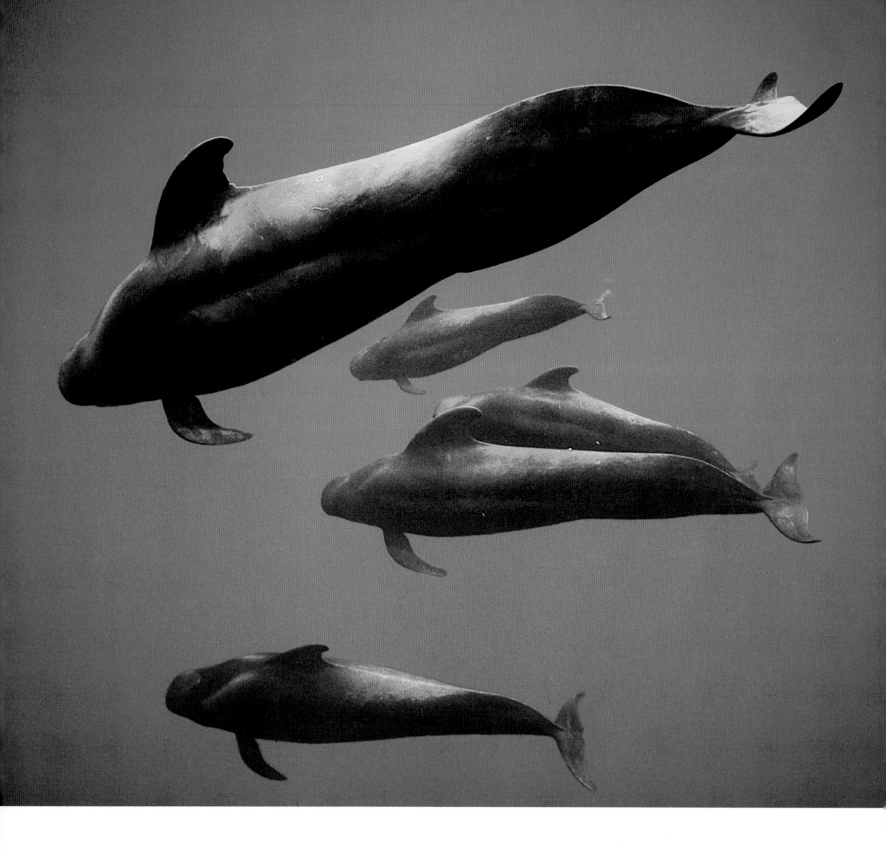

the whale was obviously attracted to the divers, it was still a lot of work positioning ourselves for the best angle as the whale fed in the sand. Now, finally, our cameras were empty. Michele gave me a wave and began swimming back to the boat. I decided to remain behind for a minute or two. Unfortunately, camerawork often requires so much concentration that I find I often return to the surface without really absorbing the experience. So this time I decided to stop, rest on the sand, and give the animal a good unhurried look. When I stopped swimming, I fully expected the whale to swim away. Instead, the whale seemed to sense my change of mood. It turned and moved slowly toward me. Then to my slack-jawed amazement, the animal came to rest in the sand six feet away. It was just lying there looking at me. I could not believe it! A thirty-foot whale lying motionless in the sand just beyond arm's reach and staring at me! I moved forward a few feet. o There are two reasons not to scratch the nose of a whale. At the time I knew of only one. This obvious reason is that the whale might not like it. In this case, however, my instinct was telling me that the whale would not be afraid. I moved closer, reached out, and gently began rubbing the large rubbery nose. The whale reacted by leaning toward me in an effort to increase the pressure of my massage. I couldn't believe this was happening. It was a magical moment. o One amazing thing about magical moments is how quickly they become boring. Most people, especially those who love whales, would probably say they could have enjoyed that moment for hours. But I doubt they'd find reality so idealistic. In fact, after only five minutes or so,

I had had enough and decided to do something different. It's not that I wanted to go back to the boat and have a burger and a beer. I just wanted to move on and maybe look more closely into the whale's eye or perhaps scratch a different place. I took my hand away and began to move. That is when I learned the second reason not to scratch the nose of a whale. The whale might like it. The whale might not want you to stop. o As soon as I stopped rubbing, the whale lurched toward me. I tried to back up, but the whale moved forward again and began nudging me with its nose, much like a dog nudges you when asking to be scratched on the head. But the whale was much larger than any puppy, and soon I found myself tumbling across the bottom as the gray whale continued to bump me with its rubbery snout. It was funny at first, but as the bumps became more violent and I found myself tumbling completely out of control across the seafloor, I began to get concerned. o Suddenly I found myself lifted six feet above the bottom. As the bubbles cleared, I saw that the whale's nose was between my knees. I realized that the next blow would be, to say the least, uncomfortable! As the nose came up, I manage to roll off to the side and tumble down the whale's flank. When I turned to see what was coming next, I found the whale moving away. o As the gray whale drifted away, he seemed to hesitate for a moment, as if to say, "Follow me." But I was low on air and would never have been able to keep up anyway. I knelt on the bottom for a minute longer as the whale turned and slowly disappeared from view. Then I turned the other way and began swimming back to the boat. o

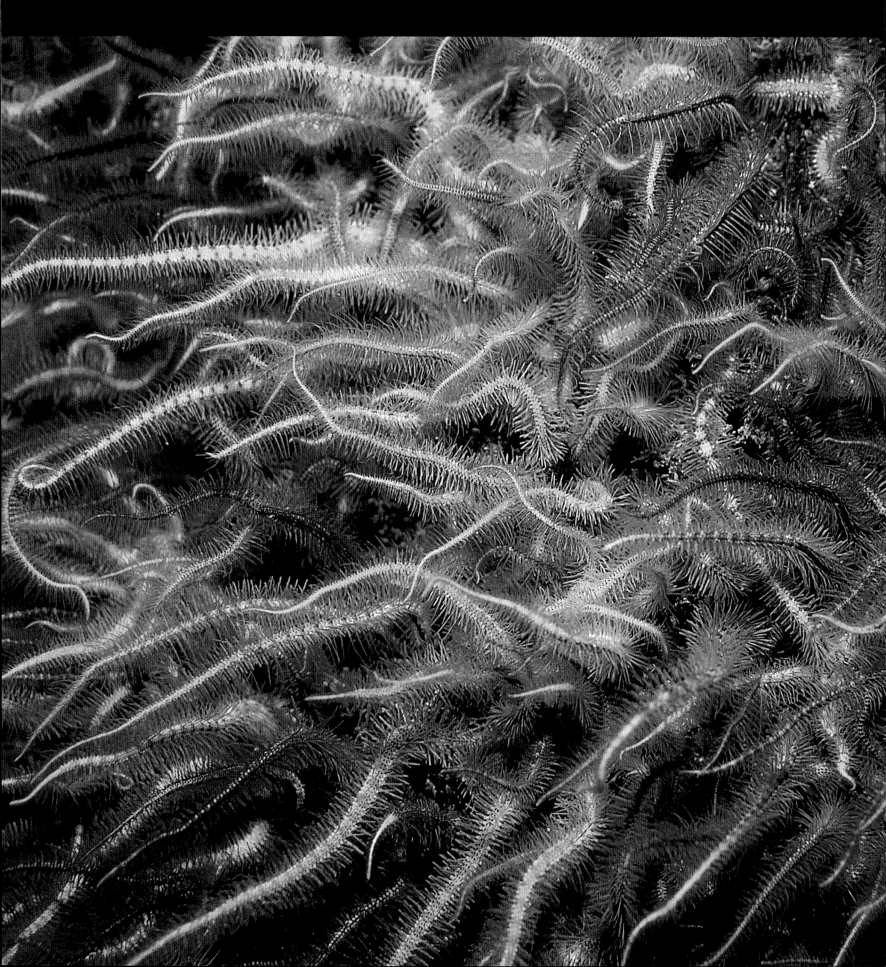

STAR GARDENS

◐ I stepped off the stern of the dive boat, purged the air from my dry suit, and began falling toward the seafloor eighty feet below. Visibility was about forty feet, which is typical for the California Channel Islands, and during the first half of my descent I could see nothing below but a featureless gray void. I imagined that it felt like skydiving through clouds or into evening fog. ◐ I was hoping to find opalescent squid eggs covering the bottom. If I could find the eggs, then we would know where to anchor the boat in preparation for filming a nocturnal squid spawn. All morning I'd been alternating with other members of our film crew in making these quick scouting dives. But after unsuccessfully searching for squid eggs much of the day, we were beginning to think our squid filming plans would have to change. ◐ As I dropped through forty feet and the bottom began to materialize, I immediately realized I was in the wrong place again. Opalescent squid lay their eggs on a sandy floor. From thirty feet above the bottom, I could see that the bottom was not sand. It was hard, rocky reef. I also immediately noticed that the reef looked strange. It appeared to be covered with feathers! ◐ I had never seen anything like it. For a moment the sight was strangely disorienting. Although I'd been diving in California waters all my life, this was something entirely new: an ocean floor covered in feathers. ◐ I hit the bottom, landing gently on my knees, and looked around in amazement. Of course, I was wrong about the feathers. Even so, this was a very strange place. The reef was completely covered by a thick layer of brittle starfish. Every square inch was

carpeted by a two-inch mat of these delicate and
brilliantly colored stars. Millions of featherlike arms
extended up and into the current in an effort to
capture plankton as the sea wind swept over the reef.
Certainly, I was familiar with brittle stars. They
are common in California waters. But to find them in
such staggering number was something new. They
completely dominated the ocean floor. ● I lifted off the
bottom and began swimming. The brittle star garden
extended in all directions as far as I could see. I couldn't
believe I had been diving these waters for so long and
had never seen this before. It's part of what I love about
California diving. The variety seems almost endless.
● In the distance I saw a large sheep crab marching across
a patch of sand between two rocky ridges. Even
the sand was thickly covered in brittle stars. The crab's
outstretched legs measured nearly three feet across
and the top of his head rose twelve inches above the mat of
brittle stars. As he moved across the bottom, the
carpet of sea stars came alive, squirming and writhing
beneath his pointed feet. ● I noticed that there
was something odd attached to the top of the crab's head.
When I got closer, I realized that a small forest of kelp
plants had begun growing on the crab's shell. Crabs, like
all other crustaceans, must shed their hard shells
regularly in order to grow. But when sheep crabs get old,
they not only stop growing, they also stop regularly
shedding their shells. Their last molt is called their
terminal molt. The crab's life often ends when it
becomes so overgrown with encrusting marine life that the
crab can no longer move. ● Looking at this crab, it

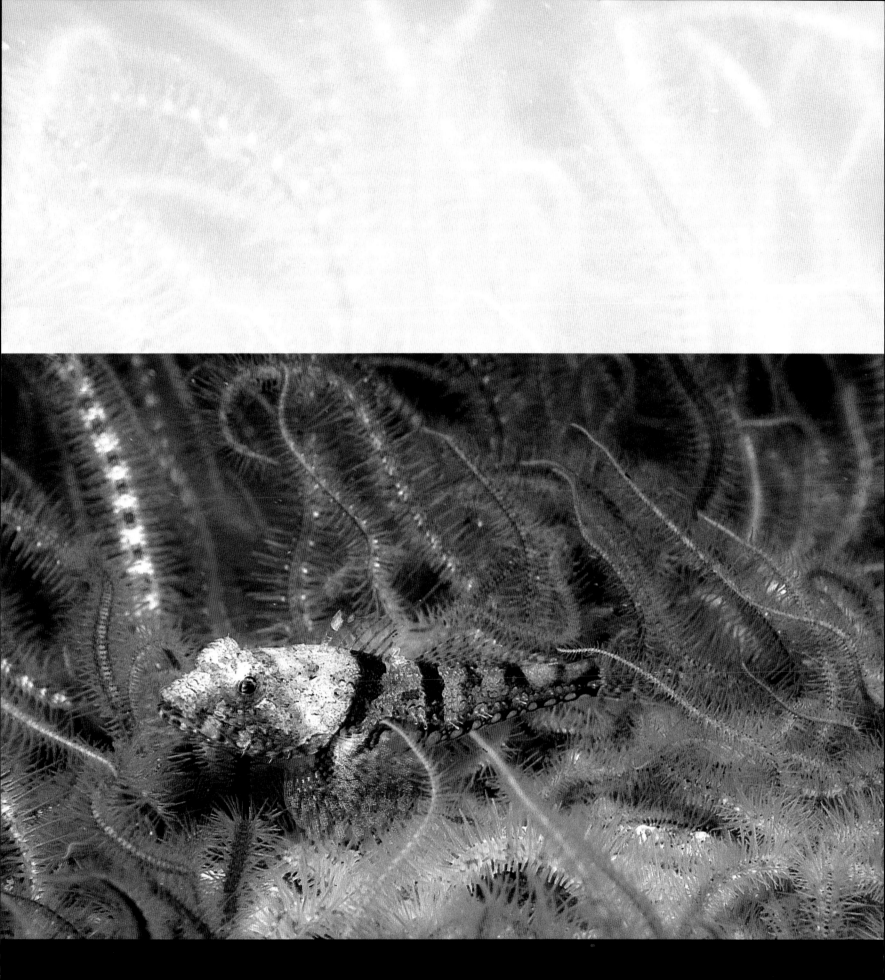

A sculpin nestled in a field of brittle stars.

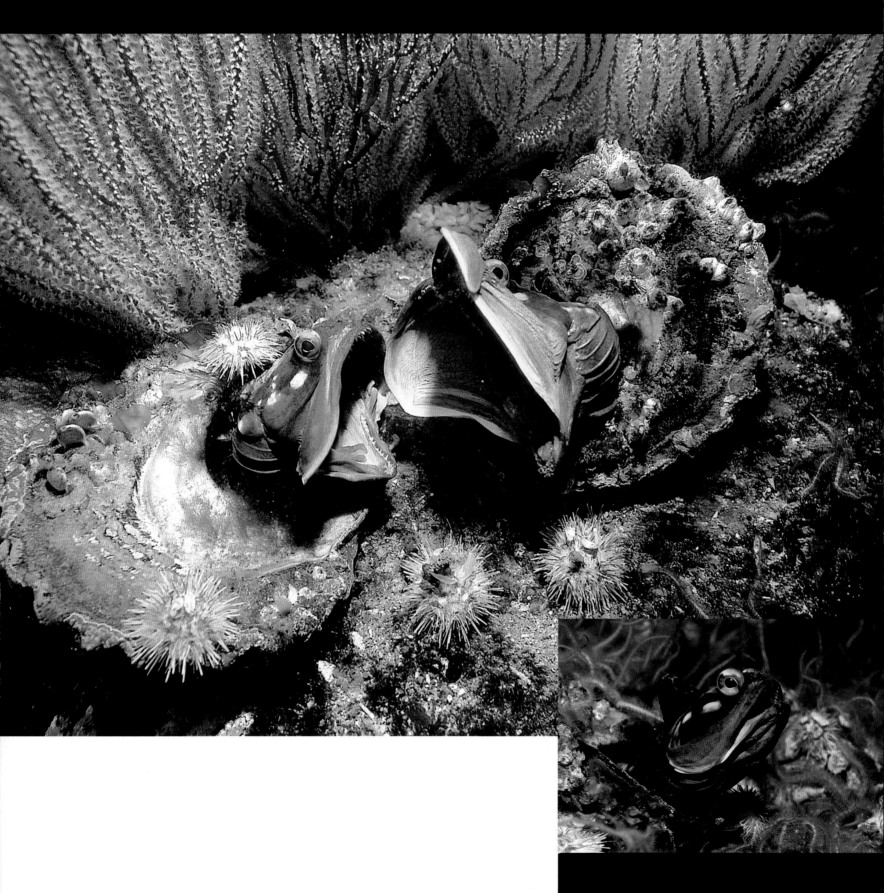

Sarcastic fringeheads engage in territorial threat display.

A sarcastic fringehead checks out the reef.

CALIFORNIA CHANNEL ISLANDS

became obvious that he was wearing his terminal molt. He was already heavily encrusted. Large barnacles grew on his back and legs. Some had grown large enough to begin limiting the articulation of his knees. But I realized that the barnacles were not the crab's greatest concern. The small kelp plants that had begun growing on his head were the real problem. ● Kelp may grow more than one hundred feet high. The plants are supported not by rigid trunks but by small gas bladders at the base of each leaflike blade. These floats lift the plant toward the surface while its base stays attached to the reef by a rootlike structure called a holdfast. The kelp growing on the sheep crab's head foretold his fate. Soon the plant would develop gas bladders as it reached for sunlight. As the kelp grew and more gas bladders developed, the plant would become increasingly buoyant.

Each day the sheep crab would find himself a little lighter on his feet. Soon he would find it difficult to maintain contact with the reef. Then, finally, one day the buoyancy of his little kelp forest would overcome gravity. He would lose contact with the ground one last time and then simply lift off and drift away. ● For several days we explored the star garden at the north end of Santa Cruz Island. Later we discovered brittle star gardens at other nearby islands. At Anacapa Island we found an amazing species of fish living in burrows on a sandy floor carpeted with brittle stars. The fish is called a sarcastic fringehead. Such a bizarre name certainly implies a fish with character. The sarcastic fringehead more than lives up to his name. ● On the last day of our expedition at Anacapa Island, I decided to drop down and take some still photographs of animals in the brittle

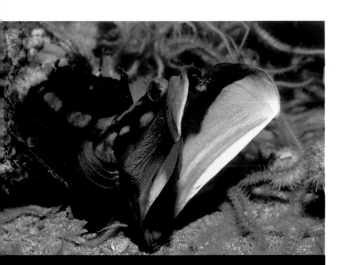

A sarcastic fringehead gives a warning threat display.

CALIFORNIA CHANNEL ISLANDS

An Irish lord contemplates a meal of crab.

PORT HARDY, BRITISH COLUMBIA

This Irish lord has nabbed its meal!

star garden. I was following the anchor chain as it snaked across the bottom in sixty feet of water when I came upon a sarcastic fringehead living in an abandoned turban shell. I decided to settle down and take a few shots. By the size and color of his head, I decided the fish was a male. I had only been settled for a few minutes when another male fringehead swam up to challenge the fish I was photographing. ❥ The threat display of the sarcastic fringehead might be one of the most terrifying sights known to man if the fish were the size of a large dog instead of the size of a chipmunk. Still, the show is spectacular. The pair of fish confront each other and open their mouths, flaring bright yellow jaws. It's the size of this animal's mouth that's so remarkable. If a human had a mouth as big as a sarcastic fringehead, relatively, then swallowing a twenty-one-inch color television would be easy. The sarcastic fringehead can open its mouth to a diameter that is nearly half the length of its body! Surprisingly, there is no actual biting involved in a sarcastic fringehead confrontation. Battles are won strictly by displaying a bigger mouth than one's opponent. ❥ After watching this amazing display for a few minutes, I noticed that two other fish were approaching. They were smaller than the two I had been photographing, and I quickly realized they were females. Upon seeing the approaching females, the male fringeheads stopped displaying and seemed to settle down about eighteen inches apart. Then each female swam over to a male and curled up next to him. ❥ I knew I was witnessing some very intimate ritual of fringehead society. But I never discovered what it

was leading up to. I lay on the bottom and watched the four fish for a half hour, wondering what I might capture on film if I studied and filmed these fish for three or four days. But our charter would be over that afternoon and I knew my crew was already back on board packing up. So I lifted myself off the bottom, left the fringeheads and my unanswered questions behind, and followed the anchor line back to the surface. ❥

❥ Most sport divers prefer diving on tropical coral reefs to diving the cold, often murky waters of temperate climates. In the tropics, the water is warm and the reef is often covered with colorful sponges and corals. Tropical fish come in a dazzling variety, each more flamboyant than the last. Certainly, the coral reef is a beautiful place to dive and to capture underwater images with motion pictures or in still photographs. However, it may not be the most beautiful place in the sea. Diving is more difficult in the colder waters of Southern California's Channel Islands. But the colors blanketing the reefs in a brittle star garden rival any coral reef I've seen. The farther north (or south) one travels from the tropics, the colder and more difficult the diving becomes. Underwater photography becomes more problematic as well. ❥ The difficulties of capturing good photographic images on reefs in cold waters are often complicated by poor water visibility and a lack of sunlight. Indeed, the cold reefs of Canada's British Columbia seldom experience illumination stronger than twilight. Often, plankton grows so densely on the surface in these waters that darkness is constant just a few feet below the

116

surface. But for those willing to accept the dark, often murky water and the bone-chilling cold, these reefs offer ample reward. o Of all the reefs I've explored throughout the world's oceans, I've found no place more spectacular than the reefs at the northern end of Vancouver Island. The most beautiful of these we found on a submerged reef called Hunt Rock, which lies exposed to the weather several miles offshore. The current rages over Hunt Rock like a river, and much of the time diving is impossible. But at high and low tides, there is a current-free window that allows brief visits to the reef below. o Michele and I dropped off the stern of the *Sea Venture* and descended quickly toward the summit of Hunt Rock. The tide had not yet peaked and the current was still running strong. We quickly drifted away from the rock as we descended. But at a depth of seventy feet we reached the lee of the rock, which was shadowed from the current. Here, behind the rock, we could feel the water swirl as turbulence spilled over the reef. As we got closer to the rocky wall, the turbulence subsided and the powerful movie lights we carried began to illuminate the life growing on the reef. o As we approached Hunt Rock, our lights revealed colors that were unbelievable. There were spectacular sponges and soft corals. Red and blue tube worms grew three feet high, looking like strange undersea dandelions. Giant barnacles, as large as your fist, extended orange legs into the passing current to capture drifting plankton. But mostly, the reef was dominated by an amazing assortment of sea anemones and a dozen or more varieties of starfish. This, too, was a starfish garden. o Michele and I made our way through a deep canyon running

The mouth of an anemone.

PORT HARDY, BRITISH COLUMBIA

117

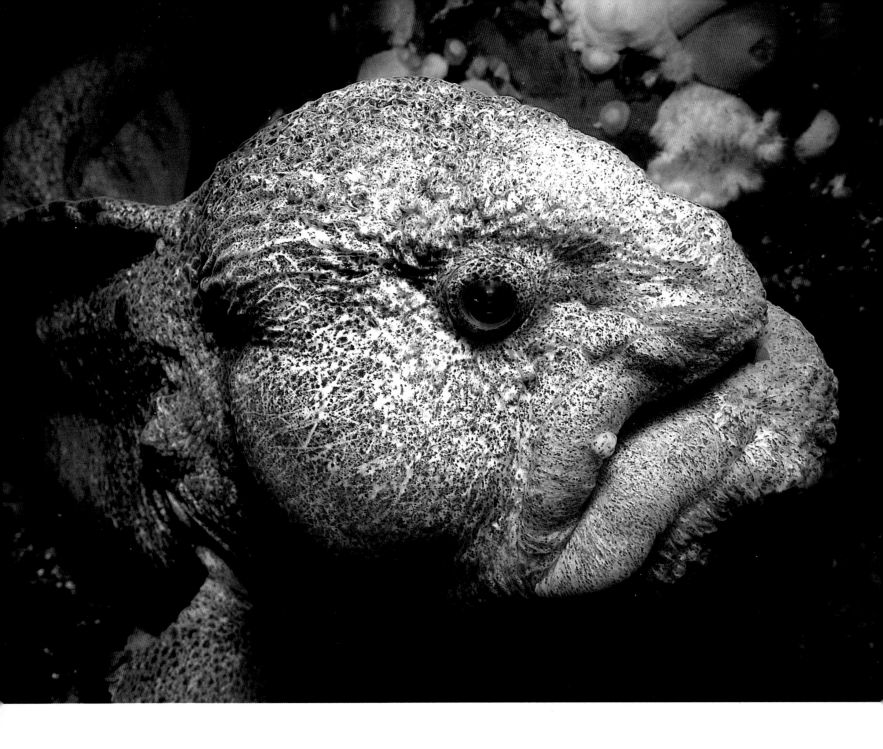

through Hunt Rock. Every inch of the bottom was covered by huge red, white, pink, and orange anemones that grew like a carpet of wildflowers. Moving slowly between the anemones were bright orange sun stars, blue sun stars, orange and white leather stars, and many others. o In this environment, any convincing camouflage requires that an animal be as brilliantly colored as the reef upon which it hopes to conceal itself. The most successful of these cryptically colored creatures is a fish called an Irish lord. As Michele and I moved along the canyon, Irish lords suddenly revealed themselves and moved out of our way. Michele was completely incapable of passing one by without stopping to photograph it. It didn't matter that during the two weeks we'd been diving here she had already taken hundreds of photographs of this species. But every Irish lord was a different color and, to Michele, each new fish seemed more beautiful than the last one she'd photographed. Finally, at the end of the canyon we found what we'd come here for. We found Hunter. o Few animals are more charmingly ugly than a wolf eel. Hunter's eight-foot body seemed composed of only two parts: an enormous head and a long tail. Hunter's head was considerably larger than Michele's, and most of that size was dominated by a very robust set of crushing jaws. Wolf eels use these jaws to crush and eat sea urchins, spines and all. This is what I had come to Hunt Rock to film. It seemed like an ideal place. Hunter was not unfamiliar with divers. Sport divers had been feeding him sea urchins for years. Since Hunter was entirely unafraid of divers, I had thought that filming him

foraging on the reef and preying on urchins would be easy and that our presence wouldn't interrupt his natural feeding behavior. It didn't turn out that way. o Hunter had become lazy. He was only willing to eat urchins that were broken in half and served to him with considerable deference. I tried placing some urchins in the vicinity of his den and hoped to film the eel feeding on them when he came out to hunt. But popularity had gone to his head, and Hunter was no more inclined to crush his own urchins than the Queen of England was to do her own grocery shopping. For more than an hour we watched as the eel arrogantly ignored the urchins that I had placed on the reef near his den. o Eventually, Michele decided to provide room service. She cracked open a large red urchin and offered half to the eel. Hunter swam out of his den and allowed himself to be cradled in Michele's arms as he accepted the meal. I was again struck by how often such formidable sea creatures can be so gentle. Michele gave Hunter a quick scratch on his chin before he carried his prize back to his den. o A moment later, another wolf eel emerged from Hunter's den. This female was smaller and darker than Hunter. She accepted the other half of the urchin without hesitation and then returned to her mate's den surrounded by the beautiful garden of anemones and sea stars. She was known as Huntress and had been living in Hunter's den for many years. Wolf eels mate for life. o On the way back to the boat, I noticed a china rockfish resting next to a group of white-plumed anemones. These beautiful black-and-yellow fish are common in these cold waters, and I wouldn't have noticed this one except that its

face seemed distorted. So I moved closer to see what
was wrong. Upon close inspection, I realized that the fish
had recently eaten a very large crab. But the crab was
not giving up without a fight, and before disappearing down
the rockfish's throat, it had managed to grab the fish's
lower lip with one of its pinchers. The fish was left with
the crab stuck in its throat and a large pincher latched
onto its lip. ⦿ The china rockfish didn't seem especially
distressed by the situation. Indeed, after a few
moments I realized that the fish was optimistically watching
another crab slowly moving over the reef nearby.
I mounted my movie camera on its tripod and was preparing
to film this comical confrontation when an Irish lord
suddenly emerged from its hiding place and devoured the
crab. ⦿ Of course, I missed the shot. But I realized
that any crab moving in the open was likely to attract
attention. Bob and Mark joined Michele and me as we
began searching for another crab. Not surprisingly, crabs
were rather scarce on Hunt Rock. Finally, we found
one, and I quickly set up my camera and focused the lens.
⦿ The bright movie lights disturbed the crab, and as
he began to retreat from the glare, his movement attracted
an Irish lord. The fish attacked the crab, but it began
to look like the crustacean was too large for the fish to
swallow. For a moment, the crab seemed to have a
chance to survive as it grasped the fish's lip with its pincher.
But after a few seconds, the crab's pincher lost its grip
and disappeared down the Irish lord's throat. I turned
my camera off and looked at my wife and friends.
Although our mouths were occupied by large rubber
mouthpieces, I could tell that everyone was smiling. ⦿

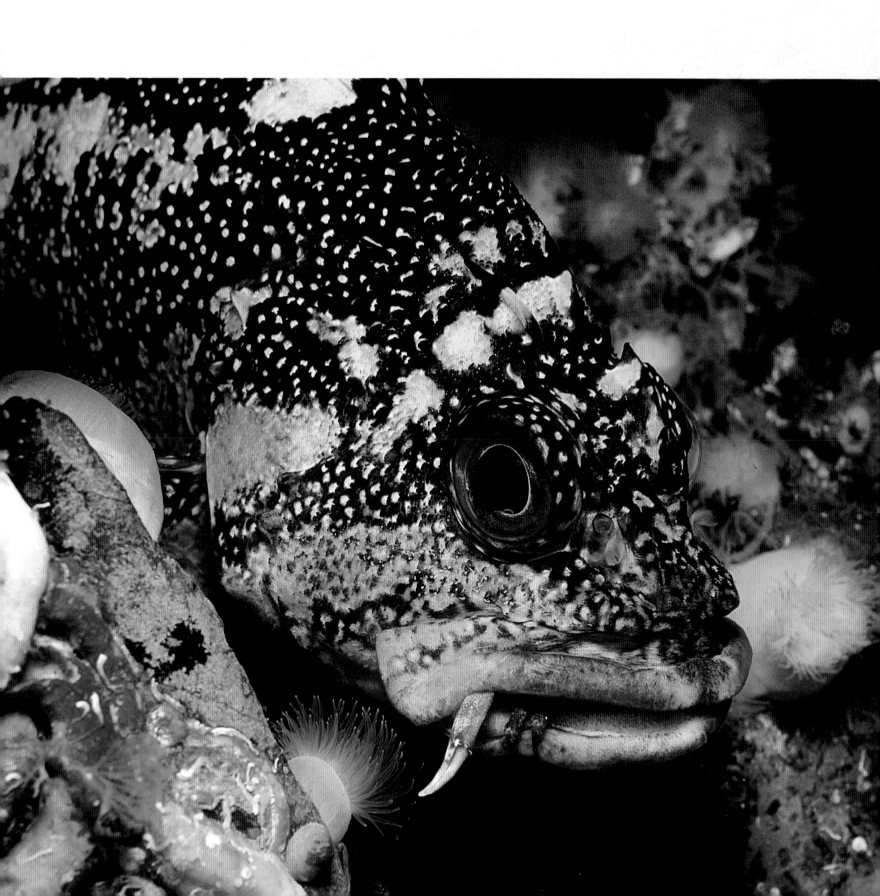

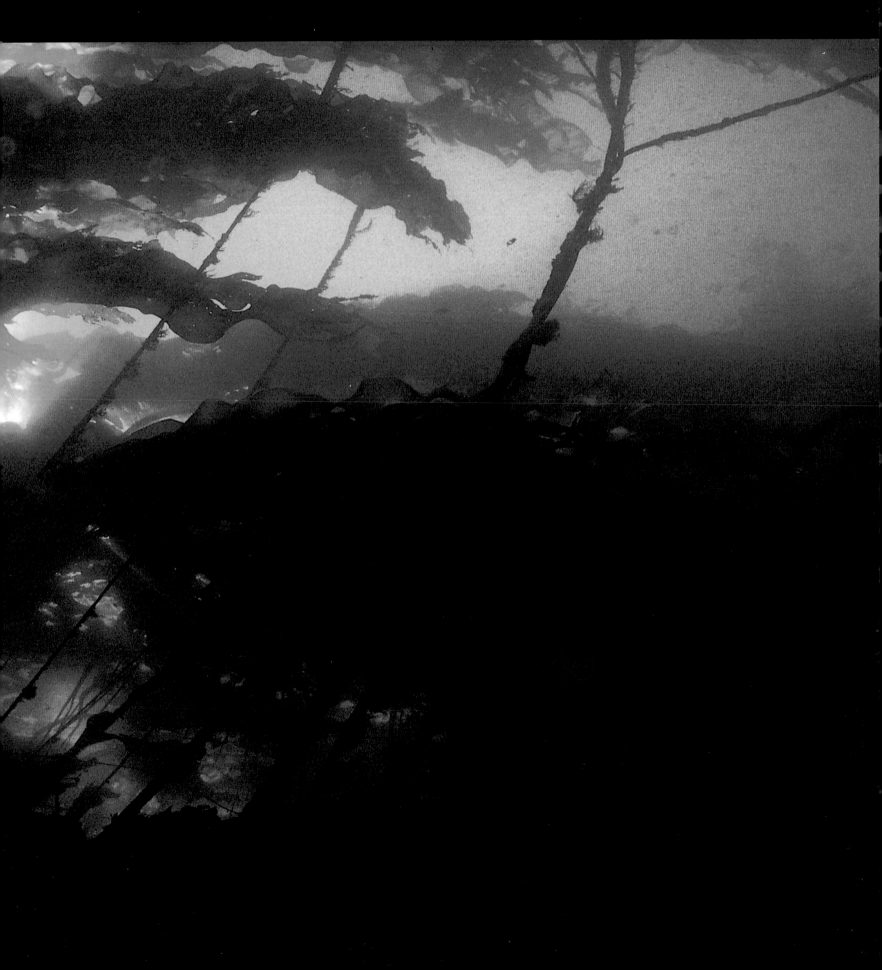

A current-swept kelp forest.

PORT HARDY, BRITISH COLUMBIA

VENOM

● The orange glow of firelight burning at the edge
of the rain forest spilled out across the water, forming a
crimson path leading to where I stood on the stern of
the vessel called *Telita*. There was a small Papua New Guinea
village buried deep in the trees, and I wondered what
those people thought of us jumping into the sea with our
cumbersome dive equipment and bright underwater
lights. ● Bob, Mark, Michele, and I stepped off the stern
and began falling slowly through the inky darkness.
As we approached the bottom fifty feet below, our lights
revealed no coral reef. The bottom here was fine silt
and sand. New Guinea may seem a long way to travel to dive
in mud. But there are some very strange creatures to
be found in this kind of habitat, especially at night. Bob
Halstead, *Telita*'s owner and our guide, calls it muck
diving. ● We were hoping to film the nocturnal hunting
behavior of cone snails. Some species can kill small
fish almost instantly with their venomous proboscis. But
that plan changed when I put my hand down on
a demon stinger. ● The demon stinger, also know as
Inimicus, is one of the strangest fish in the sea.
It's about six to eight inches long and has large, beautifully
colored pectoral fins that open like butterfly wings.
The demon's face is indescribable, looking more like the
creation of a child using a ball of clay and a pair of
pliers than the face of a living creature. ● The weirdness
of the demon stinger is accentuated by the way it
moves. Instead of using its tail to swim like a normal fish,
it curls its tail up against its side and drags itself
through the mud with hooklike fins that work like legs. This
method of travel seems very inefficient. Hermit crabs

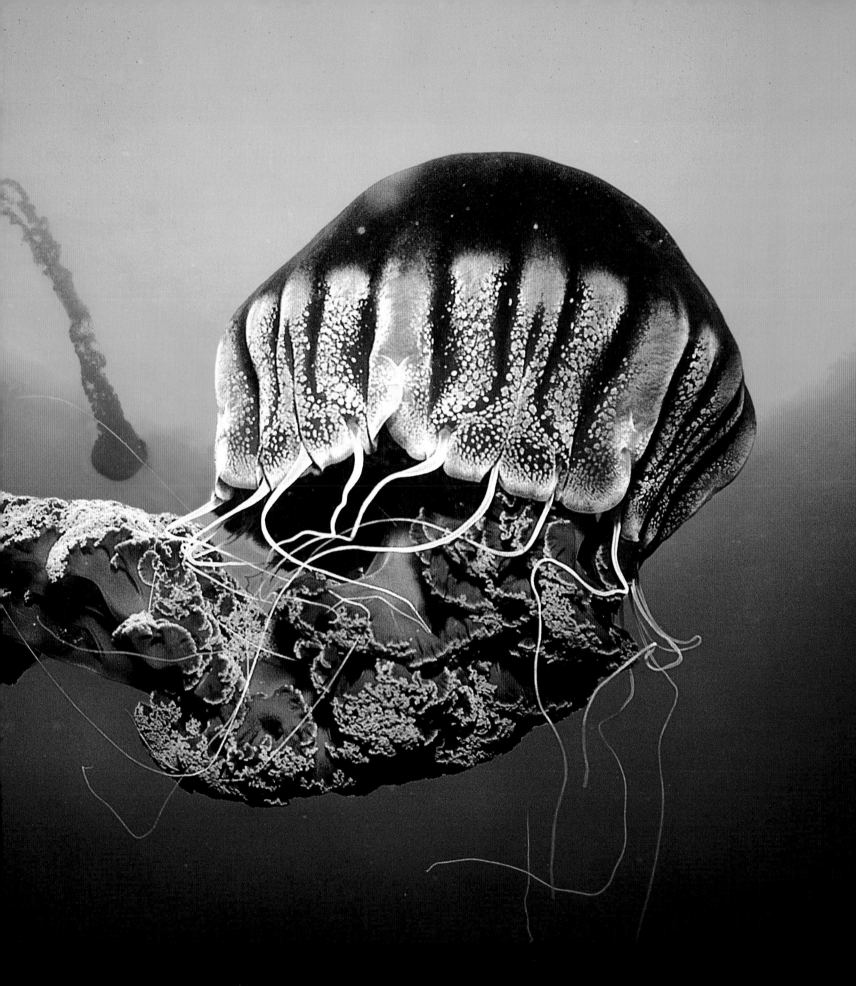

An undescribed species of jellyfish.

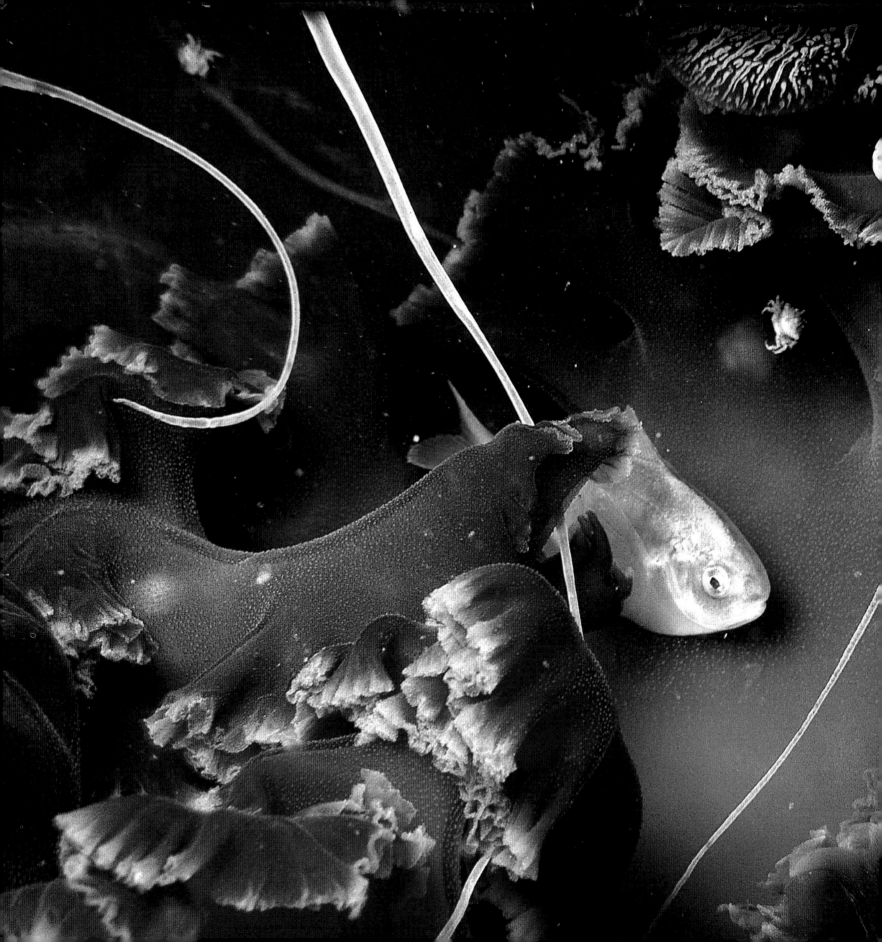

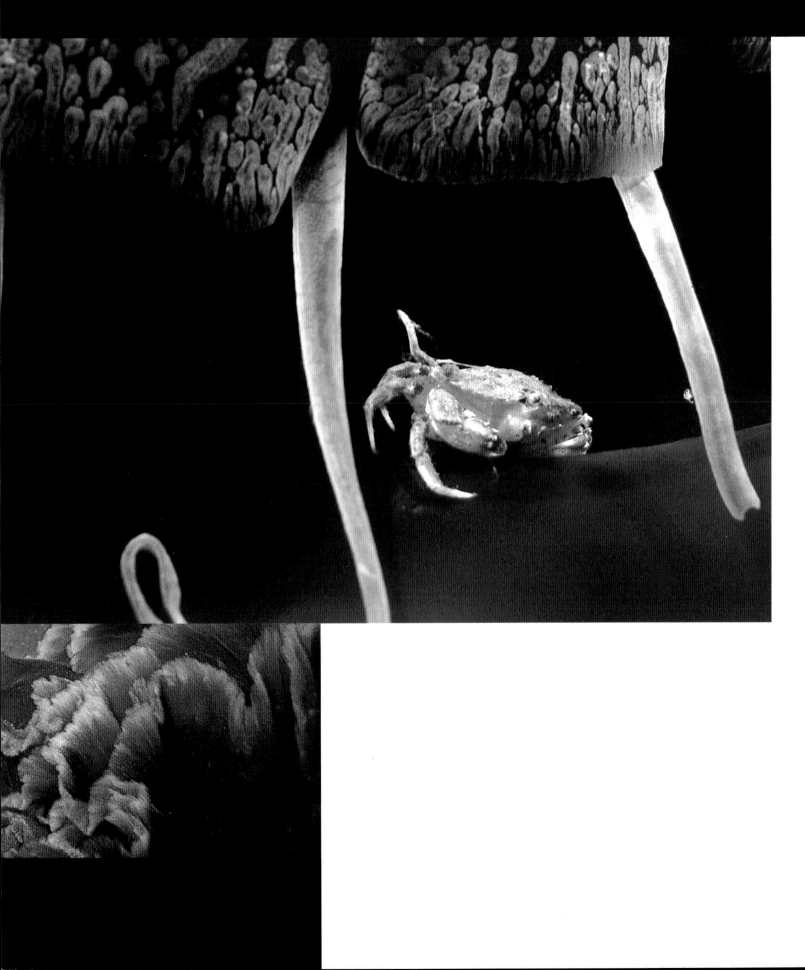

A slender crab living beneath the bell of the undescribed jellyfish.

127

are galloping thoroughbreds in comparison. But the demon doesn't need to move fast. He relies on ambush to capture prey. And when he wants to, the demon can become invisible. He accomplishes this magical feat by partially burying himself in the mud. Then, using his butterflylike fins, he flips silt up on top of his head. The only parts that remain exposed are his eyes, his mouth, and a row of savagely venomous spines that jut from his back like the quills of a sea urchin. Partially buried in this way, the demon is indistinguishable from the clumps of algae and patches of decaying rain forest vegetation that litter the muddy bottom here. ● Because the demon stinger was invisible, I didn't see him when I put my hand where he was buried. I felt him before I saw him. It's surprising how many times I've accidentally put my hand down on a stingray or hidden scorpionfish and not been stung. There are probably two reasons for this. One is that the animals really prefer escape to venomous retaliation. The other reason is that, when diving at night, if you put your hand on something unseen that squirms, the speed at which your reflexes cause withdrawal are exceeded only by the speed of light. Whatever the reason, the only pain I felt after touching the demon was the muscle strain caused by yanking my hand back at warp speed. Somehow I had missed the venomous spines and had probably placed my hand on his face or tail. When I saw what I had put my hand on, however, I did experience a brief wave of nausea.
● The demon stinger seemed little bothered by the encounter. He crawled a few feet away and then promptly buried himself again and disappeared. I quickly found

An anemonefish watches from
the sanctuary of its host anemone.
SOLOMON ISLANDS

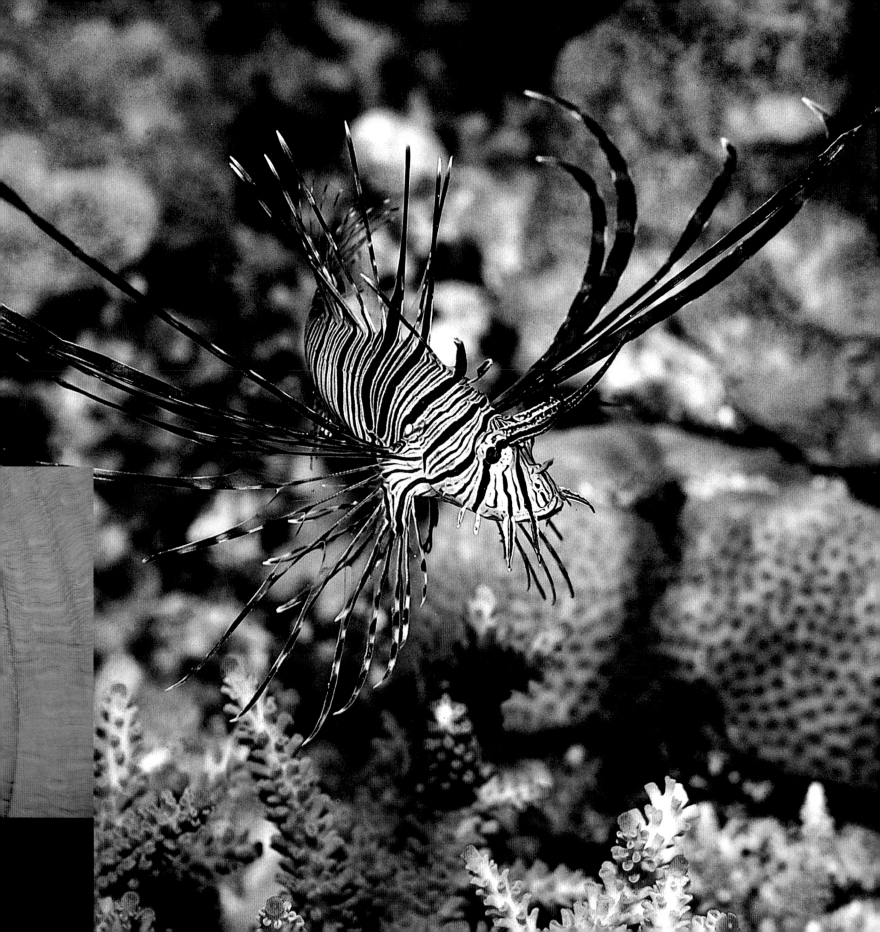

a broken piece of seashell and marked the spot.
Filming a demon stinger at hand immediately seemed like
a better idea than hunting for cone snails in the bush.
Perhaps we could even get a shot of the demon preying on a
passing fish. ● Our bright movie lights often attract
fish, which tend to bumble around in front of the lights in
a state of disorientation. Other fish are quick to take
advantage. We'd discovered that lionfish love our lights.
While night diving in New Guinea, groups of these
venomous beauties often followed us around, snapping up
fish that our movie lights exposed. I hoped that our

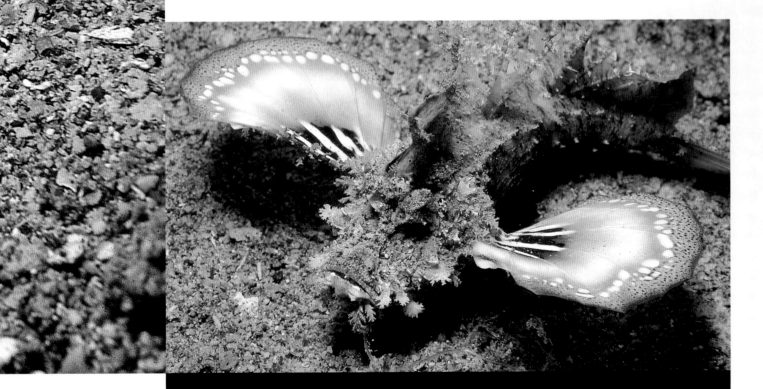

A demon stinger leaves its hiding place in the sand.

PAPUA NEW GUINEA

concealed demon would react similarly. So we settled down to see what might happen. ● After a few minutes, a small school of tiny fish began to gather. But that's not all the lights attracted. Within minutes, each of the two movie lamps was surrounded by a fast-swimming swarm of small red worms. The rapidly growing swarm buzzed around the lights like a hoard of hungry mosquitoes. Soon the light illuminating the demon's hiding place became blood red in color. Bob and Mark began fanning the lamps with their hands, blowing the worms away. But this just caused the size of the swarm to enlarge until the worms formed a buzzing cloud around our heads. ● The sensation caused when one of these worms gets inside your ear is not to be envied. As the worm zooms around and bangs against your eardrum, it sends chills running down your spine and up the back

of your neck. This is followed by an uncontrollable, reflexive shaking of your head. Within a few minutes we all had worms in our ears. ● The worms were driving me nuts. But at the same time, I saw small fish on the sand feeding on worms and coming very close to the demon's ambush. If I could just hold on, I might get the shot. Occasionally, as fish came especially close to the stinger's hiding place, I would turn the camera on and let it run. But the demon never saw fit to attack. ● Bob swam away and I thought for a minute that the worms had gotten the better of him. But soon he returned, slowly herding a small fish with his cupped hands. He'd found the fish sleeping in the sand, and in this nocturnal state, it had allowed itself to be gently moved across the bottom. I turned the camera on as Bob herded the fish up to the demon. But I couldn't hold the camera still.

A sea snake.

A venomous scorpionfish.

SOCORRO ISLAND, MEXICO

At first I thought the camera's shaking was caused by the constant chills I felt as worms banged against my eardrums. But then I realized that Mark's frantic effort to wave the now huge swarm of worms away from the lights was causing the camera to rock back and forth. I gave him a signal to cool it for a moment as Bob brought the fish close to the demon's mouth. o The camera was rolling as Bob's tiny fish came to rest on the nose of the demon stinger. Whether blinded by the lights himself, intimidated, or just not hungry, the demon stinger showed no interest in accepting an easy meal. I turned the camera off in disgust. The huge swarm of worms might have ruined the shot anyway. And they were driving us all crazy. I turned around to see Michele, Mark, and Bob all waving at their ears as if fending off a swarm of killer bees. o I had had enough. I turned back to the camera and lifted it from the bottom. As I did so, I noticed a small humpback scorpionfish walking down the slope toward the demon. o The humpback scorpionfish is about the same size and almost as bizarre as the demon stinger. Instead of swimming, it hops along on its large pectoral fins. Upon seeing the scorpionfish, the demon stinger leapt from its hiding place and gave chase. o I watched for a minute more as the demon, dragging itself by its hooklike fins, pursued the hopping scorpionfish down the slope. So much

for the predation sequence, I thought. I picked up the camera and began swimming back to the boat. As I shook the last of the worms out of my ears, I thought, What a stupid fish. It was obvious that the demon stinger thought the scorpionfish was one of its own kind and had fallen in love. It was chasing the scorpionfish and hoping to get lucky. o It wasn't until I was back on board and my mind had settled down after the ordeal with the worms that I realized how badly I had screwed up. A demon stinger attempting to seduce a humpback scorpionfish would have made a wonderful sequence. I had seen it happening and responded by picking up my camera and swimming away. Certainly, I was distracted by the worms banging against my eardrums. But that excuse hardly seems adequate in retrospect. I've been thinking about that lost opportunity ever since. o

o I almost never make a dive with my movie camera without a specific sequence in mind. But when opportunity presents itself, it pays to be flexible. While filming the predation of sea urchins by bat stars at the Coronado Islands near San Diego, I looked up to see an enormous swarm of giant purple jellyfish. Some were so huge that their tentacles trailed thirty feet behind a pulsating bell two feet in diameter. Although I've been diving California waters for more than thirty years, I realized that I'd never seen this variety. At the time, I didn't know that this jellyfish was special. In fact, it was a species that no one had ever seen before. o I immediately realized that these jellyfish had great potential as film subjects, and it didn't take long for

me to drop my plans for filming sea urchins and starfish. Actually, almost anything would have been a more exciting subject. o Certainly, the jellyfish were beautiful. Their dark purple bells were accented with pink and white markings, and the tentacles trailing behind were translucent shades of vermilion. At first I thought the jellyfish would simply make a colorful interlude in my film. But in the days that followed, a compelling story developed. o A community of strange creatures traveled within the venomous folds of each jelly's tentacles. Silvery medusa fish darted between trailing tentacles and hid behind the pulsating bells. One jellyfish had an especially strange companion. A large crab was riding on its bell. The crab carried two soft tassels attached to the tips of its rear legs. As I filmed the crab, it waved these tassels wildly. It seemed to be scraping stinging cells off the jellyfish's skin with its pinchers and depositing them on these tufts attached to its rear legs. The purpose of these tassels, however, remains unknown. I'd never seen anything like it. Marine biologists who later viewed the footage were equally mystified. o We began to realize that this squadron of jellyfish had been pulled far off course by some unusual deep-sea phenomenon. They probably began their journey in the dark abyss and were carried skyward by a transient upwelling current. For more than a week, dozens of these jellyfish washed ashore on San Diego beaches. o At the Coronado Islands, jellyfish that approached the reef were attacked by swarms of reef fish. The jellyfish's venom seemed poor protection against garibaldi and other fish who seemed happy to snack on stinging tentacles. As the garibaldi

picked and pulled at the jellyfish, kelp bass hovered below, waiting for crabs to fall free. ◐ We spent five days filming the strange invasion of purple jellyfish. In the months that followed, scientists who reviewed the footage and the specimens taken were unable to identify the animal. It's amazing what you can sometimes find right in your own backyard. Just a few miles off the coast of Southern California, a new species had been discovered that was completely unknown to science. For more than a week the waters were filled with them. Then one morning, as mysteriously as they appeared, the jellyfish vanished and have never been seen again. ◐

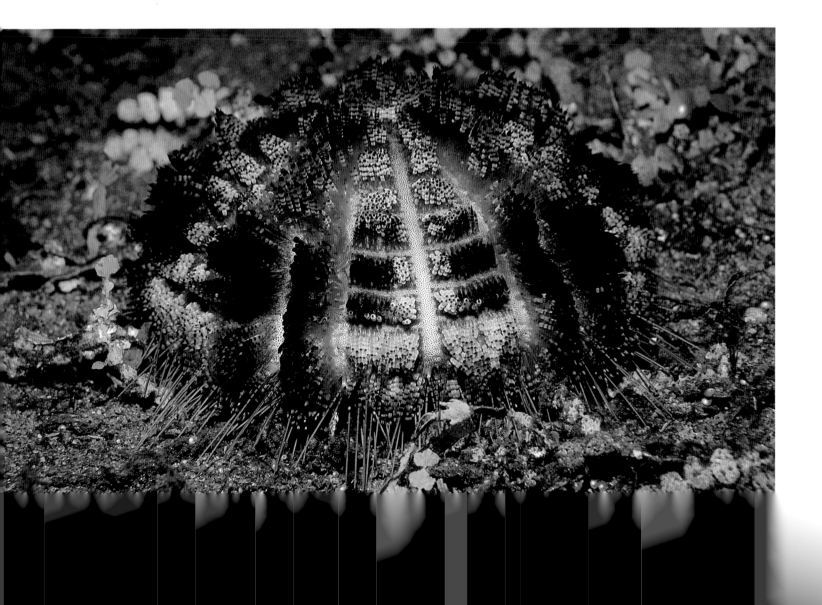

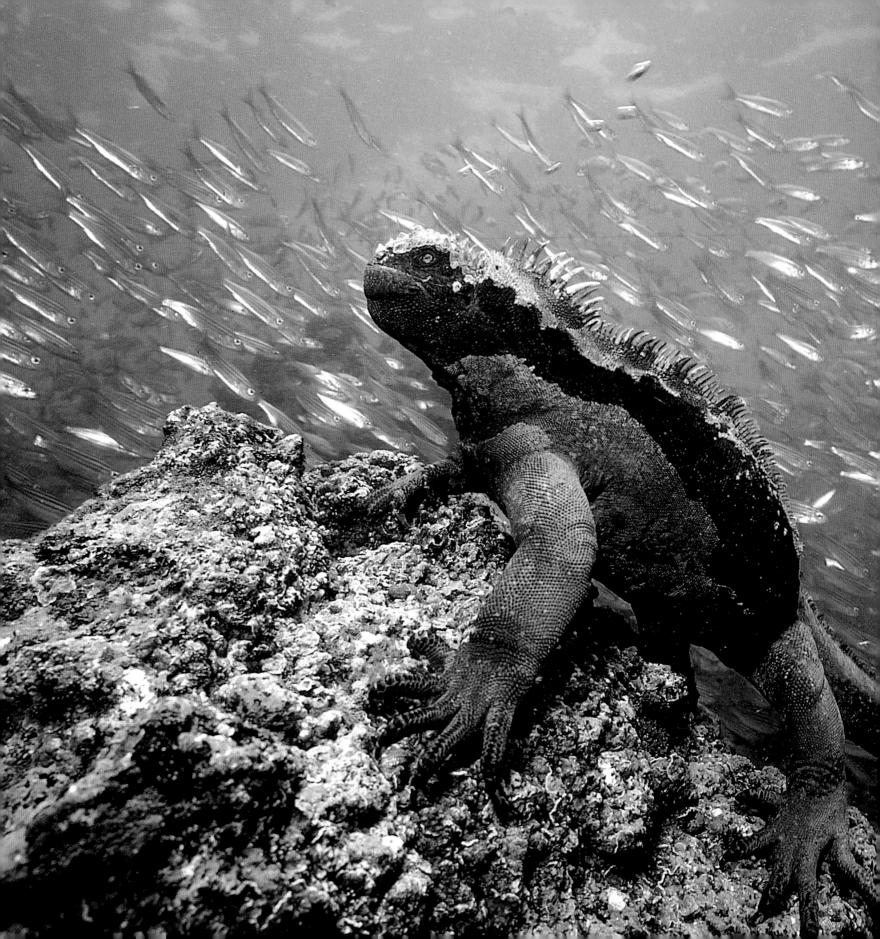

MOUNTAIN *in the* SEA

● I was standing at the summit of a rocky spire eighty feet below the surface when I heard a sound like lingering thunder. Fifty feet away, an enormous school of bigeye jacks slowly swirled, revolving in a giant column that rose from over one hundred feet nearly to the surface. It looked like a living tornado. A half-dozen hammerhead sharks moved indifferently past the school. A few of these ubiquitous predators are almost always visible here. Often they pass in schools of hundreds. ● Sometimes schools of fish fleeing from attacking predators produce a sound like distant thunder. But this didn't sound quite the same, and nothing I could see was moving fast enough to produce the rumble. I looked over to Bob and pointed to my ear. He cocked his head and nodded, acknowledging that he heard it too but was equally baffled. ● The water had grown progressively darker for the last half-hour. I checked the light meter on top of my movie camera and realized that if the light dropped any more, there wouldn't be enough for an exposure. I looked up to see what had happened to the sun. What I saw explained both the darkness and the rumble. Eighty feet above, Mark Conlin and Michele were on the surface, preparing to descend. But the ocean surface looked strange. The divers seemed to be swimming beneath a thick layer of fractured ice. This strange surface texture was caused by the impact of rain falling in a torrential downpour. The deluge was so intense that the sound of marble-sized raindrops crashing into the sea was audible eighty feet below the surface. I had never seen or heard anything like it.

Schools of jacks create living tornadoes.

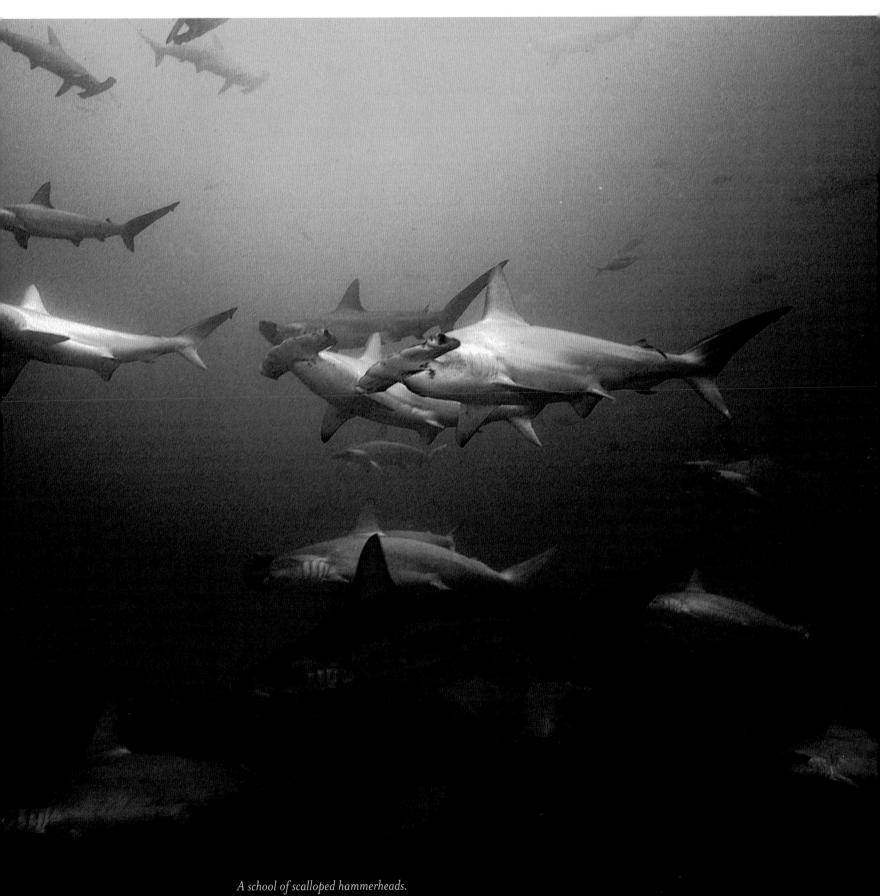

A school of scalloped hammerheads.

COCOS ISLAND, COSTA RICA

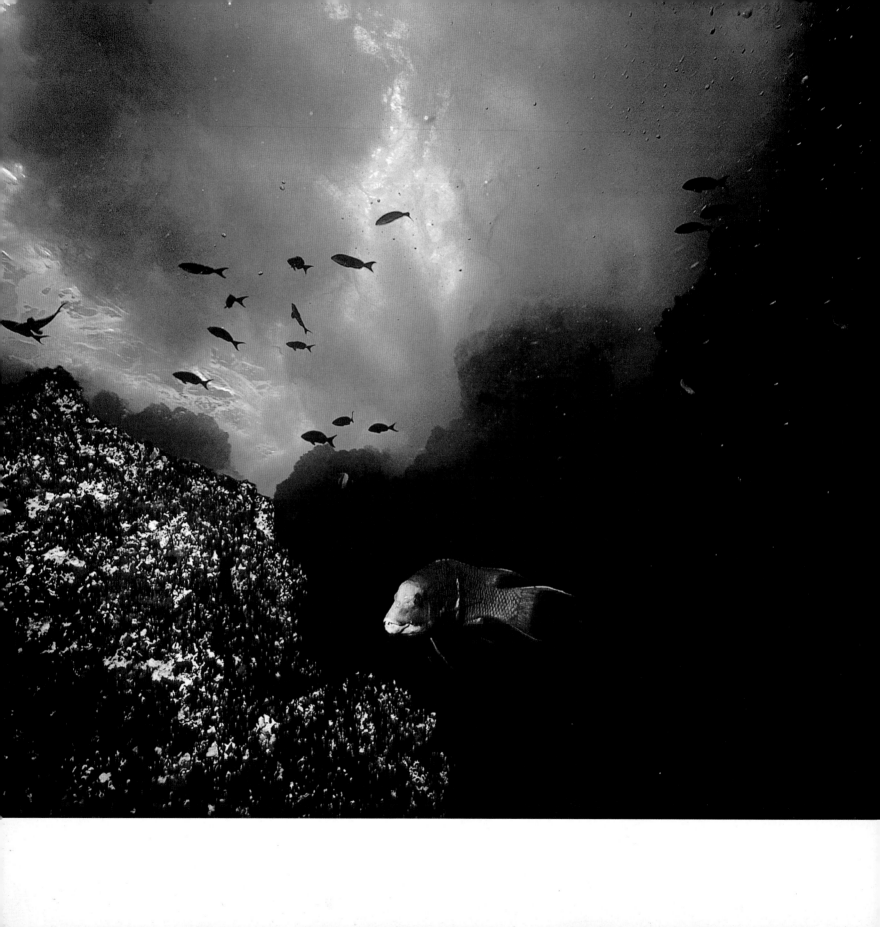

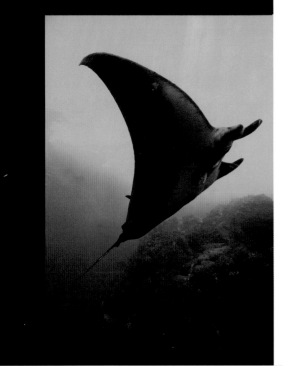

A manta ray passes over a pinnacle.

SOCORRO ISLAND, MEXICO

● This kind of rainstorm is not unusual at Cocos Island. Few places on Earth receive more rainfall. On average twenty-four feet of rain annually falls on this tiny island 300 miles west of Costa Rica. The frequent rainstorms darken the tropical sky and make underwater film work difficult. But the amazing

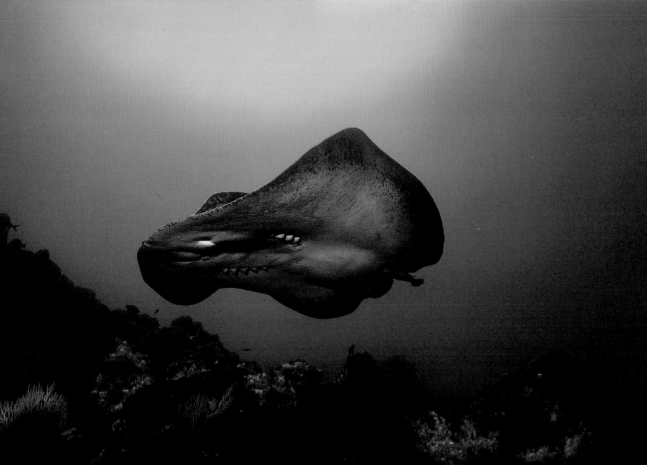

143

concentration of marine life that surrounds this isolated mountain in the sea provides more than adequate compensation for the frustrations of working here. It's not unusual to see manta rays, a whale shark, tuna, hundreds of whitetip reef sharks, and a school of hammerheads all on the same dive. ● Bob and I watched as Mark and Michele descended and moved off down the ridge. They were making a scouting dive, looking for interesting subjects for Bob and me to film. Meanwhile, Bob and I turned our attention back to the hammerheads that slowly circled past the reef. ● Often the sharks rolled on their sides as they

A pair of zebra moray eels.

neared the rocks. Then an amazing thing would happen. Dozens of black-and-yellow butterflyfish would dash out from the reef and surround one of the predators. The butterflies would gather around the shark's head, fearlessly plucking parasites from the skin covering the shark's gills and from the margins of the shark's fierce mouth. This was the behavior Bob and I were waiting patiently to film. But seeing it happen and getting it on film were two different things. In order for us to get the shot, the sharks and their colorful valets would have to approach within ten feet of our position. Our rebreathers helped us remain inconspicuous as we crouched between fingers of jagged reef. But only luck determined how close a hammerhead would approach. To get lucky, we would just have to wait.

● The deep water beyond the seamount began to glow brightly, and I suddenly realized that the rainstorm's distant thunder was gone. Sunlight was lancing down from above, and as the rain clouds parted, the light was moving toward us. A large school of hammerheads seemed to be following the light. As they passed the reef, several broke free of the school and swam toward us. Bob filmed the approaching sharks with his wide-angle lens as I captured close-ups of butterflyfish rushing out to greet the sharks. My camera was rolling as a shark passed six feet away. Through the lens, I watched a large king angelfish rise from the reef to join the butterflies and begin cleaning parasites right off the lips of the hammerhead. This is perhaps the most elegant form of symbiotic behavior. The shark benefits by having parasites removed from its skin. The angelfish and

butterflyfish benefit from an easy meal. There is an unwritten contract between predator and cleaner. The shark suspends his predatory nature, guaranteeing safe access to the cleaner in exchange for the cleaner's dermatological services. ● It was strange to watch the angelfish pecking so close to the shark's dangerous teeth. Cleaner fish are often too small to be seriously considered as prey by their hosts. But the king angel would have been a perfect bite-size meal for the hammerhead. Yet the fish showed no hesitation in approaching the predator. What makes this behavior stranger still is that many scientists now believe that cleaning behavior is not a necessary function for the survival of either host or cleaner. Instead, this contract of trust seems to be made for the convenience of the cleaner and the pleasure of the host. Many scientists still believe that animal behavior is governed entirely by instincts adapted strictly for survival. But anyone who has owned a dog knows that pets often do things simply for fun or pleasure. Why should wild animals be any different? ● Bob and I lowered our cameras as the hammerheads receded into the distance. Looking fifty yards down the reef, I could see Mark swimming toward us waving his arms. Something important was happening. Bob and I immediately left our hiding places and began swimming down the reef. Upon seeing us begin to move, Mark reversed direction and led the way. ● Michele's bubbles marked our destination. I couldn't imagine what was happening that had Mark so excited, but my anticipation was swelling with the

adrenaline that was flooding my system. Mark stopped about a hundred feet ahead of us and pointed down over the edge of the reef where, beyond our view, Michele waited. Bob and I finally made it to the reef's edge and could look down and see where Michele stood twenty feet below at the mouth of a small cave. She was entirely surrounded by huge marbled stingrays. Each dark-colored ray was nearly four feet in diameter. There were at least a hundred of them swirling around the mouth of the cave. Whatever was going on, it had the makings of a spectacular sequence. ๑ I gave Mark the signal to return to the small boat we had anchored overhead. I had little film left in my camera and wanted Mark to be dry and ready to change film when I ran out. As Bob and I dropped down toward the rays, Michele photographed us with her still camera while giant rays passed through her foreground. ๑ I had been down among the rays only a few minutes before I realized what was happening. All of the hundred or more rays circling around the mouth of the cave were males. And resting inside the cave was one very large female. Obviously this was some sort of courtship behavior. The female was about a foot larger in diameter than the largest of the males. She seemed to be asleep in the cave or, at least, trying to sleep. A half-dozen males were moving over her back and a half-dozen more were nipping at the edges of her wings. I doubted she would be able to endure this attention very much longer without reacting. I took one last shot of her lying in the cave and heard my movie camera roll out of film. ๑ I gave Bob a signal to stay put and keep track of the rays before I left.

Then I ascended to fifty feet and began swimming back in the direction of our boat. During the swim I slowly ascended to ten feet, combining swimming time with decompression time. I popped up next to the boat and passed Mark the camera. Five minutes later I was on my way back down, swimming toward the cave as fast as I could. But when I got there, Bob, Michele, and the rays were gone. ๑ A few yards farther down the reef, I saw Michele pointing down into deep water, and I continued to swim in that direction. After a few moments I could see a white glow reflecting from the fiberglass cover of Bob's rebreather down on the sand at the base of the reef. But Bob's form was indistinct. The glow from his rebreather shell shimmered and wavered like a mirage on a hot desert highway. The currents at Cocos Island were shifting. Deep abyssal water was upwelling against the side of the undersea mountain and mixing with the warm tropical Pacific. Fifty feet below, Bob was swimming in water that was twenty degrees colder than the water where I was, and the two temperatures were mixing like oil and vinegar. It was almost impossible to see through the interface. Fish swam into the swirling mixture and disappeared like an image moving across a fractured mirror. ๑ I plunged down through the temperature boundary and felt the shock as eighty-six-degree water against my skin was replaced by sixty-five-degree water. My thin wet suit was instantly inadequate. As I passed through the temperature gradient, visibility instantly improved. I could now clearly see Bob as he hovered over an amazing spectacle. The large female was moving down the slope into

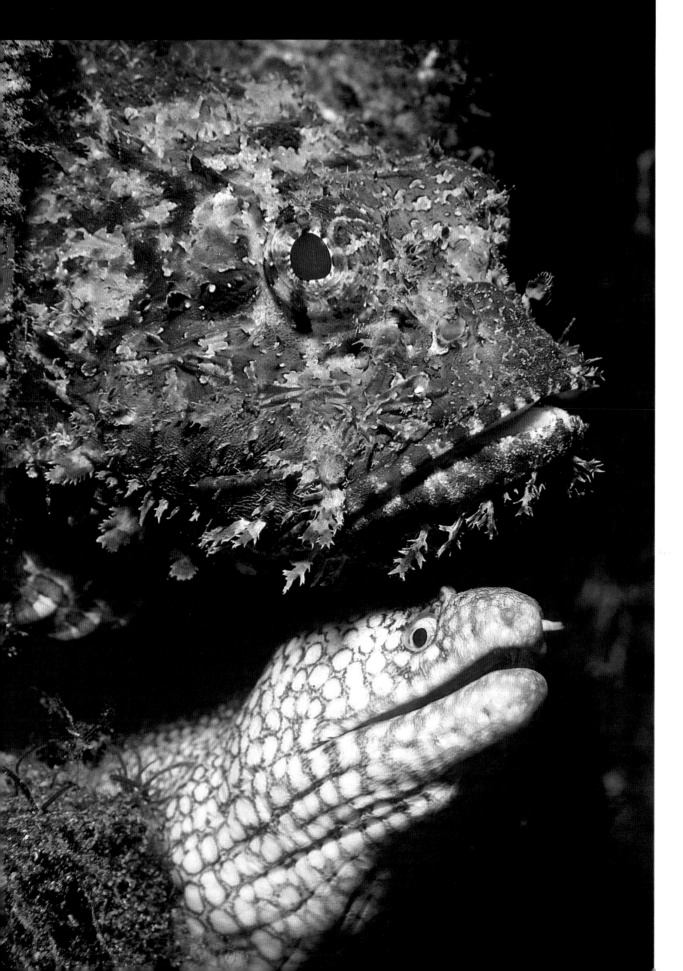

A jeweled moray and a scorpionfish make unlikely roommates.
GULF OF CALIFORNIA, MEXICO

147

A small blenny in a bed of anemones.

deep water. Behind her, moving almost in single file, a hundred male marbled rays were lined up in leisurely pursuit. They seemed content to let the female take the lead. It must have been obvious to the males that she was not yet ready to mate, and so they followed patiently in a line that stretched more than a hundred yards across the bottom. Later, Dr. Milton Love would write in the narration script for "Mountain in the Sea," "Some gentlemen just can't take no for an answer, proving that in nature, when there's a chance to get lucky, hope springs eternal." o I was breathing very hard as I descended through 140 feet and approached the head of the line. I wanted to get ahead of the female and film her as she went by. But I began to feel slightly lightheaded. I immediately knew I was overbreathing my life-support system, one of the most dangerous things that can happen while diving with a rebreather. Instantly I stopped kicking and allowed myself to drop to the seafloor, raising my camera even as I fell. I filmed the procession of males as they passed, concentrating more on purging carbon dioxide from my lungs than on composition. Sixty seconds later the rays were gone. Bob settled next to me with his camera. We rested there for another minute and then turned and began moving slowly back up the slope to join Michele at the edge of the reef. o

FILMING SECRETS

o Many of my colleagues, after viewing some of the
sequences in *Secrets of the Ocean Realm*, have told me that I
must be the luckiest underwater filmmaker on Earth.
Underwater photographer Richard Herrmann said exactly
that as we left Oceanside Harbor to film Mola molas
(also known as ocean sunfish). "Everything you touch just
plain turns to gold," he said, referring to one of the
films I'd made for the PBS series *Nature*. o I'd called
Richard because I'd seen many of his spectacular
shots of molas swimming beneath kelp paddies (patches of
kelp forest that have been torn free of the reef and
now drift on the surface in the open ocean). Marine
life tends to aggregate beneath the drifting kelp,
including schools of halfmoon perch. Molas are also
attracted to kelp paddies, where halfmoon perch
often act as cleaners by removing parasites from the molas'
skin. I knew about this behavior after seeing Richard's
still photographs. When I called and asked him about
filming the behavior, he said it would be easy.
o Richard was eager to go out with me because I was so
lucky. He probably hoped some of that luck would
rub off, blessing him with opportunities to photograph
blue whales giving birth or giant squid laying eggs. On
the other hand, I wanted to go out with Richard because I
knew he was lucky when it came to molas. After all,
I had seen his photographs, and it was obvious from them
that he had incredible luck. o Richard and I went
to sea looking for molas for five straight days. By the end of
the week, he couldn't believe our bad luck. Not only
did we not find molas, but we kept getting reports from
other divers who were seeing the fish regularly.

152

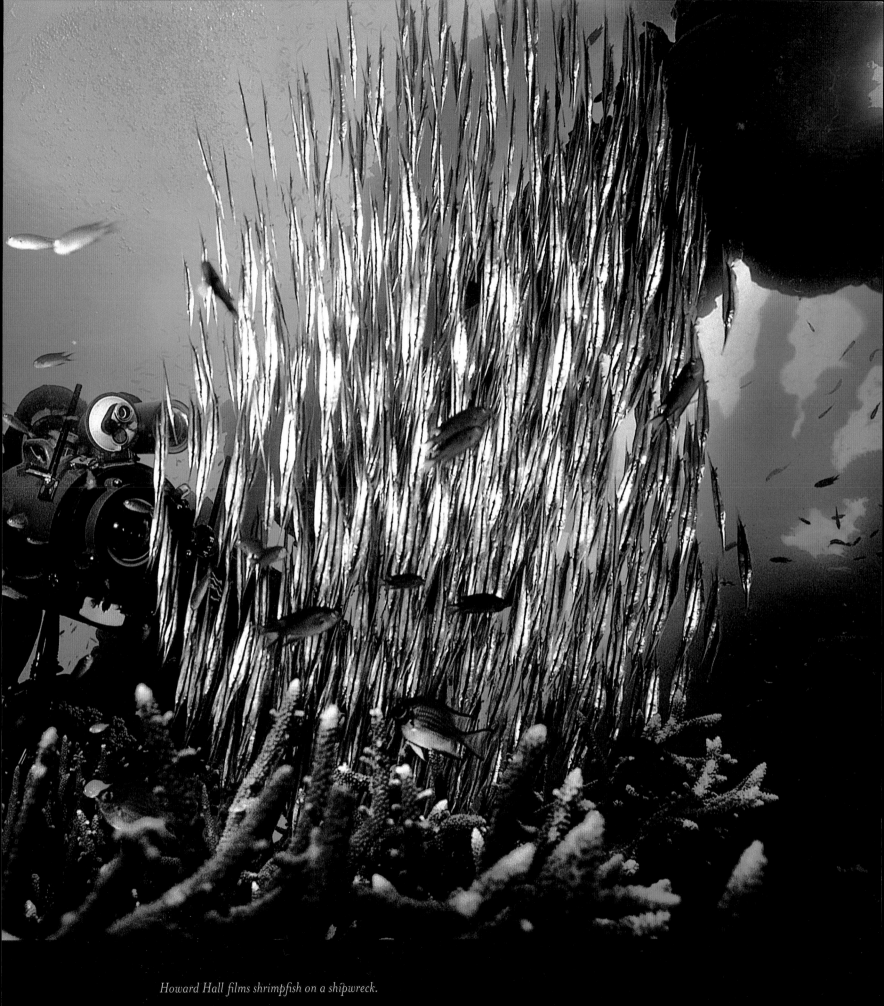

Howard Hall films shrimpfish on a shipwreck.

Papua New Guinea

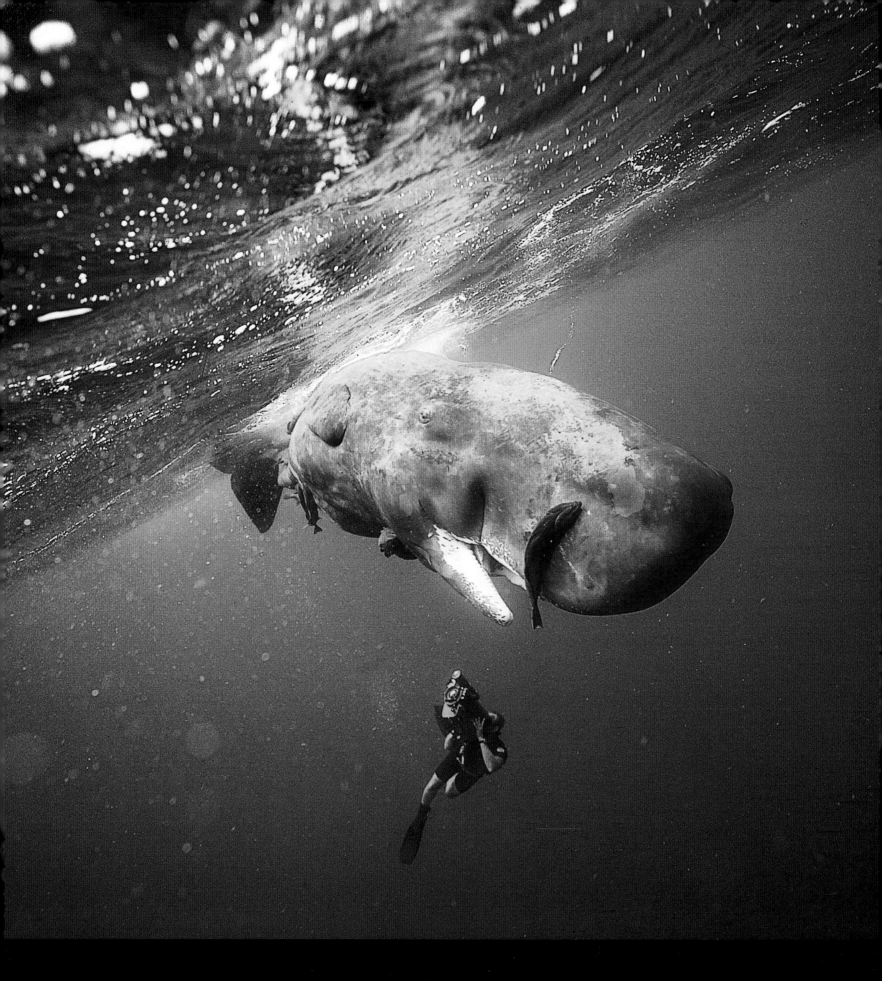

Bob Cranston films a sperm whale calf.

DOMINICA

We continued our search off and on all summer long. o On only one day that summer did I see a mola being cleaned by halfmoon perch. On that day water visibility was poor and the sky overcast, making for less than ideal photographic conditions. Still, I grasped the opportunity and filmed the sequence, which is now part of the *Secrets of the Ocean Realm* episode entitled "Cathedral in the Sea." Both Richard and I know that the sequence could be much better. But other underwater photographers who look at it will probably think, "That Howard Hall sure is lucky. Everything he touches turns to gold." o It's been said that luck is a combination of opportunity and preparedness. The more time I spend underwater trying to capture an animal or a behavior on film, the greater my chances of success. When I finally get "lucky," the results end up on television or in print and everyone can see just how lucky I was. When I spend weeks or months working on a sequence that never comes together, the results are not seen. When I'm "unlucky," it often goes entirely unnoticed. I will admit, however, that sometimes my good luck is nothing short of miraculous. o One of the luckiest sequences I ever captured on film was the underwater feeding behavior of blue whales. The lucky circumstances that came together allowing me to capture the images that appear in the episode "The Great Whales" are almost unbelievable. o The first miracle is that I went to sea at all. I received a call from a fisherman who told me that whales were feeding at the Coronado Islands, about twenty miles from my home in San Diego. When I asked how recently he had seen them, he said it had been two days ago. I thanked him for his call, shrugged my shoulders, and went back to what I was doing. After all, what are the chances those whales would still be there two days later? Probably zero. Two days later I got a call from another fisherman who said he had seen blue whales feeding at the Coronado Islands only yesterday. Again, I thanked him, shrugged my shoulders, and returned to what I was doing. Of course, I knew they couldn't be blue whales. At the time, it was thought that only 1,200 were left in the entire world. The fisherman said he saw about fifty. Ridiculous! Of course, shots of any whales feeding would make a good sequence. And though it seemed the whales had been there for several days, they would certainly be long gone before I could get out there. o Three days later a third fisherman called me and said there were blue whales feeding at the Coronado Islands. This time I didn't shrug my shoulders. This time I felt small beads of perspiration gather on my upper lip and my hands began to tremble. Obviously, something was happening at the Coronado Islands. People had been telling me about it for a week and I had let the opportunity pass while sitting on my backside at home. I was suddenly angry with myself. I'd been a slacker. I called Bob Cranston on the phone and asked him to fuel up the boat and be ready to go to sea in the morning. Of course, I knew there was virtually no chance the whales— whatever species they were—would still be there the next day. But I also knew that I couldn't stand another phone call from a fisherman if I was wrong. At dawn the next morning I parked my van in the fishing harbor

parking lot, where Mark Conlin waited to help carry my equipment to Bob's boat. ● The second miracle was that at 10 A.M. that morning the whales were still there. As we approached the islands, I could see more than a dozen whales moving on the surface. Even as whales go, these were big. Still, I knew they couldn't be blue whales. In all my years of going to sea I had never seen a blue, and I was sure there was no chance of finding a dozen or more essentially in my backyard. I decided they must be finback whales. ● Near the Coronado Islands the ocean surface was a patchwork of dark red stains. Moving the boat closer, we saw that the stains were dense patches of krill, the small crustacean that many whales feed on. As Bob and I watched, the whales moved from one dense red patch of krill to another, consuming the swarms as they passed. The whales were moving fast, and I realized that the only way to get a shot was to be where they were going. I asked Bob to drop Mark and me off next to the largest patch of krill he could find. ● The third miracle was water visibility. Whales are filter feeders. You can generally assume that water swarming with whatever planktonic animals whales might feed on will probably make for terrible water clarity. But when Mark and I jumped it, we found just the opposite to be true. In thirty years of diving in California, I had never seen clearer water. Visibility was easily 150 feet. It was absolutely incredible. The swarms of krill were confined to dense balls. Visibility inside a krill ball was zero. But outside the krill, it seemed I could see forever. Still, what would be the chances that a blue whale would choose to feed on this

particular krill ball? ● Yes, that was miracle number four. I was lying on the surface with my back to the patch of krill. When I turned around, I realized that my fins were actually inside the swarm. I was floating in a whale's soup! I suddenly realized that if a whale did eat this patch of krill, I might become part of the mouthful. I began swimming away from the krill, and after a dozen strides or so turned to check my position. I turned just in time to see a blue whale lunge at the ball of krill. I immediately pointed my camera and switched it on. ● Miracle number five: the camera worked. ● Miracle number six was the shot itself. The whale's throat ballooned toward me as the animal engulfed the entire krill swarm. With the krill gone, the whale was left surrounded by clear water. I kicked backward as fast as I could and watched the gigantic inflating throat of the whale expand to fill my viewfinder. The bulbous shape was nearly the size of a hot-air balloon. I realized that you could park a pickup truck inside the mouth of this animal and it would not make a bulge. Finally, I stopped retreating from the whale as it rolled right side up and began to swim away. The scene lasted over a minute. It was and still is the most spectacular shot I have ever captured on film. ● Miracle number seven was that, upon later examination, the whales were indeed blues, one of the rarest and most endangered animals on Earth, not to mention the largest creatures that have ever lived. ● Seven miracles is perhaps a lifetime's worth of good luck for any filmmaker. In fact, it was all the good luck I would receive for the day. When I climbed back on board the boat, my spirits were soaring

and my mind was racing. I knew I had the makings of a prizewinning sequence. Now I needed an above-water shot to match the scene I had captured underwater. I dried off as quickly as I could, then grabbed my topside movie camera and climbed to the top of the boat's thirty-foot mast. Bob maneuvered the boat close to another huge patch of krill, and I began praying that I would get lucky one more time. Then I saw a whale turn and begin swimming in our direction. A moment later it dived. ● From my position on the mast I could look straight down on the patch of krill. A silver glow began to flash deep beneath the swarm, and I realized that the gigantic whale was going to ascend straight up through the krill, mouth agape, and swallow the entire swarm. I was looking almost straight down on the krill as I focused my lens and switched on the camera. My composition could not have been better. It was the second time in one day that I had the chance for a "once in a lifetime" shot. ● The silver glow beneath the krill swarm increased in brightness as the whale ascended. Suddenly the leviathan broke the surface, its gigantic jaws open nearly wide enough to engulf our forty-foot boat. Tons of krill-laden water gushed upward with the force of the animal's lunge, and I was looking straight down the blue whale's throat. Then the animal closed its mouth and its throat expanded to accommodate the tremendous volume of water. It was a perfect match to my underwater shot. Finally, the whale turned and slowly descended. But by then I was no longer watching. ● I had collapsed to the bottom of the crow's nest and was staring at my camera. I was concentrating,

using all my willpower to prevent my trembling hands from throwing the camera to the hard deck below. Just as the whale had begun to surface, the camera battery had died! I had been offered an opportunity and had failed to grasp it. How satisfying it would have been at that moment to drop the camera and watch it explode in a spray of tiny mechanical parts! But reason prevailed. The urge was replaced by an almost terminal case of instant Tourette's syndrome. ● When I regained some of my composure, I asked Bob to maneuver for another shot. But it was too late. After feeding in these waters for over a week, the whales had decided it was time to go. Within a half hour, there was not a single whale in sight. ● All the way back to port, I was telling myself that I had captured a great sequence on film, that I should be grateful, that it should be enough. But I couldn't get my mind off that last lost opportunity. As I climbed the mast, I remember thinking that it would be prudent to change batteries. But I didn't do it. Luck is a combination of opportunity and preparedness. I had been stupidly unprepared. ● I was amazed at how quickly my luck had changed. I was filming blue whales feeding underwater one moment and I could do no wrong. A moment later my camera wouldn't work and the blue whales were gone. ● We got back to port late that night. I walked up to the parking lot and discovered that someone had stolen my van. ●

● The best way to increase your luck is to increase your opportunity and your preparedness. We did both when attempting to capture the annual mass coral spawn

on the Flower Gardens coral reef in the Gulf of Mexico. The event happens on only one day each year: eight days after the full moon in August. Unfortunately, in August 1993 there were two full moons. No one could tell us which of the two nights to choose for our filming expedition. So the only logical thing to do was to go for the first night and hope we got lucky. o The Flower Gardens expedition was five days long. The weather was great, the boat (the *Spree*) was comfortable, and the group of scientists and sport divers that joined the expedition made for good company. We had everything going for us. We were completely prepared. But the opportunity never came. The coral did not spawn. o Despite the failure of the main attraction, there turned out to be a variety of other subjects that made for interesting film work on the Flower Gardens coral reef. During our five days there, I managed to shoot nearly an hour of 16mm film. I captured some especially nice scenes of manta rays flying over colorful coral reefs in nearly crystal clear water. o Upon returning to San Diego, I sent the footage to the processing lab, where due to mechanical failure it was completely destroyed. I almost smiled when I looked at the useless footage. Had the coral actually spawned, my reaction would have been very different, requiring weeks of gentle soothing from my wife, Michele, and maybe the purchase of a new film projector. Perhaps I had been lucky after all. Certainly, it was the sort of good luck common to people who are accident-prone. A meteorite falls from the sky, crashes into a car, and breaks the driver's leg. People say to the driver,

"My God, you're lucky. You could have been killed."
Similarly, I had been lucky that the coral did not spawn. o In order to get lucky with the coral-spawning sequence, Michele and I increased our opportunity and preparedness. Using our film project's contingency funds, we booked a second expedition to the Flower Gardens, where once again we were blessed with good weather and excellent company. o The Flower Gardens reef rises to within sixty-five feet of the surface. At that depth, a scuba diver using conventional equipment can stay less than an hour before air supply and decompression time requires a return to the surface. Since most of the spawning takes place over a two-hour period, there is serious debate about when to make that one fifty-minute dive. If you make your dive too soon or too late, you could entirely miss the event. o Bob and I increased our opportunity by increasing the oxygen partial pressure setting in our rebreathers. After making the adjustment, we would be able to stay on the reef much longer than would a conventional scuba diver. We could stay down all night, if necessary. o As the sun approached the horizon eight nights after that August's second full moon, many of the people on board the *Spree* were in heated debate about what time of night to make their dive. Just before the sun disappeared over the horizon, however, Bob and I dropped off the swim step and descended to the reef. o During our time underwater, the entire coral reef exploded with spawn. Huge coral heads released millions of pink egg packets, each about a third the size of a pea. The mass of coral spawn drifted up from

Howard Hall and Marty Snyderman
film a Southern right whale.
PATAGONIA, ARGENTINA

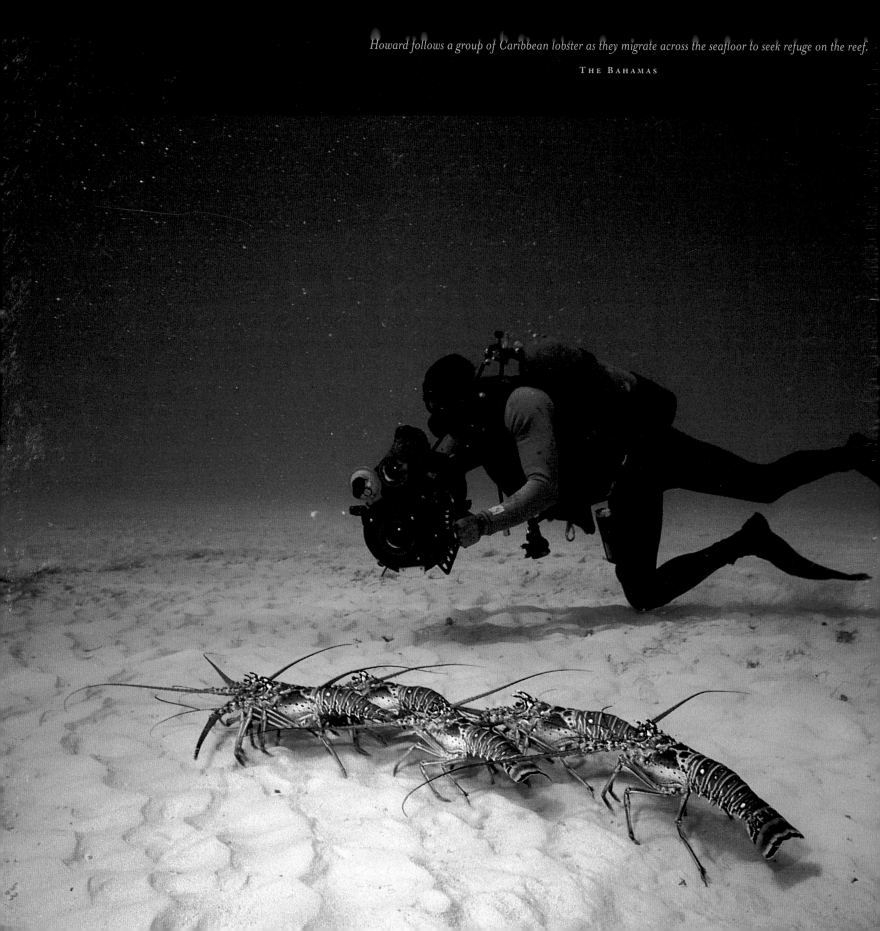

Howard follows a group of Caribbean lobster as they migrate across the seafloor to seek refuge on the reef.

THE BAHAMAS

the reef like a galaxy of stars and was carried away by the current. Other coral heads produced clouds of sperm that looked like the smoke of a forest fire beneath the sea. Predators and scavengers ate their fill but were soon overwhelmed by the amount of spawn generated by the reef. o By 11 P.M. the phenomenon had run its course. Michele and Marty Snyderman were ascending the anchor line for decompression. They had made two dives during the night, but their timing had been off. Their first dive had been a bit too early and their second dive a bit too late. Our rebreathers allowed Bob and me to witness it all. Not only had we been the first ones in the water, but by 11 P.M. we were the last ones on the bottom. We had exposed forty minutes of film. This time we'd been lucky. o Many people, and especially divers, who look at the films we've made and the photographs in this book will wonder at our good luck. Many will think that we must have been very lucky indeed to get some of the shots we captured on film. And they will be right. But we were lucky, not because we got the shots, but because we had the opportunity to search for them in the first place. The real payoff for Michele and me and our crew is not seeing the work aired on television or seeing the still photographs published in magazines and books. The real payoff is being offered the chance to make the dive in the first place. Not a day goes by that Michele and I don't appreciate the opportunity we have been given to live this kind of life. Yes, we were lucky to capture the images seen on these pages and in the films that make up *Secrets of the Ocean Realm*. In fact, we were more than lucky—we were blessed. o

ACKNOWLEDGMENTS

Secrets of the Ocean Realm, both the television series and this book, have been more than two and a half years in the making. Projects of this magnitude don't happen without help. If not for the persistent enthusiasm and unwavering confidence of our executive producers, Ron Devillier and Brian Donegan, neither the book nor the television series would have made the transition from dream to reality. The entire staff at Devillier Donegan Enterprises deserves credit in helping create these works, and we wish to thank especially Ciara Byrne, Greg Diefenbach, and Joan Lanigan for efforts above and beyond the call of duty. The artistic impact of the book Secrets of the Ocean Realm is more the achievement of the publishers and designers than the authors and photographers. We are indebted to Beyond Words Publishing for their application of talent and insistence on quality. We particularly wish to thank Cindy Black and Richard Cohn, our publishers, and Principia Graphica, the book's designer. Much of the photography for this book and for the television series was accomplished during one hundred and forty days at sea over a span of almost two years. The images captured during our filming expeditions required a team effort. The contributions from each member of our excellent team were invaluable. We give our sincere thanks to Secrets film crew members Bob Cranston, Mark Conlin, Mark Thurlow, Marty Snyderman, Norbert Wu, Mike DeGruy, and Peck Euwer. Thanks for sharing the load, when times were tough, as well as the fun, when times were good. And thanks for maintaining a sense of humor through it all. There are many others who contributed their efforts during one or more of our fifteen field expeditions. We wish to thank the scientists, location guides, travel and dive companions, and other experts for joining us and sharing their knowledge. We want to thank especially Dan Sammis and Gary Adkison in the Bahamas; Neil McDaniel in British Columbia; Jack Engle, Ph.D., Richard Herrmann, Dave Miller, Pat O. Daily, M.D., Steve Drogin, Evan Hall, Doc Anes, Jim Jenson, and the staff of Truth Aquatics in California; Avi Klapfer and the staff at Undersea Hunter in Costa Rica; Jim Watt in Hawaii; Tim Means and Baja Expeditions in Mexico; and Bob Halstead in Papua New Guinea. Several innovations in diving equipment made our many hundreds of dives safer, more comfortable, and more productive than ever before. For these we wish to credit especially Diving Unlimited International, Ocean Technology Systems, and Scubapro. Finally, a special thanks to our friend Peter Benchley for his thoughtful foreword.